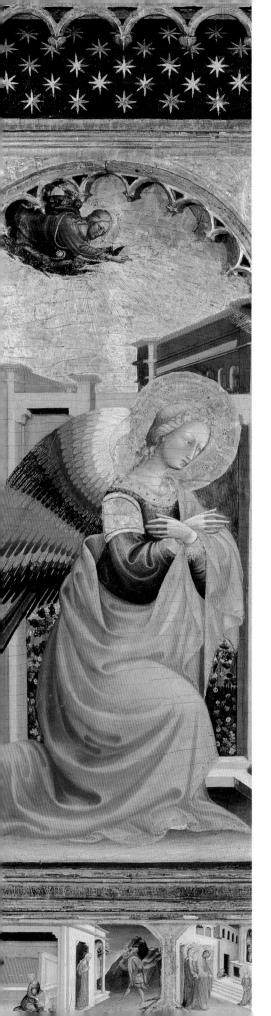

Masterpieces of
Italian Painting

The Walters Art Museum

Masterpieces
of Italian Painting

The Walters Art Museum

The WALTERS
ART MUSEUM

THE WALTERS ART MUSEUM, BALTIMORE

in association with
D GILES LIMITED, LONDON

Volume Editors
Morten Steen Hansen
Assistant Curator of Renaissance and Baroque Art
Joaneath A. Spicer
James A. Murnaghan Curator of
Renaissance and Baroque Art

This publication has been generously supported with gifts from:
The Samuel H. Kress Foundation
The Dr. Frank C. Marino Foundation
Mr. and Mrs. Nicholas Mangione
Furthermore: a program of the J. M. Kaplan Fund

First published in 2005 by GILES
an imprint of D Giles Limited
57 Abingdon Road, London, W8 6AN, UK
www.gilesltd.com

ISBN (paperback): 0–911886–58–3
ISBN (hardback): 1–904832–14–8

All measurements are in inches and centimeters;
height precedes width precedes depth.

For the Walters Art Museum:
Edited by Deborah E. Horowitz
Photography by Susan Tobin

For GILES:
Copy-edited and proofread by Sarah Kane
Designed by Peter Ling
Produced by GILES, an imprint of D Giles Limited
Printed and bound in China

Front cover illustration:
Veronese (1528–88), *Portrait of Countess Livia da Porto Thiene
and Her Daughter Portia*, ca. 1551 (detail), oil on canvas

Back cover illustration:
Attributed to Fra Carnavale, *The Ideal City*, ca. 1480–84 (detail), oil on panel

Contents

CONTRIBUTORS

Martina Bagnoli (MB), Kim E. Butler (KEB),
Cathleen A. Fleck (CAF), Maia Wellington Gahtan (MWG),
Morten Steen Hansen (MSH), Eik Kahng (EK),
C. Griffith Mann (CGM), Shilpa Prasad (SP),
Joaneath A. Spicer (JS), Tanya Tiffany (TT),
Jane Van Deuren (JVD)

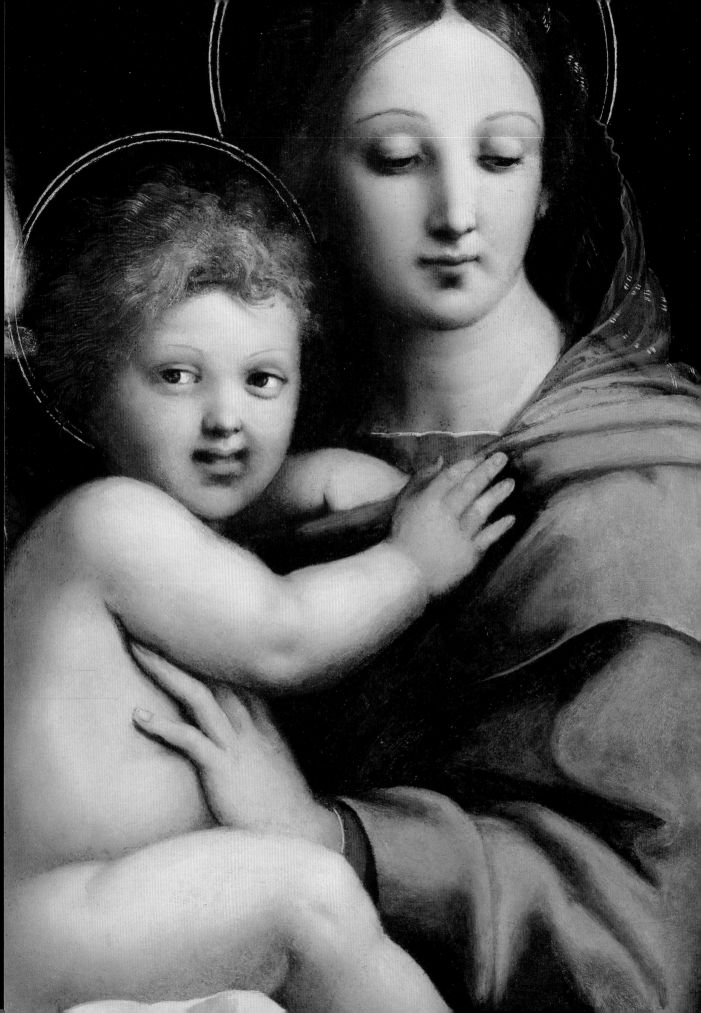

Foreword

In 1902, Henry Walters completed a transaction then unprecedented in American collecting, the purchase of an entire assemblage of over 1,700 works of art owned by Don Marcello Massarenti, a priest and member of the papal court. Stored at the Palazzo Accoramboni in Rome, the collection comprised Greek, Etruscan, and Roman antiquities; a range of medieval and Renaissance bronzes, ivories, and furniture; and a wealth of Italian paintings dating from the twelfth through the eighteenth centuries that would form the core of one of the most significant collections in the United States.

Although Walters never again acquired paintings on such a scale, he did augment his holdings with individual purchases, and the museum has continued to add important works through purchase and the gifts of generous, civic-minded donors. Its holdings of Italian art constitute a magnificent array of individual works as well as a historical journey through seven centuries of Italian art.

Published to celebrate the reopening of the Italian galleries, *Masterpieces of Italian Painting: The Walters Art Museum* presents fifty of the finest examples in the collection. Both the installation and the publication have required the concentrated efforts of the entire Walters' staff as well as interns, volunteers, and outside scholars, and I am grateful to all of them for the time and enthusiasm they have dedicated to this project.

Special thanks are due to the numerous current and former Walters' curators and fellows who contributed to the present volume, including Morteen Steen Hansen and Joaneath A. Spicer, who also served as volume editors, Martina Bagnoli, Cathleen A. Fleck, Maia Wellington Gahtan, Eik Kahng, C. Griffith Mann, and Tanya Tiffany, as well as to those scholars from other institutions, Kim E. Butler, Shilpa Prasad, and Jane Van Deuren. Their endeavors were greatly aided by museum conservators Gillian Cook, Karen French, Eric Gordon, and Terry Drayman-Weisser, photographer Susan Tobin, and editor Deborah Horowitz.

In addition, I wish to express my gratitude to the Samuel H. Kress Foundation, the Dr. Frank C. Marino Foundation, and Furthermore: a program of the J. M. Kaplan Fund for their support of this publication. Nick and Mary Mangione provided generous funding of both the book and essential conservation work. The Richard C. von Hess Foundation sponsored several key conservation analyses and treatments as well as the restoration of frames. I am deeply grateful to Andie Laporte and Doug Hamilton, co-chairs, and to the Palazzo Centennial Committee for the enthusiasm, generosity, and high energy they brought to the campaign. It is my hope that the many generous donors, too numerous to mention here, take personal satisfaction in the wonderful new galleries for Renaissance and Baroque art.

GARY VIKAN
Director

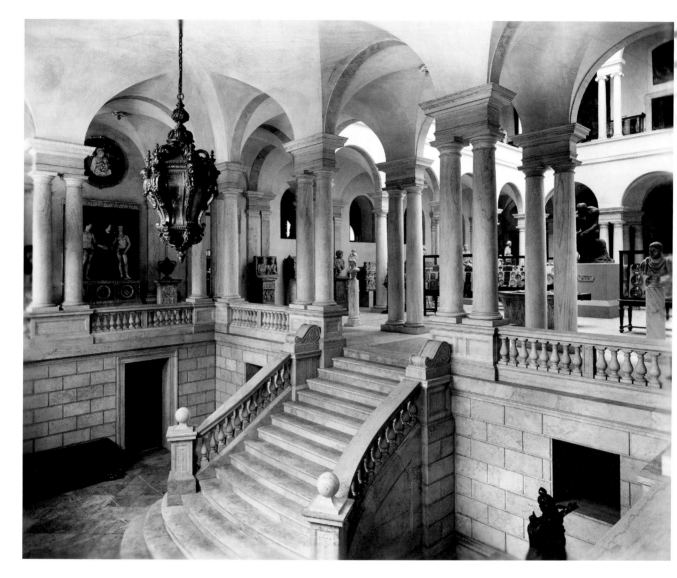

FIG. 2 Sculpture Court of the Walters Art Gallery, 1909. The Walters Art Museum archives.

Introduction

The Walters Art Museum has the second largest collection of Italian paintings from the later Middle Ages through the eighteenth century in North America, following that of The Metropolitan Museum of Art in New York.[1] By far the majority of these more than 450 works were acquired by Henry Walters (1848–1931), a railway magnate from Baltimore, an art collector, and one of the wealthiest men in nineteenth-century America (fig. 1). While his father, the financier William T. Walters (1819–94), had primarily purchased nineteenth-century European and American painting and sculpture as well as Japanese and Chinese decorative arts, his son adopted a different approach. Acquiring objects from five continents and from more than five millennia, his encyclopedic holdings were to become the basis of a public museum. Following Henry Walters' death in 1931, the collection housed in the palazzo building, the family house on 5 West Mount Vernon Place, and an endowment were donated to the city of Baltimore "for the benefit of the public."[2]

The range and scope of Henry Walters' interests widened in the late nineteenth and early twentieth centuries. In 1901, Walters purchased his first significant Renaissance painting. The *Madonna of the Candelabra* (cat. no. 22) became the first Raphael Madonna to enter an American collection.[3] Although some questioned the attribution, Walters was sure of the value of this daring acquisition. In 1910, he wrote to his art agent Bernard Berenson

FIG. 1 Portrait of Henry Walters, ca. 1920.
The Walters Art Museum archives.

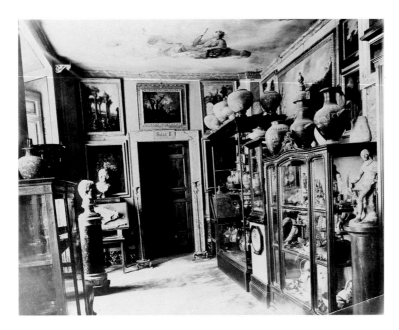

Fig. 3 Interior from the Palazzo Accoramboni, Rome, ca. 1900. The Walters Art Museum archives.

(1865–1959), "Like others, I doubt if Raphael painted the two angels, but there are few obtainable pictures by him that I would have in preference to the *Madonna of the Candelabra*."[4] Until 1922, he continued to use Berenson, the great connoisseur of Italian art, as his art agent. Himself a collector, his Villa I Tatti in the hills of Fiesole outside of Florence today serves as a research institute for Harvard University.[5] Among the works bought through Berenson were Bartolomeo di Giovanni's *The Myth of Io* (cat. no. 12) in 1911 and Bicci di Lorenzo's *Annunciation* (cat. no. 9) in 1913.

In 1902, Walters made his most momentous purchase—one that was unprecedented in scale in the history of American art collecting. From Don Marcello Massarenti (1817–1905), a priest who served as fiduciary secretary to the Vatican, he acquired over 1,700 works of art dating from the Etruscan period through the eighteenth century. The collection was then housed in space rented in the Palazzo Accoramboni on the Piazza Rusticucci in Rome (fig. 3), later demolished by Italy's fascist government to make way for the construction of the panoramic via della Conciliazione leading up to Saint Peter's.

In 1897, an expanded collection catalogue of the "museum" in the Palazzo Accoramboni had been published, listing paintings by such masters as Giotto, Masaccio, Verrocchio, Leonardo da Vinci, Correggio, Andrea del Sarto, Titian, Tintoretto, Annibale Carracci, and Caravaggio.[6] None of these attributions has stood the test of time, and even then they appeared overly optimistic if not downright fraudulent. When visiting the Palazzo Accoramboni in 1898, the art dealer Joseph Joel Duveen (1843–1908) thought the paintings to be nothing but copies after famous masters and works by minor artists.[7] Given these questions of authenticity, it is not surprising that Henry Walters' purchase of the

collection for roughly one million dollars caused quite a stir. It was praised by the American press, but some European voices were skeptical. One critic in a Berlin newspaper insinuated that the anonymous gentleman from Baltimore who bought it had been duped. Another unfortunate circumstance was the discovery after the purchase had been completed that a Raphael self-portrait, presumably a prize object in the collection, was determined to be a modern forgery.[8]

The dubious reputation of the Massarenti collection, however, was not justified. Henry Walters was well aware that not all of the works were of the highest quality, and from the outset he expected to sell around one fourth of the holdings;[9] however, the collection did contain crucial masterpieces by important Italian painters, as this book testifies, admittedly by artists of names less known to a broader public than Giotto, Leonardo da Vinci, and Caravaggio.

Since the Walters Art Gallery opened as a public museum in 1934 (in 2000 renamed the Walters Art Museum to emphasize its public role rather than its former status as a private collection), its holdings of Italian paintings have been expanded to include a few important works acquired by purchase or as gifts from private collectors and individual donors. Gaps in the collection have thereby been filled with such important pieces as Giovanni Paolo Panini's pair of views of ancient Rome (cat. no. 48) in 1954, a large-scale mannerist history painting by Giorgio Vasari (cat. no. 27) in 1973, the *Penitent Magdalene* by the great Bolognese baroque master Guido Reni (cat. no. 35) in 1987, and, most recently, in 2003, a monumental genre painting in the style of Caravaggio attributed to Pietro Paolini (cat. no. 36).

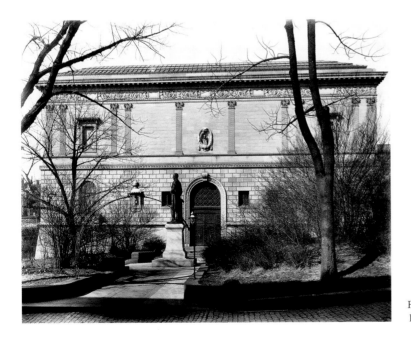

FIG. 4 Façade of the Walters Art Gallery, 1909. The Walters Art Museum archives.

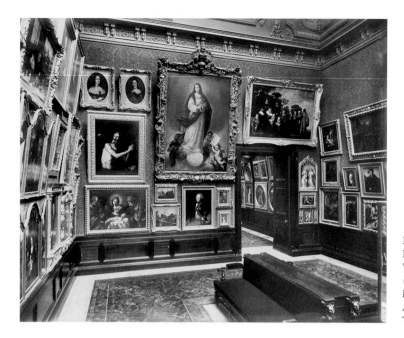

FIG. 5 View of a gallery, 1909. To the left of Bartolomé Esteban Murillo's monumental *Virgin of the Immaculate Conception* of ca. 1660 (37.286) are Jusepe de Ribera's *Saint Paul the Hermit* (cat. no. 42) and Bernardo Strozzi's *Adoration of the Shepherds* (cat. no. 43). The Walters Art Museum archives.

An impressive gallery was erected in an Italianate palatial style in 1905–7 by the firm of Delano and Aldrich, and, in 1909, it opened for the first time to the public (figs. 4–5). Built in the beaux-arts style, it drew on numerous European models.[10] The young architect, William Adams Delano (1874–1960), thought the topography of the location was comparable to the Italian harbor city of Genoa, with its steep streets and impressive baroque palaces. He, therefore, based the core of the building, a two-story glass-covered courtyard (fig. 2), on the Collegio dei Gesuiti (today the Palazzo dell'Università), built by the Balbi family for the Jesuits after drawings by Bartolomeo Bianchi in the early seventeenth century. Although the majority of the citizens of Baltimore would not have recognized the particular architectural sources of the building, many would have understood its character as a neo-Renaisssance/baroque palazzo.

The contrast between William Walters' taste for contemporary art and Henry Walters' preference for works by Old Masters was symptomatic of changing trends among collectors in nineteenth-century America.[11] The shift toward a focus on European art of the previous centuries was guided by these collectors' perception of their own role as inheritors and disseminators of European cultural traditions. The acquisition of Old Master paintings and the construction of grand historical-revival-style buildings to house them were ways of making claims to this past.

The Italian Renaissance held a particular fascination for Henry Walters, as it did for other American millionaires of the period. A textual example that throws light on the phenomenon is the work of James Jackson Jarves, who in *A Lesson for Merchant Princes* (1883) urged the industrialists of his age to follow the footsteps

of their "ancestor," the banker Giovanni Rucellai, who in fifteenth-century Florence rose from humble means, made a fortune, and patronized the arts.[12] The Italian Renaissance could, therefore, serve as a mirror for the industrialist collectors of the New World at the turn of the twentieth century.

The dominant image of the Italian Renaissance at this time was influenced by such writers as Jakob Burckhardt, whose *The Civilization of the Renaissance in Italy* was published in 1860, and Walter Pater, whose classic work *The Renaissance* appeared in 1873. Their ideas were transmitted to American collectors through the writings of Bernard Berenson. Pater glorified the notion of a "Renaissance man," a worldly individualist who surrounded himself with beautiful representations that reflected the real world—in contrast to the focus on the spiritual world that characterized the art of the Middle Ages. The notion of the worldly individualism of the Renaissance would have suited Henry Walters.

When he bought the contents of the Palazzo Accoramboni in 1902, he must have had a public museum in mind to be realized after his death. This museum was to be a civilizing institution for public edification (for the middle and upper classes) as well as a monument to himself and to his father as the cultured lovers of beauty in the image of Renaissance princes. Such "semi-aristocratic" aspirations were manifest in the building façade—indeed over the main entrance in an oval niche he placed a bust of his father as a means of honoring his ancestry (fig. 4).

MSH

NOTES

1 B. B. Fredericksen and F. Zeri, *Census of Pre-Nineteenth-Century Italian Paintings in North American Public Collections* (Cambridge, Massachusetts, 1972), 555, 644. The introduction is based on Zeri 1976, 2:xi–xv; Zafran 1988a, 10–16; W. R. Johnston, *William and Henry Walters, the Reticent Collectors* (Baltimore and London, 1999), passim. See also A. McClellan, "A Brief History of the Art Museum Public," in *Art and Its Publics: Museum Studies at the Millennium*, ed. A. McClellan (Malden, Massachusetts, Oxford, Melbourne, and Berlin, 2003), 1–49.

2 Johnston 1999, 221.

3 For the controversial history of that acquisition, see Brown 1983, 72–79.

4 Zafran 1988a, 11.

5 For Berenson, see D. A. Brown, *Berenson and the Connoisseurship of Italian Painting*, exh. cat., Washington, D.C., National Gallery of Art (Washington, D.C., 1979); E. Samuels, *Bernard Berenson: The Making of a Connoisseur* (Cambridge, Massachusetts, 1979); M. Secrest, *Being Bernard Berenson: A Biography* (New York, 1980).

6 *Catalogue du Musée de peinture, sculpture et archéologie au Palais Accoramboni*, 2 vols. (Rome, 1897). The first part of the catalogue dealing with the paintings was written by the Belgian painter Edouard van Esbroeck (1869–1949).

7 Zafran 1988a, 11.

8 Johnston 1999, 163.

9 Ibid., 163; Zafran 1988a, 13.

10 Johnston 1999, 163–69. The façade imitated the Hôtel Pourtalès in Paris.

11 Brown 1983, 28–36.

12 Brown 1983, 32.

The Twelfth–Fourteenth Centuries

In Italy, the twelfth through the fourteenth centuries marked the age of the city. Spurred by the growth of international banking and commerce, municipalities like Bologna, Florence, and Siena emerged as powerful political entities and vibrant artistic centers. Major public buildings such as cathedrals, churches, and town halls were seen as outward expressions of civic pride, and their creation required the participation of disparate elements of society even amidst periodic episodes of war, famine, and disease. While new buildings radically redefined the fabric of Italian cities, they also played a direct role in expanding and diversifying their visual culture. The erection of large edifices, many of them constructed with public funds, provided opportunities for major commissions of sculpture, altarpieces, and frescoes. They also allowed unprecedented opportunities for artistic patronage by private citizens, who had amassed fortunes in international banking and trade. In mendicant churches especially, where private burial chapels often flanked the high altar, families commemorated their dead with liturgical vessels, sculpted tombs, paintings, and murals.

From the thirteenth through the fourteenth centuries, especially in central Italy, the altarpiece emerged as the pre-eminent form of panel painting. Many of the large works produced at this time were conceived for chapel and church interiors (see cat. nos. 8 and 13). In Florence and Siena, the art of painting on panel and devotion to the Virgin led to the creation of altarpieces that celebrated the importance of the Virgin's position as the queen of the heavenly court. These monumental paintings expressed the Virgin's role as the primary point of contact between the celestial and terrestrial realms (see cat. no. 8). Her special status as the mother of Jesus ensured her efficacy as an intermediary between Christ and humankind.

As the fourteenth century progressed, painters became increasingly skilled at expressing the tension between the human and divine aspects of the figures they depicted. Glimmering in candlelit interiors, the gold backgrounds of these majestic altarpieces evoked the splendor of heaven. The solid, three-dimensional forms of their figural subjects, however, responded to new ideas about the importance of human experience in sacred history and evoked sympathetic emotional responses from worshipers. The resulting synthesis of the heavenly and earthly realms is perhaps the greatest achievement of the pictorial arts in Italy during this period. Indeed, the human elements that artists introduced into their paintings would emerge as a defining characteristic of the Gothic period, which expressed the new, civic orientation of Italian art at the end of the Middle Ages. In painting and sculpture, religious subjects were increasingly filled with concrete references to the lived experience of late medieval audiences. Direct appeals to emotions, the use of contemporary settings and costumes, and a new interest in conveying the physical presence of sacred figures combined to create a direct and immediate visual language.

The results of these experiments can be seen in the exploration of themes such as Mary's role as mother (cat. no. 4), and the human drama of Christ's Passion (cat. no. 6), as well as in portable objects that expressed the importance of saints as advocates and protectors of the faithful (cat. no. 7). Responding to a rising demand for works of private devotion, painters such as Pietro Lorenzetti (cat. no. 3) skillfully translated the grandeur of monumental altarpieces into a more intimate and personalized, domestic language. In both private and public spheres, therefore, panel painting emerged as one of the dominant art forms of Italian cities, establishing a legacy that would extend into the beginning of the Renaissance.

CGM

1

SCHOOL OF SPOLETO

The Mourning Virgin Mary, late twelfth century

THIS DELICATE PANEL depicts the mourning Virgin as she would have appeared on a painted monumental crucifix, such as the one in the cathedral of Spoleto (fig. 1). In the Spoleto cross, similar figures of Mary and Saint John the Evangelist flank the crucified Christ. The mourners are intended to represent the Church (Mary as the universal mother) and the priesthood (John as son of the Church), a theme found in a passage of John's Gospel (John 19:25–27) that was fundamental to Church doctrine.[1]

In the twelfth and thirteenth centuries, this kind of crucifix was generally placed between the nave and the sanctuary—the area around the altar—on or above the beam, screen, or arch separating the laity from the clergy, seen, for example, in the fresco of Saint Francis's *Miracle at Greccio*, in the church of San Francesco at Assisi, Italy (fig. 2).[2] The large scale of these crosses would have allowed the viewers to see them from afar. Visually, therefore, these painted crosses were connected with the altar, and their imagery related to the celebration of the Mass. They functioned as a reminder of Christ's divinity and triumph and made real his sacrifice during the Eucharist. The same associations also underscore images of the Crucifixion that usually accompany the first prayer of the blessing of the Eucharist in illustrated manuscripts of this period, such as in the Saint Francis Missal (fig. 3).[3] In this case, the missal would stand on the altar and be opened to the image of the Crucifixion while the celebrant prepared the Host for Holy Communion, thus visualizing the process of transubstantiation (in which the bread and wine of the Eucharist is transformed into the body and blood of Christ).

The style of this panel is typical of the school of Spoleto, a town in central Italy, which during the twelfth century saw the emergence of a new trend in Italian painting that grew out of diverse influences: namely the Roman, the Byzantine, and the northern European traditions. The best-known figure of this school is the painter who, in 1187, signed and dated the cross in Spoleto's cathedral. This artist has been identified as Alberto Sotio, even though this name might refer to the patron of the cross. The Walters' fragment has been associated with Sotio's cross by virtue of the Virgin's elongated proportions and her expressiveness. She lacks some of the most typical traits of Sotio's style, however, including the continuous curving line that links the nose and eyebrows. In addition, the Walters' panel demonstrates a higher

PROVENANCE
Don Marcello Massarenti, Rome, by 1897; Henry Walters, 1902

SELECTED BIBLIOGRAPHY
Zeri 1976, 1:3–4 (with earlier literature); Marques 1987, 28–33; Zafran 1988a, 18–19; Todini 1989, 1:338; Gandolfo 2003, 117–44

NOTES
1 S. Sinding-Larsen, "Some observations on liturgical imagery of the twelfth century," *Acta ad Archaelogiam et Artium Historiam Pertinentia* 8 (1978): 193–212.
2 E. Lunghi, *The Basilica of Saint Francis at Assisi. The Frescoes by Giotto his Precursors and Followers* (London, 1996).
3 G. C. P. Voorvelt and B. P. van Leeuwen, "L'évangeliaire de Baltimore, étude critique sur le missel que Saint François aurait consulté," *Collectanea Franciscana* 59 (1989): 261–321.

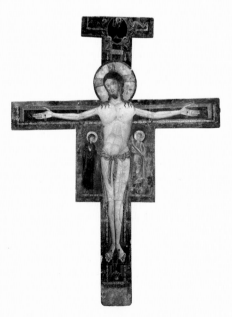

FIG. 1 Alberto Sotio, *Crucifix*, 1187, tempera on parchment and panel. Cathedral of Spoleto. Scala/Art Resource, NY.

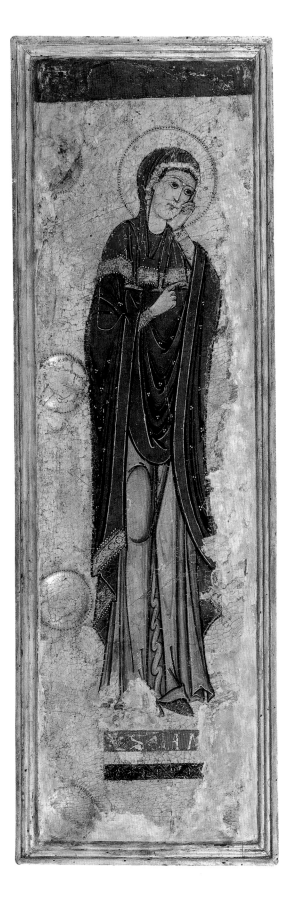

The Mourning Virgin Mary,
late twelfth century
Oil and gold on parchment
mounted on wood,
35 ¹⁄₁₆ x 11 ⁷⁄₁₆ in. (89 x 29 cm)
37.1155

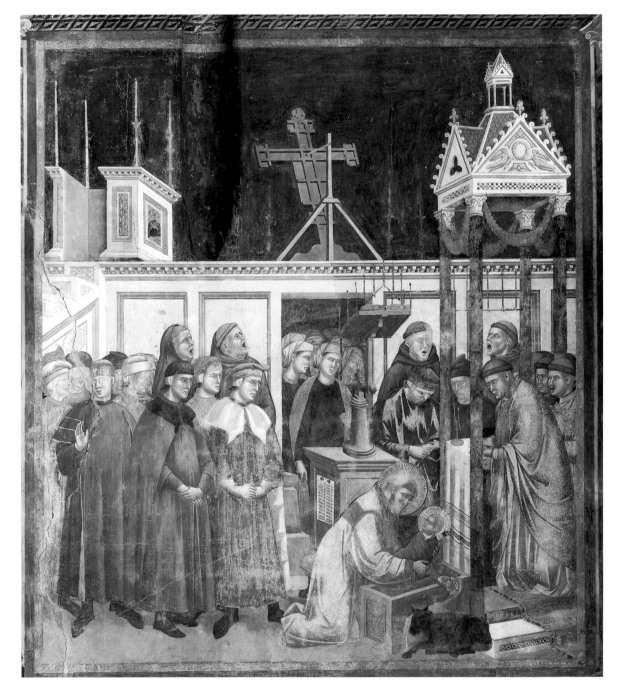

FIG. 2 Giotto di Bondone (?), *Saint Francis's Miracle at Greccio*, 1295–1301/30, fresco. Assisi, San Francesco. Scala/Art Resource, NY.

degree of sophistication in the sweeping folds of the Virgin's mantle, which falls organically to the ground. The sweetness of her expressive eyes, dark pools of sorrow in her thin face, is echoed in her calm and elegant demeanor. Recently, Francesco Gandolfo has argued that these characteristics are typical of a group of paintings from Spoleto that include a painted cross from the cemetery of Roccatamburo, now in the Museo della Castellina in Norcia, and the panel with the head of the Virgin once in a private collection and now in the Galleria Nazionale di Brera, in Milan, and a breviary in Rome (Biblioteca Valicelliana, C. 13, fol. 225v) in which the Virgin in a scene of the Presentation in the Temple closely recalls the elongated elegance of the Walters' figure. Thus, the Virgin in the Walters Art Museum stands as one of the best-preserved examples of a rich Umbrian painting tradition that included Sotio, but which was in no way restricted to him.

The bright and elegant coloring indicates the affinity between the painter of the Walters' panel and a book illuminator. Moreover, the fact that the Walters' artist painted on a piece of parchment and not directly on the primed panel seems to be an indication that he was originally trained in a manuscript workshop and was adjusting his art to the demand of the relatively new medium of panel painting. At this time, panel painting was growing increasingly popular in Italy and eventually became the medium of choice of the rising mercantile class and a prominent form of church decoration.

MB

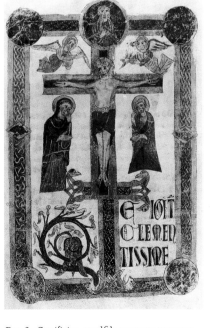

Fig. 3 *Crucifixion*, twelfth century, tempera on parchment. Baltimore, The Walters Art Museum, Ms. W.75, fol. 166v.

SCHOOL OF FLORENCE
Crucifix, ca. 1270–90

THIS MONUMENTAL CRUCIFIX presents a haunting figure of Christ. His head falls forward, while the swaying curve of his dead body is suspended from his bloody hands and outstretched arms. The grim physicality of his torso, depicted in a stylized manner with geometric modeling and a green tint, contrasts with the delicate nature of the diaphanous cloth draped around his hips. This vulnerable representation of the "suffering Christ" was developed in the mid-thirteenth century to elicit sympathy and create a devotional focus for worshipers during church services.

Busts of the mourning Virgin Mary (left) and apostle John (right) appear at the ends of the cross's arms. These figures act as the loyal witnesses to Christ's Crucifixion, just as the painted Virgin from Spoleto (cat. no. 1) would have done. The inscription on the top panel, meaning "Jesus of Nazareth, King of the Jews," is the title the Romans are recorded to have placed mockingly over Christ's head. The top of the crucifix was perhaps once crowned by a round medallion showing Christ the Redeemer, referring to the salvation brought about by Christ's death on the cross.

The unknown artist of this work depicted the elegance and emotive qualities of the crucified Christ in a manner clearly influenced by the Florentine painter Cimabue (ca. 1240–ca. 1302), recognized as one of the great Italian masters of the thirteenth century. His crucifixes in the church of San Domenico in Arezzo (1268–71) (fig. 1) and in Santa Croce in Florence (1287–88, now partially destroyed) make this connection clear. In both works, Christ hangs in a similarly exaggerated curve that highlights the drama and elegance that Cimabue borrowed from Byzantine art. The muscle and rib patterns on Christ's body exhibit the artist's experiments with light and dark shading to convey a sense of dimensionality and attention to nature that was new in the late thirteenth century.

CAF

INSCRIPTION
On the top panel: "*IHS. NAZARE | NUS. REX. IU | DEORUM*"

PROVENANCE
Don Marcello Massarenti, Rome, by 1897; Henry Walters, 1902

SELECTED BIBLIOGRAPHY
Zeri 1976, 1:4–5 (with earlier literature); Marques 1987, 129–31, fig. 146; *The Walters Art Gallery* 1997, 48

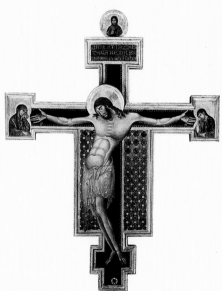

FIG. 1 Cimabue, *Painted Crucifix*, 1268–71, tempera and gold leaf on panel. Arezzo, San Domenico. Alinari/Art Resource, NY.

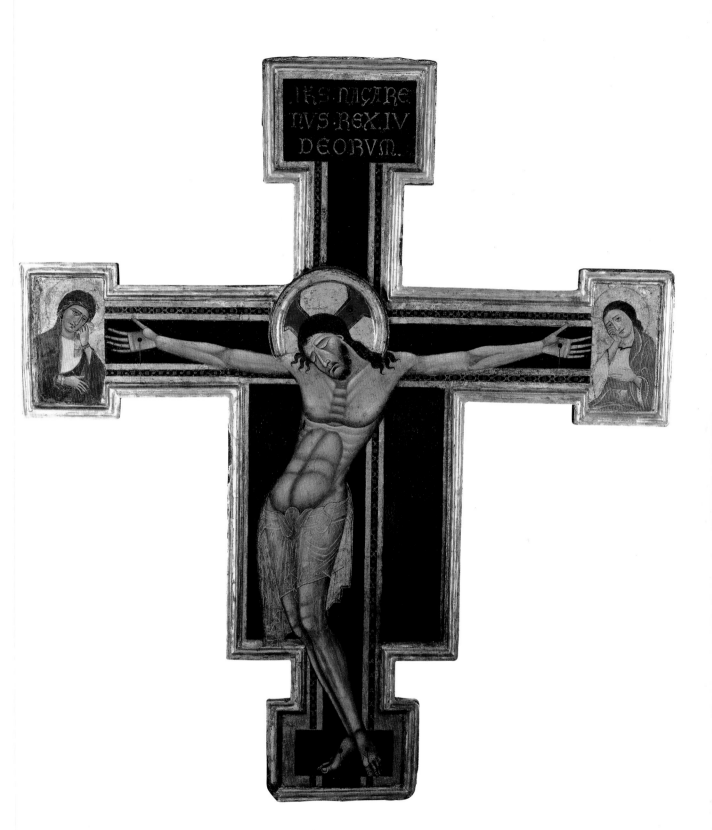

Crucifix, ca. 1270–90
Tempera and gold leaf on panel, 98 $^{11}/_{16}$ x 89 $^{9}/_{16}$ in. (250.7 x 227.5 cm)
37.710

4

NADDO CECCARELLI, ACTIVE CA. 1330–60
Reliquary Tabernacle with Virgin and Child, ca. 1350

NADDO CECCARELLI, a talented follower of Simone Martini (ca. 1284–1344), whose reputation was based on his virtuoso imitation of precious materials, was one of a handful of painters to create reliquaries that emulated the work produced by goldsmiths.[1] The format Ceccarelli adopted in this painting is filled with allusions to works traditionally executed in other media, particularly those that combined architecture and sculpture. The object's thirty-four clear glass windows, enamel-like colors, and gilded architecture give it the appearance of a sacred vessel fashioned from precious materials. Indeed, the gabled enclosure around the central painting of Christ and the Virgin explicitly draws on forms usually associated with tabernacles, or shrines that were erected over an altar to display relics or the consecrated Host.

Representations of the standing Virgin are rare in fourteenth-century Italian painting, and Ceccarelli's figural composition consequently appropriates a format traditionally linked with free-standing sculptures. In order to invest his painting with the three-dimensional character of statuary, Ceccarelli extended the punched haloes of each figure into the border of the inner frame, creating the appearance of two overlapping surface planes. As a result, the Virgin and Child seem to stand in front of the gold field that surrounds them. In contrast to the glimmering haloes and border, the smooth gold backdrop, which was burnished to diminish its reflective qualities, would have receded into the background, throwing the figures of the Virgin and Child into even sharper relief.[2] Candlelight undoubtedly enhanced this effect and serves as a reminder of how fourteenth-century painters experimented with the dimension-generating potential of gold-ground decoration.

Ceccarelli's use of sculptural elements is not unique to this piece, and comparisons with surviving sculptures of the Virgin and Child suggest that the artist consciously emulated the compositions of such sculptors as Nino Pisano (active 1343–68). His depiction of the Christ Child with a goldfinch—the bird whose feathers were speckled red with blood when it removed thorns from Christ's head during his Passion—is remarkably similar to Nino's rendition of the same subject in a mid-fourteenth-century statue in which Christ also holds the bird while gesturing toward it (fig. 1).[3] In another work by Ceccarelli from the same period (fig. 2), the artist depicted the Virgin on a pedestal, a remarkable

IDENTIFICATION OF RELICS
Relics identified by inscriptions: (inner frame, clockwise from top) illegible (pair), illegible, a bone of Saint John the Baptist, a stone from the column of the flagellation, illegible, a stone from Calvary, a stone from… [illegible], a stone from the place where Christ's cross was found, illegible, a nail from the gates of Jerusalem (?), a relic from the sepulcher of… [illegible], illegible, illegible, a stone from the sepulcher of Saint John the Evangelist, a stone from the ground where the wood of the cross stood (?), a stone associated with Mary Magdalene, a piece of the stone from which Christ ascended, illegible, a stone from the sepulcher of Christ, illegible, a stone from the sepulcher of Christ; (left pilaster from top down) bones from Saint Barnabas the Apostle, a fragment of the tunic of Saint Francis; (right pilaster from top down) illegible, illegible, a piece of the tunic of Saint Agnes (?), a relic of Saint James the Apostle, a relic of the sepulcher; (rectangular chamber from left to right) the bones of Saint Peter Martyr, relic of Saint Damascus Pope, the bones of Saint Gregory the Great, a relic of Saint Alexis, a stone from the temple of God, stones used in the martyrdom of Saint Stephen, an illegible saint's relic, and a relic of the True Cross (?)

PROVENANCE
Henry Walters from Arnold Seligman Rey and Co., New York, 1920

SELECTED BIBLIOGRAPHY
De Benedictis 1974, 140–41; Zeri 1976, 1:43–44 (with earlier literature); Wixom 1978, 128; Rowlands 1979, 122–38; Preising 1995, 19–22

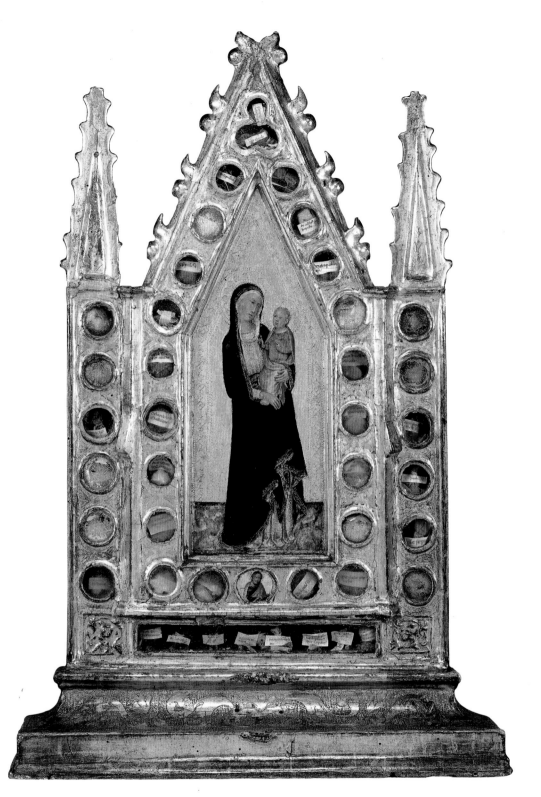

Reliquary Tabernacle with Virgin and Child, ca. 1350
Tempera, gold leaf, and glass on panel, 24 x 17 ⅛ in. (62 x 43.5 cm)
37.1159

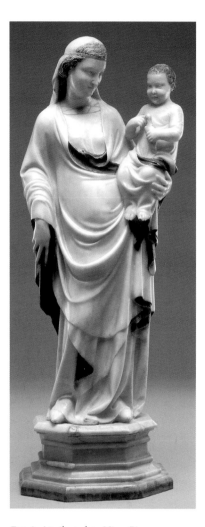

FIG. 1 Attributed to Nino Pisano,
Madonna and Child, ca. 1350–60, marble.
The Detroit Institute of Arts, Gift of
Mr. and Mrs. Edsel B. Ford, 27.150.

FIG. 2 Attributed to Naddo Ceccarelli, *Madonna and Child with Saints*, ca. 1350,
tempera on panel. Norfolk, Virginia, Chrysler Museum of Art.

allusion to freestanding polychrome sculpture on hexagonal bases.[4] Both the iconographic parallels with surviving sculptures and the use of pedestal bases in other paintings attributed to Ceccarelli testify to the painter's conscious attempt to invent visual strategies that simulated the physical characteristics of statuary.

In the Walters' tabernacle, however, Ceccarelli seems to have gone beyond sculpture and created an object that suggests in miniature an entire chapel. By placing the Virgin on a faux-marble platform, Ceccarelli's painting recalls the position of statues of Mary above altar tables. The presence of the rectangular relic chamber below the painted marble surface enhances the allusion to an altar table, which was required by canon law to contain relics. By combining these elements in his painted tabernacle, Ceccarelli presented worshipers with the miniature equivalents of the furnishings of a funerary chapel complete with statuary, altar, and relics.[5] When understood in this context, the Virgin's presence on the altar stone denotes her role as a heavenly advocate from whom help might be requested, particularly in moments of death and judgment.

In this sense, Ceccarelli's painting presents the Virgin in her role as the *porta caeli* (Gate of Heaven). This is how she is described, for instance, in the liturgy of the Feast of the Purification of the Virgin: "She is heaven's portal: does she not support in her embrace the king whose coming is the dawn of glory?" This language was particularly suited to the Virgin's representation on the reliquary, in which she cradles the Christ Child in the bend of her left arm. Framed by a sparkling portal with embedded relic windows and standing on a miniature altar, the Virgin hovers before a field of burnished gold, which alludes to the eternal realm of heaven that glimmers behind her figure. The threshold created by the marble platform on which she stands helps to clarify her role as the mediator between heaven and earth. By combining allusions to sculpture with the expressive capacity of gold-ground painting, Ceccarelli created a reliquary tabernacle that derived its potency both from the assertive, physical presence of the Virgin and Child and from the sacred remains and mementos of holy sites that the object protected.[6]

CGM

NOTES

1 Other painters included Pietro Lorenzetti, Francesco Vanuccio, and the anonymous painter of the tabernacle frame in the Cleveland Museum of Art, as well as the Florentine painter Fra Angelico. For a catalogue of painted reliquaries, see Preising 1995, 54–84.

2 Cennino Cennini (1360–1437), the painter and author, calls attention to two distinct characteristics of gold leaf: "stamping amounts to making the gold lighter; because by itself it is dark wherever it is burnished." C. Cennini, *The Craftsman's Handbook (Il libro dell'arte)*, ed. and trans. D. V. Thomson (New Haven, 1954), 86.

3 For the attribution to Nino Pisano, see A. Moskowitz, "A Madonna and Child Statue: Reversing a Reattribution," *Bulletin of the Detroit Institute of Arts* 61 (1984): 35–47.

4 For this painting, see J. Harrison, *The Chrysler Museum Handbook of the European and American Collection. Selected Paintings, Sculpture, and Drawings* (Norfolk, 1991), 2.

5 For the standing Virgin and mortuary chapels, see J. Czarnecki, "Giovanni del Biondo's Standing Madonna and Child: An Image of Mercy in the Late Trecento," in *Visions of Holiness: Art and Devotion in Renaissance Italy*, eds. A. Ladis and S. Zuraw (Athens, Georgia, 2001), 93–100.

6 Nearly all of the relics in the interior frame are stones from sacred sites and objects, while those in the outer frame are saints' relics and objects from sacred sites (see the list on p. 24)

BARTOLO DI FREDI, ACTIVE 1353–1410, AND ANDREA DI BARTOLO, ACTIVE BY 1389–1428

Massacre of the Innocents, 1388

THIS PAINTING IS REMARKABLE both for its state of preservation and for its iconography. Standing in a pulpit-like structure, King Herod orders the execution of all the male infants living in Bethlehem (Matthew 2:16). Below, Roman soldiers tear babies from their mothers and scatter the corpses across the foreground. The painter's use of color contrasts the rosy tones of the living with the green pallor of those recently killed. The forked beards, ringlets, and cowls identify the priests who accompany Herod as Jewish. This element diverges from traditional representations of the scene, which often feature a devil whispering in Herod's ear. The priests' presence reflects the anti-Semitism that defined late-medieval Christian attitudes toward local Jews, who were frequently viewed as culpable participants in Christ's suffering.[1]

This extraordinary painting was certainly part of an altarpiece at the convent of Sant'Agostino in the Tuscan hill town of San Gimignano.[2] The massive altarpiece originally combined scenes of the Massacre of the Innocents with Christ's Presentation in the Temple (fig. 1). Standing figures of Saint Gregory the Great and Saint Augustine are thought to have flanked the Walters' painting.[3] The crown-like extensions of the Walters' panel indicate that it surmounted the *Presentation in the Temple*, an arrangement that placed the first victims to die in Christ's name above Christ at the moment he demonstrates his humanity with a trickle of blood.[4] Both events were understood as prefigurations of Christ's sacrifice, which was commemorated on the altar during the Mass.

Bartolo di Fredi's workshop created several monumental altar-pieces in the 1380s requiring the efforts of several skilled craftsmen, including apprentices and assistants. The most important young painter in the artist's employ during this period was his son, Andrea di Bartolo (cat. no. 6), to whom this painting has also been attributed.[5] Bartolo often sketched the work of his predecessors and contemporaries, and borrowed single figures, groups, and even entire compositions from their paintings, including murals.[6] This work reproduces several figures from a fresco of the same subject in San Gimignano's collegiate church, where Bartolo di Fredi had, in 1367, painted a cycle of Old Testament murals.[7] His appropriation of compositions from these murals for a panel painting reflects the diminishing separation between the subject matter of altarpieces and frescoes, which previously had been the dominant medium for narrative painting.

CGM

PROVENANCE
Church of Sant'Agostino, San Gimignano; Malenotti collection, San Gimignano; Cardinal Feschi collection, Rome; Viscount Bernard d'Hendecourt collection, Paris; Henry Walters from Demotte, Paris, 1917

SELECTED BIBLIOGRAPHY
Zeri 1976, 1:48–50 (with earlier literature); Kanter 1983, 17–28; Harping 1993, 118–19; Freuler 1994, 260–72

NOTES
1 H. N. Claman, *Jewish Images in the Christian Church: Art as the Mirror of the Jewish-Christian Conflict 200–1250 C.E.* (Macon, Georgia, 2000), 149–54.
2 See Kanter 1983 and Freuler 1994.
3 See Freuler 1994, 260–72.
4 For a now famous essay on Christ's circumcision, see Steinberg 1996, 49–64.
5 Andrea di Bartolo accepted a joint commission with his father and Luca di Tommè in 1389, for which see G. de Nicola, "Andrea di Bartolo," *Rassegna d'arte senese* 14 (1921): 15.
6 For the fourteenth-century attitude toward copying, see C. Cennini, *The Craftsman's Handbook (Il libro dell'arte)*, ed. and trans. D. V. Thomson (New Haven, 1954), 14–15, and R. W. Scheller, *Exemplum: Model-book Drawings and the Practice of Artistic Transmission in the Middle Ages (ca. 900–ca. 1470)*, trans. M. Hoyle (Amsterdam, 1995).
7 See C. Fengler, "Bartolo di Fredi's Old Testament Frescoes in San Gimignano," *Art Bulletin* 63, no. 3 (1981): 374–84; Freuler 1994; and C. G. Mann, "From Creation to the End of Time: The Nave Frescoes of San Gimignano's Collegiata and the Structure of Civic Devotion," unpublished Ph.D. dissertation, The Johns Hopkins University, 2002, 278–354.

FIG. 1 Bartolo di Fredi, *Presentation of Christ in the Temple*, ca. 1380, tempera and gold leaf on panel. Paris, Musée du Louvre, M.I. 394. Erich Lessing/Art Resource, NY.

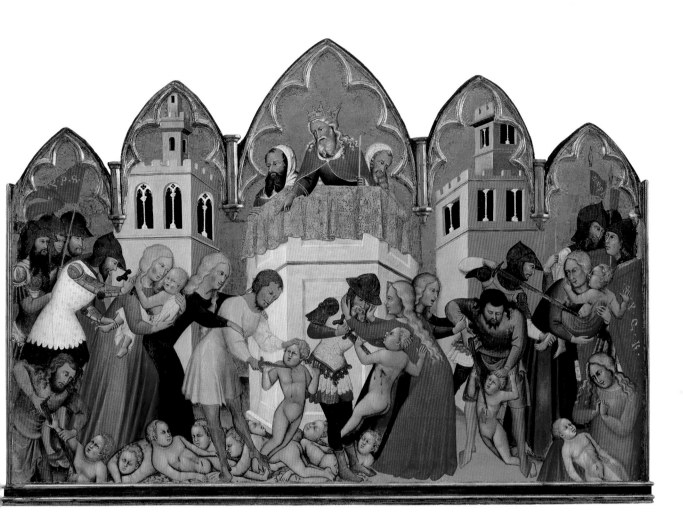

Massacre of the Innocents, 1388
Tempera and gold leaf on panel, 35 ⅛ x 51 ⅛ in. (89.2 x 129.8 cm)
37.1018

ANDREA DI BARTOLO, ACTIVE 1389–1428
Resurrection, ca. 1390–1410

DRESSED IN WHITE and emitting a golden light, Christ steps out of the hillside tomb that shelters his empty sarcophagus. The gold rays that overlap the top and right edges of the cave's entrance create the impression that Christ stands in front of the tomb, pushing his body into the light and allowing his banner to flutter in the wind. Christ's glowing presence is enhanced by the dark void of the tomb's entrance. In a fitting metaphor for his resurrection, Christ emerges from darkness into the world of the living, represented here by the naturalistic landscape. In the foreground, the soldiers stationed at the tomb are asleep, making the worshiper the sole witness of this miracle.

This scene was once one of five predella panels illustrating Christ's Passion. First appearing in the early fourteenth century, predellas featured painted scenes that were incorporated into the base of the altarpiece.[1] Their addition allowed artists to introduce serial narratives—a category of painting traditionally associated with murals—directly into their altarpieces. The subjects of predellas, typically episodes from the life of Christ or Mary, were arranged chronologically from left to right. This predella featured *The Betrayal of Christ* (private collection), *The Way to Calvary* (Lugano, Thyssen-Bornemisza Collection), *The Crucifixion* (New York, The Metropolitan Museum of Art), *The Lamentation* (Stockholm, Nationalmuseum), and *The Resurrection* (The Walters Art Museum).[2] These scenes presented the story of Christ's Passion directly above the altar where his sacrifice was ritually commemorated.[3]

Judging by their combined width, these panels belonged to an altarpiece roughly ten feet wide, a scale that reflects the kind of monumental commission typically reserved for a church's most important altars.[4] The original altarpiece may have combined images of standing saints flanking a Madonna and Child, which would have rested on the predella.[5] Produced at a time when Andrea had emerged as the head of his own workshop, this altarpiece reflects the preference for massive, multipart altarpieces that developed in Siena during the latter part of the fourteenth century. Andrea, who learned his trade in his father Bartolo di Fredi's workshop (cat. no. 5), specialized in producing altarpieces that combined imposing primary subjects and detailed narrative predellas. The juxtapositions of colors, and long, fluid lines that define the torsos and outstretched limbs of Andrea's figures characterize the painting style that he learned from his father.

CGM

PROVENANCE
Don Marcello Massarenti, Rome; Henry Walters, 1902

SELECTED BIBLIOGRAPHY
Zeri 1976, 1:50–51 (with earlier literature); Zeri 1977, 87–88; Boskovits 1990, 18–19

NOTES
1 For an overview of the altarpiece in Siena, see H. Van Os, *Sienese Altarpieces 1215–1460* (Groningen, 1988), and for the altarpiece in general, see P. Humfrey and M. Kemp, *The Altarpiece in the Renaissance* (New York, 1990).
2 For a comparable five-panel predella in Siena's Pinacoteca (no. 57), see C. Brandi, *La regia pinacoteca di Siena* (Rome, 1933), 32–33.
3 For an overview of the liturgy in Siena, see K. van der Ploeg, *Art, Architecture and Liturgy: Siena Cathedral in the Middle Ages* (Groningen, 1993); and for the liturgy in general, see T. J. Heffernan and E. A. Matter, *The Liturgy of the Medieval Church* (Kalamazoo, 2001).
4 For comparable altarpieces by Andrea di Bartolo, see L. Kanter, "Giorgio di Andrea di Bartolo," *Arte Cristiana* 74 (1986): 19ff.
5 For the proposed arrangement, see M. Boskovits, *Early Italian Painting 1290–1470* (London, 1990), 19.

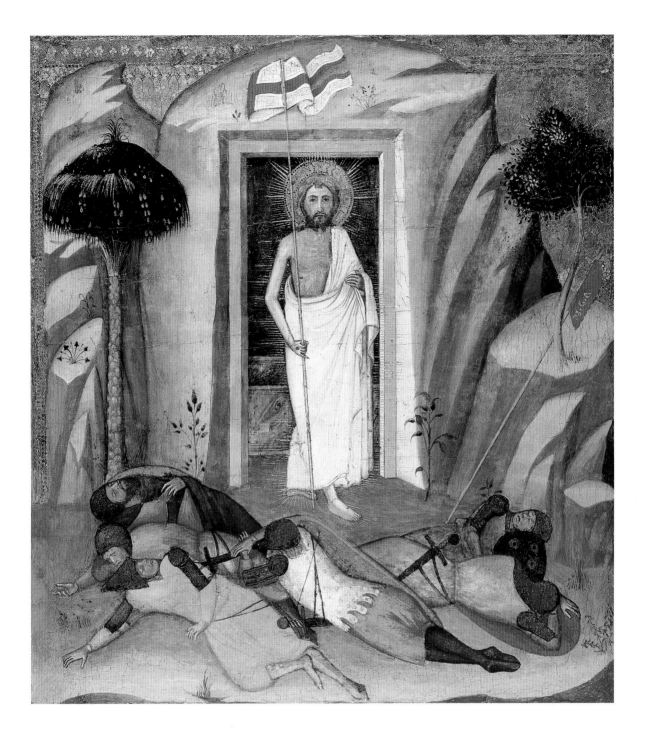

Resurrection, ca. 1390–1410
Tempera and gold leaf on panel, 20 $^{13}/_{16}$ x 18 $^{11}/_{16}$ in. (52.8 x 47.5 cm)
37.741

TOMASO DA MODENA, 1325/26–79, AND ANONYMOUS ARTISTS
Right Wing of a Reliquary Diptych, ca. 1355–70

THIS EXQUISITE WORK was once probably the right half of a small diptych, or two-winged altarpiece. The wing consists of painted wood and reverse painted glass (glass decorated on the reverse with incised drawing through gold leaf backed with gold- and silver-colored foil) panels, along with ceramic and marble insets—a highly unusual combination. The painted panels have been attributed to Tomaso da Modena (also known as Barisini), an artist active in central and northern Italy.[1] His work, found in panel painting, fresco, and manuscript illumination, is noted for its detailed depictions of everyday life, attention to clothing textures and styles, and compact figures with delicate features.

The work has many components that in themselves are common in Italian art of the fourteenth century, but assembled together they are unusual for their time. Painted panels of Saint Francis and the archangel Michael are paired below the glass panel of the crowning image of the Virgin Annunciate. She faces left, suggesting that a facing wing was attached to the left and represented the archangel Gabriel, who announced to the Virgin that she has been chosen by God to be the mother of Christ. Below, three-quarter-length representations of Saints Anthony Abbot and Cosmas (top and bottom left) and Anthony of Padua and Damian (top and bottom right) flank the central glass panel depicting the Crucifixion with the Virgin and Saint John. Quadrilobe panels at the corners of the central glass segment represent the symbols of the four Evangelists: John (eagle, upper left), Matthew (man, upper right), Luke (bull, lower right), and Mark (lion, lower left). On the edges of the central panel are bust images of twelve saints, with Saints Peter, Paul, James, Andrew, Luke, Stephen, Lawrence, and Louis of Toulouse distinguishable among them. Strips of paper in four compartments claim that the bone and stone relic fragments—remarkably still present—of Saints Andrew, Luke, Peter, and Paul (left); the Holy Cross and the Holy Sepulcher (top); the 11,000 Virgin Martyrs and one of the three Kings (right); and Saint James (bottom) are held behind the glass. The grouping of these many saints' images and relics must have been arranged at the behest of a patron with interests in a wide variety of saints' cults, which were popular across Europe.

Although the object itself gives no clues as to where or for whom it was made, the reverse-painted gold panels, an ancient Roman technique revived in the late thirteenth century,[2] offer

PROVENANCE
Sale, Villa Borghese, Rome, 17 March 1893, lot no. 385; private collection; Don Marcello Massarenti, Rome; Henry Walters, 1902

SELECTED BIBLIOGRAPHY
Zeri 1976, 1:63–64 (with earlier literature); Gibbs 1989, cat. no. 23, 200–2, 296, frontispiece, pls. 110–12; Hueck 1991, 183–88; Pujmanová 1992, 83–84; Gordon 1994, 33–42

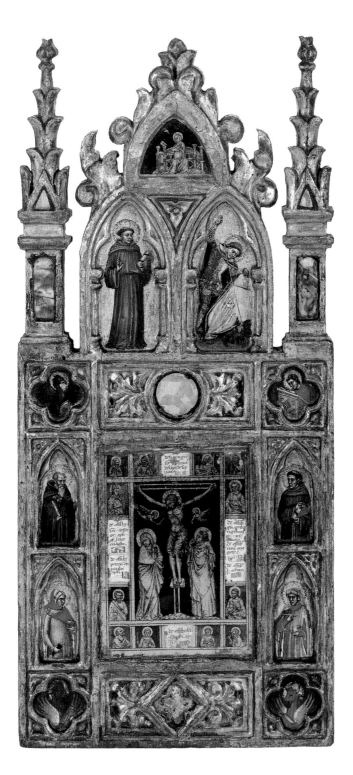

Right Wing of a Reliquary Diptych, ca. 1355–70
Tempera on panel, with reverse-painted glass insets, ceramic, marble; gilded wood frame,
17 ⁷⁄₈ x 8 ³⁄₁₆ in. (45.4 x 20.8 cm)
37.1686

information about its background and meaning. These panels of reverse-painted glass have been attributed to artists working in central (Umbria)[3] and northern Italy (Veneto and Emilia).[4] The most recent arguments point to a workshop connected to a Franciscan monastery in Assisi.[5] The inclusion of Franciscan saints—Saints Francis and Anthony of Padua in the painted side panels and Saint Louis of Toulouse on the border of the central glass section—supports this idea. The choice of reverse-painted glass as a material in this wing is perhaps linked to the relics contained within. Cennino Cennini, in his artist's handbook written in the 1390s, associates reverse-painted glass with the adornment of and devotion to saints' relics.[6] The painted gold glass shimmers just behind the surface, changing from a brilliant to dull yellow-gold from different angles. Perhaps it was seen as an inexpensive method of copying gold, crystal, and enamel techniques commonly chosen for reliquaries to honor and elevate the base form of the saints' fragmented remains held inside.[7]

The figures' clothing styles and the robust painting technique indicate that Tomaso produced the painted panels later in life,[8] when he lived mainly in Modena and Treviso. The piece compares in particular to the style, structure, decoration, and carved frame of the diptych that he created for Charles IV, Holy Roman Emperor in Prague (1316–78), now found in the Karlštejn Castle collection (fig. 1).[9] Charles IV traveled in 1355 to Rome to be crowned emperor. The sophisticated patron likely discovered Tomaso's painting during this journey and later commissioned his work.[10] The lower quadrilobe of the Walters' piece seems to have traces of black and white paint analogous to that found in the Karlštejn piece's lower quadrilobe, in which Charles' imperial coat of arms is found.[11] The special combination of the wing's varied relics with its marble, ceramic, and painted and glass elements, in addition to its diminutive size suggesting its ownership by an individual, indicates that it may have been made to appeal to Charles's—or another court patron's—taste for unique curiosities.

CAF

NOTES

1 E. Sandberg-Vavalà ("Panels by Tomaso da Modena," Journal of the Walters Art Gallery 3 [1940]: 69–74) was the first to attribute the piece to Tomaso, and others have unanimously accepted this attribution.
2 Gordon 1994, 41.
3 Gibbs 1989, cat. 23, 200–202, 296, frontispiece, pls. 110–12; Gordon 1994, 33–42; Hueck 1991, 185; F. Rossi, "Un reliquario con vetri dorati del Museo nazionale in Firenze," Dedalo 9 (1928): 707ff.
4 G. Swarzenski, "The Localization of Medieval Verre églomisé," Journal of the Walters Art Gallery 3 (1940): 35–68, figs. 1, 4; Zeri 1976, 1:63–64.
5 Gordon 1994, 33–42, fig. 14. A similar panel by the same hand is a little-known Nativity in the Wallace Collection, London; see Gordon 1994, 38, fig. 15.
6 See C. Cennini, The Craftsman's Handbook (Il libro dell'arte), ed. and trans. D. V. Thomson (New Haven, 1954), 112–14.
7 See Gordon 1994, 34.
8 See Gibbs 1989, 200–202.
9 Ibid., 176–202; cf. 286–88, pl. 93.
10 Ibid., 185–86.
11 This suggestion was made by Pujmanová 1992, 83–84.

FIG. 1 Tomaso da Modena, Diptych, ca. 1355–59, tempera on panel, pastigla, gilding. Prague, Karlštejn Castle Collection.

OLIVUCCIO DI CICCARELLO, ACTIVE 1388–1439

Madonna and Child with Saints Peter, Paul, John the Baptist, and Francis, ca. 1410–20

A MASTERPIECE by the founder of the Marchigian school of painting (the Marches being a region in eastern central Italy), Olivuccio di Ciccarello's *Madonna and Child with Saints* brilliantly exhibits the artist's eclectic integration of the ethereal and lyric qualities he learned from Sienese masters with the solid, heavy forms used by Giotto (ca. 1267–1337) and his followers.

Until recently, Olivuccio's oeuvre was attributed to a certain Carlo da Camerino on the basis of an inscription with a date (1396) on a crucifix from the Franciscan convent in Macerata Feltria. In 2002, the name in that inscription was reinterpreted to read "Olivuccio di Ciccarello da Camerino," an artist whose name has long been known to scholars from archival records but to whom no works had been definitively assigned.[1] This new reading of the Macerata inscription combined with the discovery of a second signature on a *Madonna and Child* from San Francesco at Mondavio dated 1400 has permitted scholars to reunite works once given to Carlo da Camerino with the figure of Olivuccio, who was in charge of one of the most important workshops in Ancona.[2]

In the Walters' altarpiece, the Virgin and Child appear as if in a vision, hovering within an elaborate and highly unusual lobed mandorla-like frame. The pair is accompanied by half-length images (clockwise) of Saints Peter, Paul, Francis, and John the Baptist. The Virgin's feet rest on the moon, and her body appears to emit solar rays, features drawn from the description of the apocalyptic woman of Revelation 12:1 ("And there appeared a great wonder in heaven; a woman clothed with the sun, and the moon under her feet and upon her head a crown of twelve stars"), who had been interpreted in biblical commentaries as the Virgin in her guise as Queen of Heaven. She is crowned, and her halo incorporates the words of Gabriel from the Annunciation, "Hail Mary full of grace," so that her celestial appearance to Saint John is linked to her and Christ's roles in inaugurating a new era of Grace in which mankind is absolved from the sins of Adam. This conceit is repeated in the scroll held by the Baptist in the lower left, on which are written the words "Behold the Lamb of God who takes away the sins of the world."

In order to emphasize the Virgin's solar radiance, Olivuccio used a special technique called *sgraffito* in crafting her blue mantle: first, he applied gold leaf to the entire surface over which he

INSCRIPTION
On Virgin's halo: "*AVE MAR[IA] GRATIA PLENA*"
On bottom of left panel, in two roundels: "*P, E*"
On bottom of right panel, in two roundels: "*T, R*"
On scroll held by John the Baptist:
"*ECCE/AGNUS/DEI QUI/TOLLIS/PEC[CATA MUNDI]*"

PROVENANCE
Don Marcello Massarenti, Rome, by 1897;
Henry Walters, 1902

SELECTED BIBLIOGRAPHY
Zeri 1976, 1:68–71 (with earlier literature);
Zafran 1988a, 24–25; Polverari 1989, 42–44;
De Marchi 1992, 121; Zeri 2000, 79–82; De Marchi 2002, 122, 138–39

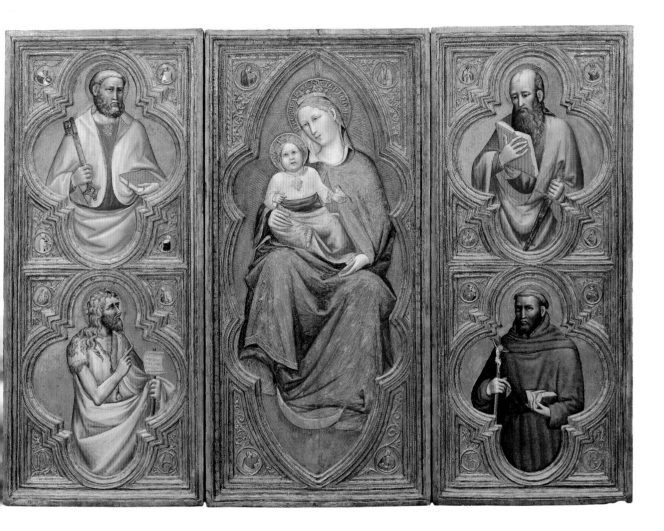

Madonna and Child with Saints Peter, Paul, John the Baptist, and Francis, ca. 1410–20
Oil on panel; central panel, including frame: 63 x 30 ⅜ in. (160 x 77.2 cm);
wing with Saints Peter and John the Baptist, including frame, 63 ¼ x 27 ⁹⁄₁₆ in. (160.6 x 70 cm);
wing with Saints Paul and Francis, including frame, 63 ⁵⁄₁₆ x 27 ⁵⁄₁₆ in. (160.8 x 69.3 cm)
37.699

Fig. 1 Detail of the Virgin's knee showing *sgraffito* technique.

Fig. 2 Drawings on reverse of panel.

painted in blue lapis lazuli. While the paint was still wet, he incised many lines in harmony with the folds of her dress so that the gold background shows through. In this way, the Virgin's spiritual light appears to radiate outwards through her garment, producing an overall brightening of the blue fabric, and an explosive shimmering effect in the places where the gold is exposed (fig. 1). The gold on her robe is thus differentiated from other passages, including Christ's robe, in which the gold is applied to the surface. The use of both methods side by side highlights the Virgin's supreme importance in this context. Olivuccio employed *sgraffito* elsewhere, and it is possible that he learned it from contact with works by either Andrea di Bologna (active in the second part of the fourteenth century) or one of the contemporary Sienese masters. Although the use of gold highlights derives from Byzantine models, this "subtractive" *sgraffito* method appears to have been a central Italian innovation of the fourteenth century.

Roundels of the four Evangelists occupy each corner of the central panel. Three hold books, but Saint John in the lower left corner has a scroll and a pen, held up to his mouth, possibly alluding to his devouring of his own prophetic text as described in Revelation 10:8–9. Just as the Virgin and Christ Child are surrounded by those who disseminated his teaching, so the other four saints are likewise surrounded by followers of their teachings in roundels—Saint John by hermit saints, Saint Francis by Franciscan friars, Saint Peter by Doctors of the Church, and Saint Paul with both elderly sages and young saints carrying scrolls with mock-Greek inscriptions. Four of the roundels are occupied by the letters P, E, T, R, of uncertain reference. The prominence of Saint Francis suggests that the work was originally meant for the main altar of a Franciscan church.[3]

MWG

NOTES

1 The inscription is offered in two different readings, one by Alessandro De Marchi in his monographic essay with catalogue on Olivuccio (De Marchi 2002, 102–59) and the other by Matteo Mazzalupi—the scholar credited with the discovery—in his appendix of inscriptions (De Marchi, ed. 2002, 467). Both agree on the identity of Olivuccio di Ciccarello.
2 De Marchi suggests that Olivuccio's expressiveness influenced his young apprentice, Bartolomeo di Tommaso, who entered his Ancona shop in 1425 (De Marchi 2002, 122).
3 Zeri 1976, 1:69. That the unusual format of the saints in the wings was later imitated by the painter Nicola di Maestro Antonio d'Ancona, working in Ancona, suggests that the convent might have been in that city or nearby. A likely candidate is the Franciscan convent of San Francesco alle Scale, founded in 1323, for which Olivuccio is documented to have painted an altarpiece at the behest of his first wife's sister, Tommasa, sometime before 26 March 1432. The convent was closed and its artworks were dispersed in 1862. The document, produced on 26 March 1432, around the time of the death of his first wife, Colozia, refers to an altarpiece that Colozia's sister, Tommasa, had earlier commissioned for the church of Saint Francis. For this document, see A. Gianandrea in *Di Olivuccio di Ciccarello pittore marchigiano del secolo XV* (Jesi, 1890), 6, 16–17 (doc. no. 30); and it is also partially reported in De Marchi 2002, 122.

BICCI DI LORENZO, 1373–1452,
WITH STEFANO DI ANTONIO, 1405–83
The Annunciation, ca. 1430

THE *ANNUNCIATION* ALTARPIECE by the Florentine artist Bicci di Lorenzo remains remarkably intact for a work of this early date. It has retained its original canopy, frame, and predella (the painted base). Documents reveal that the painter collaborated with another artist, Stefano di Antonio, whose hand has been discerned in the less refined style of the predella and the figure of King David in the spandrel above center.[1]

The cult of the Virgin Mary was among the most widespread in Italy. As intercessor, she was believed to save sinners by representing their petitions to God. In Florence, the cathedral of Santa Maria del Fiore was named for her in 1412 and numerous altarpieces throughout the city were also dedicated to her. Bicci di Lorenzo's painting was most likely commissioned for one of these.

The kneeling archangel Gabriel greets the seated Virgin Mary at the moment of the Annunciation. Above left, God the Father appears surrounded by angels, while the dove of the Holy Ghost, amidst golden rays, approaches Mary. The exchange of words between Mary and Gabriel can be read in their haloes. The angel exclaims, "Hail Mary full of grace, the Lord is with thee," and Mary replies, "Behold the handmaid of the Lord; be it done to me according to thy word" (Luke 1:28, 38).[2] Her modest posture reflects her acceptance. An open doorway in the room where the Virgin is seated reveals her bedchamber, and behind Gabriel, a little garden is visible. The *hortus conclusus* (enclosed garden) was a common metaphor associated with Mary to symbolize her virginity. The canopy is painted as a dark blue sky covered with stars, like those often found in the vaults of contemporary Gothic churches in Florence.[3]

The scenes from the life of the Virgin pictured in the predella are all based on apocryphal traditions. As her mother Anna rests in bed, the infant Mary, while being washed, folds her hands in prayer. The *Presentation in the Temple* shows the young Mary being taken by her parents to the temple. The girl climbs the steps eagerly. The *Dormition* (literally, "the falling asleep") reveals that the Virgin's death was akin to sleep. Mourned by holy men and women, Mary's soul is being lifted by Christ in the form of a swaddled baby. The text on the base of the altarpiece, praising the miracle of the virgin birth, is from an epistle by the medieval theologian Fulbert of Chartres.[4] On the bases of the framing pilasters are the now illegible coat of arms of the patron.

INSCRIPTION
On Gabriel's halo: "*AVE MARIA GRATIA PLENA D[OMI]N[U]S TECV[M]*"; on Mary's halo: "*ECCE ANCILLA DOMINI FIAT M[IHI] S[ECUNDUM] V[ERBUM]*"; on the book held by Mary: "*ECCE VIR / GO CONC / IPIET*"; on the book next to Mary: "*FEMI[N]A CIRCUM / DABIT VIRV[M] IEREM / IA P[RO]PH[ET]A / 31*"; along the base of the main panel: "*O BENE FECUNDA VIRGINITAS QUE NOVO I[N]AUDITOQ[U]E GENERE ET MATER DICI POSSIT ET VIRGO*"

PROVENANCE
Lawrence W. Hodson, Compton Hall, Wolverhampton, England; sale, Christie's, London, 25 June 1906; C. Fairfax-Murray, London and Florence, 1907–13; Henry Walters through Bernard Berenson, 1913

SELECTED BIBLIOGRAPHY
Zeri 1976, 1:32–35 (with earlier literature); Padoa Rizzo and Frosinini 1984, 5–26; Zafran 1988a, 30–31

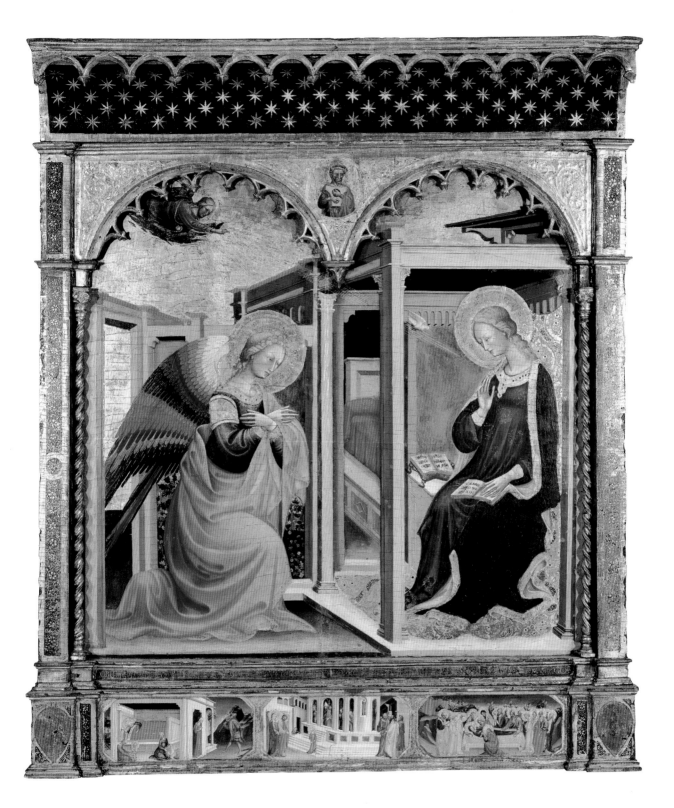

The Annunciation, ca. 1430
Tempera and gold leaf on panel, 64 ¾ x 57 in. (164.4 x 144.7 cm)
37.448

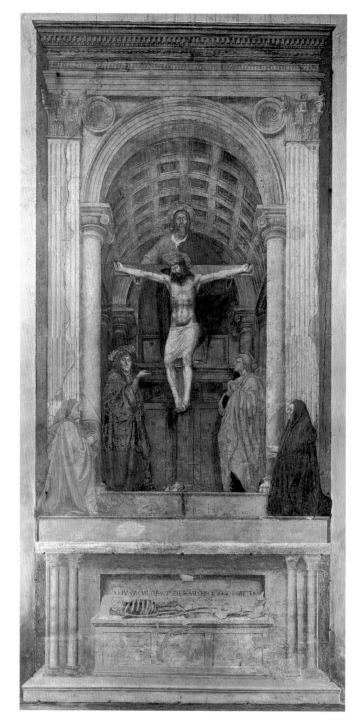

FIG.1 Masaccio, Trinity, ca. 1425, fresco. Florence, Santa Maria Novella.
Scala/Art Resource, NY.

The altarpiece reveals the way in which Christians interpreted the Old Testament: as prophecy of the advent and life of Christ. Among Christ's prophets was King David, the author of the Book of Psalms and one of Christ's ancestors, here pictured with the psaltery. Mary is depicted at the Annunciation as reading a passage in Isaiah (7:14), which was taken to allude to her virgin birth. Another book lying on a cushion with a passage from Jeremiah (31:22) has similar significance.

The predella draws on prototypes by artists associated with Florence from the early fourteenth century, while the Annunciation scene reveals Bicci di Lorenzo's engagement with the late Gothic style of Lorenzo Monaco (ca. 1370/75–ca. 1425/30). It is from this tradition that the artist developed the linear gracefulness and refinement of his figures as well as the delicacy of his colors.

Florentine artists of the early fifteenth century were particularly concerned with the representation of pictorial space. When Bicci painted his work, the famous fresco of the Trinity by Masaccio (1401–28) in Santa Maria Novella, which was the first monumental image to utilize central perspective, already existed as a model (fig. 1, see also cat. no. 15). Bicci di Lorenzo, however, chose a more traditional and intuitive way of suggesting space. Open architectural structures are created in overlapping spatial units that do not conform to a single, unified perspective. This stylized way of constructing space, together with the gold background, which is not evocative of real space, placed greater emphasis on the symbolic nature of the altarpiece than on its representation of the natural world.

MSH

NOTES
1 Zeri 1976, 1:33; Padoa Rizzo and Frosinini 1984, 8.
2 For Annunciation scenes in the fifteenth century: M. Baxandall, *Painting and Experience in Fifteenth Century Italy* (Oxford, 1972), 49–56.
3 For an interpretation of David and the sky as symbolic of the music of the heavenly spheres, see C. de Tolnay, "The Music of the Universe: Notes on a Painting by Bicci di Lorenzo," *Journal of the Walters Art Gallery* 6 (1943): 83–104.
4 Fulbert of Chartres, *Epistola X, De Assumptione B. Vigninis Mariae*, II.

FRA FILIPPO LIPPI, CA. 1406–69, AND WORKSHOP
Madonna and Child, ca. 1446–47

Fra Filippo Lippi's sixteenth-century biographer Giorgio Vasari recorded that although "all of the artist's work was outstanding, he excelled himself in his smaller paintings, which were made with unequaled grace and beauty."[1] Highly valued in fifteenth-century Florentine painting, these qualities—grace and beauty—are celebrated in Lippi's small-scale Madonna and Child devotional images, such as this well-preserved version. Responding to the increased demand for small, relatively inexpensive devotional paintings, fifteenth-century artists produced half-length Madonna and Child images with increasing frequency.[2] Although some could be found in more formal, ecclesiastical settings, their familial subject matter and intimate scale made these images ideally suited for private devotions. Within this domestic context, these paintings served various functions and evoked highly complex responses. In addition to receiving prayers and aiding meditation, sacred images were also expected to educate and to provide examples of ideal behavior for their viewers to imitate.

The composition of Lippi's panel, like many Madonna and Child images produced in Florence during the mid-fifteenth century, emerged from the innovative and influential new configurations of the subject sculpted earlier in the century by Donatello (1386/87–1466), Lorenzo Ghiberti (1378–1455), and their followers. These popular sculptural versions, such as Donatello's *Pazzi Madonna and Child* (fig. 1), had transformed the traditionally static compositional formula of the Byzantine Virgin icon by emphasizing the Madonna and Child's tender physical and psychological relationship.[3]

In the Walters' panel, Lippi builds on Donatello's portrayal of human emotion through the expressive and nuanced gestures of the figures. The mother and child are physically and symbolically linked together as Christ nestles his head and gilded halo into the Virgin's neck. One of his hands caresses her throat, while the fingertips of the other reach into the pleated front of her simple red dress.[4] The Virgin lovingly pulls the standing infant towards her, resting one hand on his thigh, while the other gracefully catches her translucent veil.[5] Falling from Mary's head, the veil loosely winds around the naked Christ Child's arm and waist before pooling on the marble ledge on which the infant stands. This fabric appears to flow out of the picture space, thereby linking the secular realm of the viewer with the holy one depicted. Moreover, the

Inscription
On original wood frame: "*AVE GRATIA PLENA DOMINVS TECVM*"

Provenance
Marquess Filippo Marignoli, Rome and Spoleto, until 1898; Marquess Francesco Marignoli, 1898–99; Don Marcello Massarenti, Rome, 1899; Henry Walters, 1902

Selected Bibliography
Zeri 1976, 1:73–74 (with earlier literature); Ruda 1993; Holmes 1999

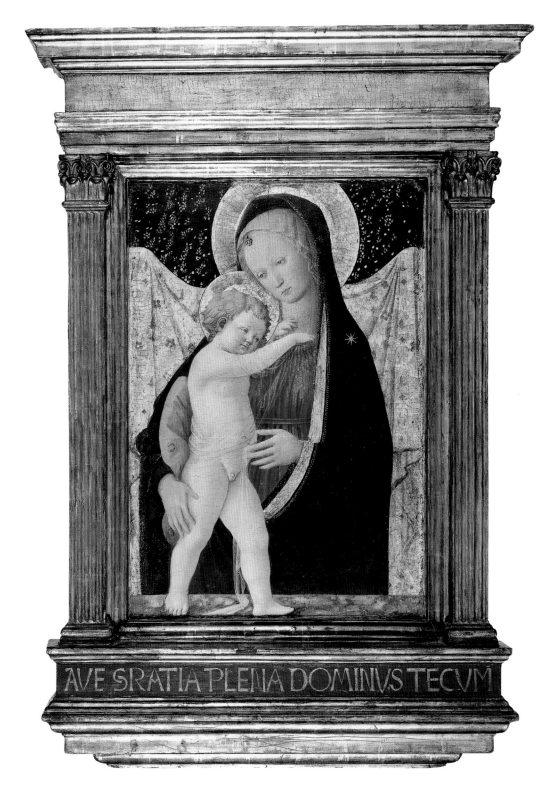

Madonna and Child, ca. 1446–47
Tempera and gold on panel, 29 ¾ x 20 ⅝ in. (75.5 x 52.3 cm)
37.429

Virgin's halo is truncated by the original wood frame. This note-worthy configuration is indicative of the artist's emphasis on naturalism, as it presupposes a pictorial space that extends beyond the framing elements, thus heightening the illusion of the Virgin and Child's tangible presence. These playful yet sophisticated pictorial devices together with Lippi's emphasis on the tender interaction between the Virgin Mother and her infant son enable the devotee to relate physically to and empathize emotionally with the holy figures depicted.

Significantly, in the Walters' panel, the humanity of the figures is closely interwoven with their divinity. To this end, Lippi integrates the Virgin and Child into a heavenly setting, conforming more closely to traditional representations of the subject. For example, the Virgin stands in front of an elaborately brocaded gold fabric, or cloth of honor, which traditionally represents her divinity as Queen of Heaven yet also recalls the uniform gold ground

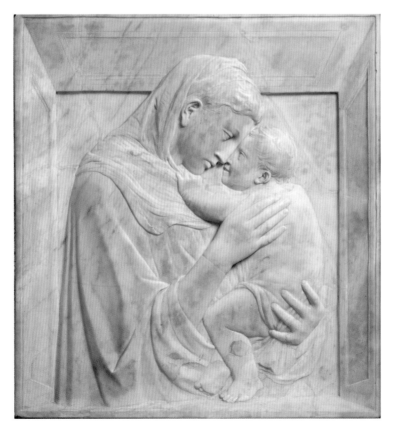

FIG. 1 Donatello, *The Pazzi Madonna and Child*, ca. 1420, marble relief. Berlin, Staatliche Museen. Bildarchiv Preussischer Kulturbesitz/Art Resource, NY.

of Byzantine icons.⁶ Moreover, the gilt fabric, draped loosely over two lateral supports, resembles Mary's royal throne. This structure, familiar to fifteenth-century viewers from its frequent depiction in contemporary altarpieces, reinforces the reference to the Virgin's divine majesty. In the background, Lippi includes an impenetrable wall of foliage covered with budding white flowers representing the *hortus conclusus* (enclosed garden), which symbolizes Mary's purity. The Virgin, painted on a large scale and pushed up against the picture plane, is positioned within the heavenly realm behind the simulated marble parapet on which her infant son stands. The ledge is rendered so it appears to belong to both the painted panel and to the original wood tabernacle frame. This arrangement emphasizes the continuity of the picture space and that of the viewer by seeming to dissolve the physical boundaries between them.

Lippi pays considerable attention to defining the physical beauty and grace of the Virgin. Mary's blond hair, arched eyebrows, refined features, and smooth ivory skin all reflect prevailing notions of female beauty and exemplify her inner character and virtue. Her simple red *gamurra* (outer dress) gathers at the neck and is belted beneath her breasts.⁷ Fashionable in the 1440s, this style is repeated in other Lippi panels of the period. An elegant pearl brooch decorates Mary's high forehead. Moreover, a lavender pillow with two ornate buttons cushions the Christ Child in Mary's arms and recalls the type of household object familiar to viewers of the day. By depicting the Virgin according to conventions of ideal beauty with contemporary dress, jewels, and decorative items, Lippi draws further parallels between the painted realm of his holy figures and the reality of fifteenth-century Florentine viewers. This heightened naturalism, which proved to be influential for painters later in the century, including Sandro Botticelli (1445–1510) and Andrea del Verrocchio (1435–88), strengthens the efficacy of the image by intensifying the viewer's devotional experience.

JVD

NOTES
1 "E se fra' Filippo fu raro in tutte le sue pitture, nelle piccole superò se stesso, perchè le fece tanto graziose e belle che non si può far meglio…" Vasari 1906, 2:626.
2 R. Goldthwaite, *Wealth and the Demand for Art in Italy 1300–1600* (Baltimore and London, 1993), 140–48.
3 For the shift in artistic objectives from Byzantine to Early Renaissance depictions of the Virgin and Child, see S. Ringbom, *Icon to Narrative: The Rise of the Dramatic Close-Up in Fifteenth-Century Devotional Painting* (Åbo, Finland, 1965), 58–61, and H. Belting, *Likeness and Presence: A History of the Image Before the Era of Art* (Chicago, 1994), 362–76.
4 The gesture of reaching for his mother's chest signals and preludes his nursing at her breast, emphasizing the pair's humanity in a variant of the *Madonna lactans* or "Nursing Madonna" type. See M. Holmes, "Disrobing the Virgin: The *Madonna lactans* in Fifteenth-Century Florentine Art," in *Picturing Women in Renaissance and Baroque Italy*, eds. G. Johnson and S. Matthews Grieco (Cambridge, 1997), 167–95.
5 Faint traces of the original position of Mary's right hand can be seen around the Child's waist. Similar adjustments to hands in other works suggest that this fine-tuning of gesture was typical of Lippi's working procedure.
6 Jeffrey Ruda notes that the folds on the cloth of honor are slightly worn, thereby making the composition appear flatter than it may originally have been. Moreover, Mary's mantle has lost most of its modeling, now appearing almost uniformly black. *Fra Filippo Lippi* (New York and London, 1993), 183.
7 The gold star on the Virgin's mantle refers to her epithet *stella maris* or "Star of the Sea," which derives from the Jewish form of Mary's name, Miriam. This widely used symbol articulates various characteristics of the Virgin, including her mission as mother of the Redeemer and her allegorical role as the dawn preceding the Rising Sun, which is Christ.

NERI DI BICCI, 1419–91

The Coronation of the Virgin with Angels and Four Saints, ca. 1470–75

THIS MONUMENTAL *Coronation of the Virgin* by the Florentine painter Neri di Bicci, who was the son of Bicci di Lorenzo (cat. no. 9), was probably made for the high altar of a Tuscan church.[1] The artist executed several versions of this subject, which testifies to the importance of the cult of the Virgin in Renaissance Italy. In this painting, the seated Christ places a crown, resembling the one he himself is wearing, on his mother's head. The pair is set before a golden, circular background surrounded by worshiping angels. This post-biblical scene, revealing Christ's and Mary's roles as King and Queen of Heaven, takes place after the Virgin's assumption into heaven. Below are, from left to right, Saints John the Baptist, then Augustine and his mother Monica (?), and Nicholas of Bari.

Underneath is a tabernacle depicting the Crucifixion with the grieving Virgin and Saint John the Evangelist. The image is worshiped by two angels, creating a picture within a picture. This lower part of the image was originally cut and hinged, providing a recess that opened inwards.[2] Perhaps it housed the sacrament of the Holy Eucharist to be used during Mass.

Neri di Bicci's figures, with their characteristic fleshy noses and large eyes with heavy lids, have a three-dimensional, sculptural quality characteristic of mid-fifteenth-century Florentine painting (see also cat. no. 10). The artist has created a gilded disk containing concentric rings consisting of rays and flames. This divine radiance alludes to the music of the heavenly spheres—an ancient belief that the spheres of the planets produced harmonies that could not be heard by humans.[3] Christians came to think of this as the music of the angels. Neri di Bicci may have learned of this notion from the *Divine Comedy* by Dante Alighieri (1265–1321). In the altarpiece, the Virgin and Christ are symbolically placed at the center of this cosmic order.

Although he has not used linear perspective, the painter did foreshorten the angel that holds the tabernacle (a technique in which the length of a figure is reduced to produce an illusion of extension into space) as a demonstration of his mastery of pictorial perspective.[4]

MSH

PROVENANCE
Don Marcello Massarenti, Rome, by 1897; Henry Walters, 1902

SELECTED BIBLIOGRAPHY
Zeri 1976, 1:87–89 (with earlier literature); Thomas 1997, 103–6

NOTES

1 Zeri 1976, 1:87–89. For a dating to the early 1470s on the basis of style, see Thomas 1997, 104.
2 G. Cook, "Three Generations of a Florentine Workshop: a Comparative Study of the Materials and Techniques of Lorenzo di Bicci, Bicci di Lorenzo and Neri di Bicci," in *ICOM Committee for Conservation: 13th Triennial Meeting, Rio de Janeiro* (London, 2002), 415.
3 C. de Tolnay, "The Music of the Universe: Notes on a Painting by Bicci di Lorenzo," *Journal of the Walters Art Gallery* 6 (1943): 83–104, esp. 94.
4 For *scorci* (foreshortenings) as a means of displaying difficulty, see M. Baxandall, *Painting and Experience in Fifteenth Century Italy* (Oxford, 1972), 143–45.

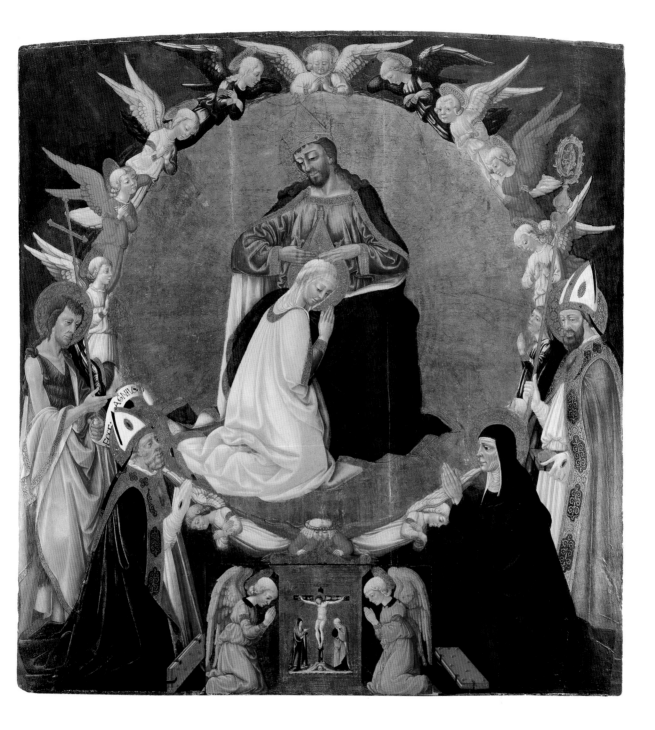

The Coronation of the Virgin with Angels and Four Saints, ca. 1470–75
Tempera and gold leaf on panel, 81 x 79 ⅜ in. (205.7 x 201.6 cm)
37.675

BARTOLOMEO DI GIOVANNI, ACTIVE CA. 1483–1500/1505

The Myth of Io, ca. 1490

THE SUBJECT OF *The Myth of Io* is taken from Book 1 of the *Metamorphoses* by the ancient Roman poet Ovid.[1] Bartolomeo di Giovanni's painted narrative begins in a pendant panel (fig. 1). This first image depicts Jupiter pursuing and overpowering the young nymph Io. Then, to protect her from his jealous wife Juno, he transforms Io into a heifer. Pretending not to know the identity of the animal, Juno asks Jupiter to give it to her, and she sets the hundred-eyed Argus (though here only depicted with two) to guard over her. The distressed Io then sees her father, the river god Inachus, and her sisters.

The story of the very human emotions of the gods continues in the Walters' panel, in which Jupiter sends Mercury to save Io from Argus.[2] Disguised as a flute-playing shepherd, Mercury lulls Argus to sleep and cuts off his head. Juno then picks up Argus's many eyes and sets them on the tail of her bird, the peacock. To take revenge, Juno sends one of the furies, though here the artist has depicted all three of them, to torture Io. The panicked Io escapes to the River Nile, where finally she is allowed to return to her human form. In the end, she is deified as the goddess Isis, represented here in this guise in the sky.

The story is played out in an idyllic, pastoral landscape with fresh green fields, a clear blue sky, and a horizon that turns whitish and hazy. The landscape is evocative of an idealized version of the Tuscan countryside, even though intended to represent the Egyptian Nile valley.

The panels are *spalliera* paintings probably commissioned for the palace of a patrician household in Florence.[3] The painter, who served as an assistant to his more famous Florentine colleagues Sandro Botticelli (1444/45–1510) and Domenico Ghirlandaio (1448/49–94), specialized in smaller works such as predellas and *spalliera* paintings.

MSH

PROVENANCE
Mrs. Baillie-Hamilton, Langton, near Duns, Berwickshire, Scotland, by 1903; Henry Walters through Bernard Berenson, 1911

SELECTED BIBLIOGRAPHY
Zeri 1976, 1:100–102 (with earlier literature); Zafran 1988a, 38–39; Barriault 1994, 145–46

NOTES
1 Zeri 1976, 1:100–101; Barriault 1994, 145–46. For the artist, see E. Fahy, "Bartolomeo di Giovanni Reconsidered," *Apollo* (May 1973): 462–69; *Bartolomeo di Giovanni: collaboratore di Ghirlandaio e Botticelli*, ed. N. Pons, exh. cat., Florence, Museo di San Marco (Florence, 2004).
2 The story was even mocked by Lucian in his *Dialogues of the Sea-Gods* 11 (7).
3 Other *spalliera* paintings in the Walters Art Museum include Orioli's *Sulpicia* and *The Ideal City* (cat. nos. 14 and 15).

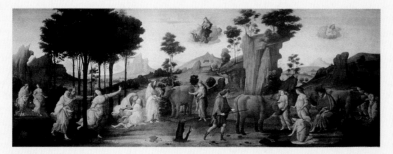

FIG. 1 Bartolomeo di Giovanni, *Myth of Io*, ca. 1490, oil on panel. Munich, Wittelsbacher Ausgleichsfonds, B I 28.

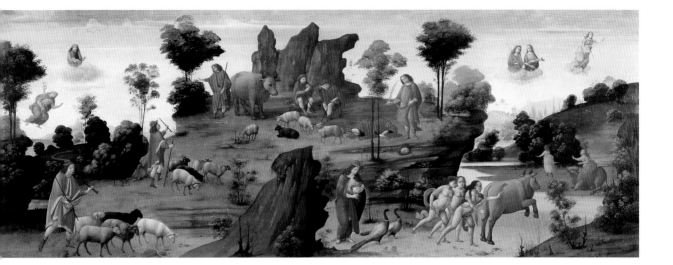

The Myth of Io, ca. 1490
Tempera and oil on panel, 25 ⅝ x 67 ½ in. (65 x 171.5 cm)
37.421

GIOVANNI DI PAOLO, ACTIVE 1420–82

The Resurrection of Lazarus, The Way to Calvary,
The Descent from the Cross, and The Entombment, 1426

GIOVANNI DI PAOLO'S four early masterpieces were once part of the predella of a large polyptych (multi-panel altarpiece) installed in the chapel of the Malavolti family in the church of San Domenico in the Tuscan city of Siena. The main panel depicted the Virgin and Child, while Saints Dominic (the titular saint of the church) and John the Baptist were represented in lateral panels on the left (figs. 1–3). Images of Saints Paul and Lawrence, now lost, could be seen on the right. The central predella panel was a Crucifixion scene (fig. 4).[1]

With the exception of the first scene depicting the resurrection of Lazarus, this complex series depicts moments from Christ's Passion. The visual focal point is the central and somewhat larger image of the Crucifixion. With the Entombment as the narrative culmination of the predella, Giovanni di Paolo has placed emphasis on Christ's physical sufferings and death. The only allusion to his glorious Resurrection is the first scene with Lazarus, which prefigured that event.

PROVENANCE
The church of San Domenico, Siena, "Pecci-Paganucci" altar, 1426 until around the mid-sixteenth century; Malavolti altar, from the early seventeenth to perhaps the late eighteenth century; Comm. Galgano Saracini, Siena, by 1819 (as Duccio di Segna, together with the *Crucifixion* now at Altenburg); the Counts Chigi-Saracini, Siena, until around 1911; Henry Walters from Luigi Grassi, Florence, 1911

SELECTED BIBLIOGRAPHY
Zeri 1976, 1:116–21 (with earlier literature); Christiansen 1982, 50; Cole 1985, 72–88; Zafran 1988a, 26–19

FIG. 1 Giovanni di Paolo, *Saint Dominic,* 1426, tempera and gold leaf on panel. Siena, Pinacoteca, 197.

FIG. 2 Giovanni di Paolo, *Saint John the Baptist,* 1426, tempera and gold leaf on panel. Siena, Pinacoteca, 193.

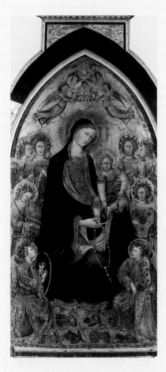

FIG. 3 Giovanni di Paolo, *Virgin and Child Enthroned Surrounded by Angels,* 1426, tempera and gold leaf on panel. Castelnuovo Berardenga, Propositura.

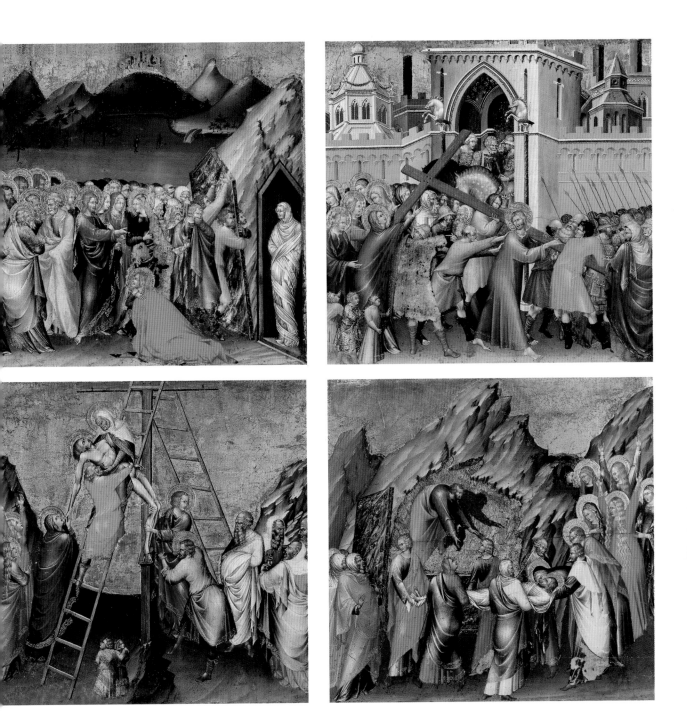

The Resurrection of Lazarus, The Way to Calvary,
The Descent from the Cross, and The Entombment, 1426
Tempera and gold leaf on panel, 15 ¹⁵/₁₆ x 17 ⅛ in. (40.5 x 43.5 cm); 16 x 17 ⅛ in. (40.6 x 43.5 cm);
15 ⅝ x 17 ¼ in. (40.4 x 43.8 cm); 15 ⅞ x 17 ¼ in. (40.4 x 43.8 cm)
37.489a–d

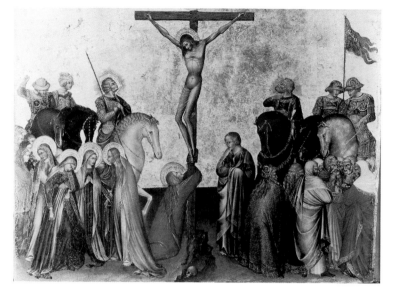

FIG. 4 Giovanni di Paolo, *Crucifixion*, 1426, tempera and gold leaf on panel. Altenburg, Lindenau Museum.

The participants and onlookers of the biblical narrative communicate a variety of strong emotional responses. In the Lazarus painting, some of the Jews are overwhelmed by the stench of the dead body, while the Magdalene (according to one tradition Lazarus's sister), dressed in red, has thrown herself gratefully in front of the majestic figure of Christ. *The Way to Calvary* contrasts the indifference and cruelty of the Romans and Jews with the compassion of Christ's followers, identified by their haloes. In the scenes with the dead Christ, the Marys have raised their arms in despair and grief. The presence of frightened children enhances the sense of tragedy.

It is through his focus on Christ's humanity that Giovanni di Paolo appeals to the worshipers and engages them in biblical history. This connection is enhanced by the reactions of the onlookers. The emphasis on Christ's humanity was a key aspect of Christian spirituality in the late Middle Ages and Renaissance, and the paintings are associated with the intense devotion to the Eucharist that was then prevalent.[2] During mass, when the Eucharistic wafer was consecrated, Christ was believed miraculously to become present in the Host (known as transubstantiation). Seeing the consecrated Host meant beholding the physical body of Christ, and images of Christ's life on earth enhanced the sense of this mystery.

The panels are executed in the expressive, late Gothic style that flourished in Siena.[3] However, Giovanni di Paolo has also referred back to the Byzantine origins of the great tradition of Sienese painting, which had such exponents as Duccio (active 1278–1319) and Simone Martini (ca. 1284–1344). The archaic features of the paintings are particularly obvious in the scenes with the dead Christ, in which the jagged, stylized rock formations stand against gold backgrounds, as in Byzantine painting. Throughout his long and productive career, Giovanni di Paolo drew on the pictorial sources of artists both past and present, but he rejected the new naturalism that characterized Florentine painting (see Fra Filippo Lippi, cat. no. 10).[4] Giovanni di Paolo thereby proudly produced a particularly Sienese style. An example of the stylized manner of his later period is a polyptych also in the Walters Art Museum (fig. 5).

To the artist, painting was a means of communicating mystical experience. His prominent use of gold ground was a way of placing emphasis on the symbolic aspect of pictorial representations, and this he explored in a novel way in *The Entombment*. The divine light emanating from the grotto has been tooled to suggest rays. On the background of this mysterious glow falls the shadow of a figure, who might be Nicodemus. It has been noted that this is one of the first painted shadows in Western art.[5] However, this should not be regarded as an attempt to document a realistic effect of light. Rather, the shadow is important as an ephemeral, intangible phenomenon. Falling on a miraculous, golden radiance, it enhances the sense of divine mystery.

MSH

NOTES

1 Zeri 1976, 1:116–21. I. Bähr, "Die Altarretabel des Giovanni di Paolo aus S. Domenico in Siena. Überlegungen zu den Auftraggebern," *Mitteilungen des Kunsthistorischen Institutes in Florenz* 31, nos. 2–3 (1987): 357–66.
2 See A. Derbes, *Picturing the Passion in Late Medieval Italy: Narrative Painting, Franciscan Ideologies, and the Levant* (Cambridge, 1996).
3 For characterizations of Giovanni di Paolo's style, see J. Pope-Hennessy, *Giovanni di Paolo 1403–1483* (London, 1937); Cole 1985, 72–88; Christiansen, Kanter, and Strehlke 1988, 11–12, 168–242.
4 A. Ladis, "Sources and Resources: The Lost Sketchbooks of Giovanni di Paolo," in *The Craft of Art: Originality and Industry in the Italian Renaissance and Baroque Workshop*, eds. A. Ladis and C. Wood (Athens, Georgia, 1995), 48–85. The predella panels contain many sources from the Sienese tradition but also from Gentile da Fabriano in the *Entombment*. Christiansen 1982, 50.
5 Cole 1985, 75

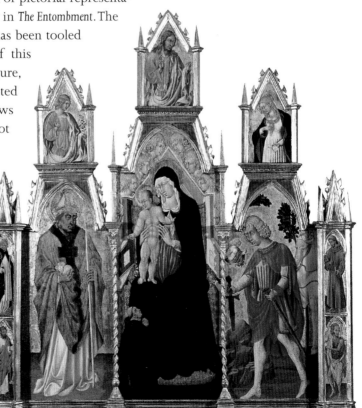

FIG. 5 Giovanni di Paolo and workshop, *Madonna and Child with Saints*, ca. 1475–80, tempera and gold leaf on panel. Baltimore, The Walters Art Museum, 37.554.

PIETRO ORIOLI (PIETRO DI FRANCESCO DEGLI ORIOLI), 1458–96

Sulpicia, ca. 1493–95

BORN IN SIENA in 1458, Orioli was probably trained in the work-shops of the painter Matteo di Giovanni (active by 1452–95) and Francesco di Giorgio (1439–1501), who was an antiquarian and architect as well as a painter and sculptor. Orioli's surviving oeuvre demonstrates a sophisticated understanding of perspective and of antique architecture, leading some scholars to hypothesize that he spent time in Urbino, where he would have come into contact with Piero della Francesca[1] or perhaps Fra Carnavale (cat. no. 15). The figures in his last works, including *Sulpicia*, exhibit vibrant colors and delicate modeling of light and shadow attributable to the influence of Luca Signorelli (ca. 1450–1523), who was working in Siena in the early 1490s.[2]

According to several ancient Roman writers,[3] Sulpicia, wife of the Roman nobleman Quintus Fulvius Flaccus, was considered the most virtuous woman in all of Rome. Because of her chastity, she was chosen to dedicate the temple to Venus Verticordia, the Roman goddess who protected women from licentiousness. When Giovanni Boccaccio included her biography in his *On Famous Women* (ca. 1360–63), he attached a long moralizing section describing the ideal wife, for which she was considered the model.[4] This is certainly how her story was viewed in fifteenth-century Siena.

In Orioli's painting, Sulpicia stands on a pedestal and holds a model of the temple to Venus Verticordia, a nice example of the artist's antiquarian knowledge, as is the vignette in the distance, in which Sulpicia reappears in the company of other chaste Roman women at the temple's construction site. Her role in the erection of the temple—as opposed to merely the consecration of Venus' statue—is discussed only by Ovid among the ancient writers but is also advanced in the Latin inscription on her pedestal, probably written by a contemporary Sienese humanist. It reads: "I am Sulpicia, who from the whole city was deservedly selected to build the temple to the chaste and virtuous Venus. Whatever breast is chaste in itself is an altar of chastity. All earthly things come to ruin but fame and honor remain."

Orioli's *Sulpicia* is one of seven or possibly eight related panels identified today, each representing an historical figure—Greek, Roman, or Israelite—known for his or her superior virtue and honor: four men (Scipio Africanus, Alexander the Great (fig. 1), Tiberius Gracchus, and the Old Testament figure Joseph) along with three (or four) women (Sulpicia, Artemisia, Claudia Quinta

INSCRIPTION

On pedestal: "*QUAE FACERE VENERI TEMPLUM CASTAE QUE PROBAEQUE / SULPITIA EX TOTA SUM MERITA URBE LEGI/ ARA PUDICITIAE PECTUS SIBI QUODQUE PUDICUM EST / TERREA CUNCTA RUUNT FAMA DECUS QUE MANENT*"

PROVENANCE

Don Marcello Massarenti, Rome, by 1897; Henry Walters, 1902

SELECTED BIBLIOGRAPHY

Mode 1974, 73–83; Zeri 1976, 1:134–38 (attributed to Pacchiarotto; with earlier literature); Tatrai 1979, 27–66; Angelini 1982; Gilbert 1986, 190–92; Kanter 1988, 335; Zafran 1988a, 44–45; Bellosi, ed. 1993, 462–68; Barriault 1994, 152; Johnston 1999, 157; Kanter 2000, 148; Boskovits and Brown 2003, 498, 501, 538

NOTES

1 Angelini 1982, 30–43.
2 See, for example, the *Madonna and Child with Saints* (private collection), commissioned by the Piccolomini family (Christiansen, Kanter, and Strehlke 1988, no. 72).
3 Ovid, *Metamorphoses* IV, 157–58; Pliny the Elder, *Natural History*, VII, 35.120; Valerius Maximus, *Factorum et dictorum memorabilium* VIII.15.12.
4 Sulpicia is also included in Petrarch's "Triumph of Chastity" (178–80), as are Judith, Artemesia, Scipio, Alexander, and Tiberius.
5 See Boskovits and Brown 2003, especially 502 n. 11 for the discussion and illustration of the series, also on the *Judith* in Bloomington, responding to Gilbert 1986.
6 An important early example by Taddeo di Bartolo (1413–14) exists in Orioli's native Siena in the Palazzo Pubblico.
7 As some earlier cycles contained nine figures, vaguely modeled on the idea of the "nine worthies," it is likely that one of the series is missing, probably a female figure such as Lucretia or Hippo, both of whom were represented standing over dedicatory inscriptions on a Sienese *cassone* of approximately the same date by Guidoccio Cozzarelli (collection of Marchesa Chigi-Zondadori Bonelli, Vicobello [Siena]), discussed and illustrated in Mode 1974, 74–75, fig. 51. See also Tatrai 1979, 46–47 and Gilbert 1986, 190–92.
8 See Boskovits and Brown 2003, 498.
9 For whom, see most recently Kanter 2000 and Boskovits and Brown 2003.
10 On the *Bichi Altarpiece*, see Christiansen,

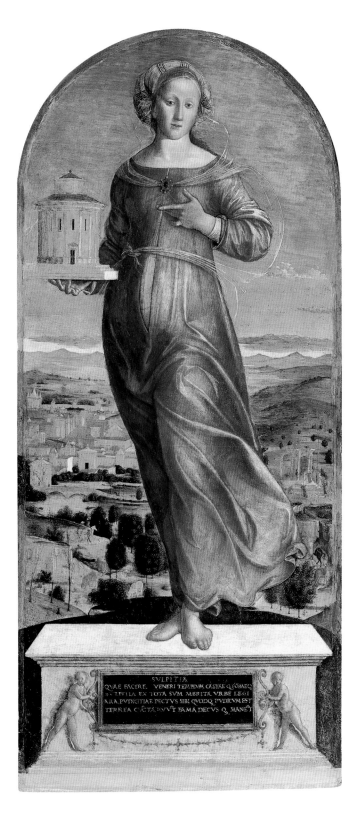

Sulpicia, ca. 1493–95
Tempera and oil on panel, 42 ⅝ x 18 ¹¹⁄₁₆ in. (108 x 47.5 cm)
37.616

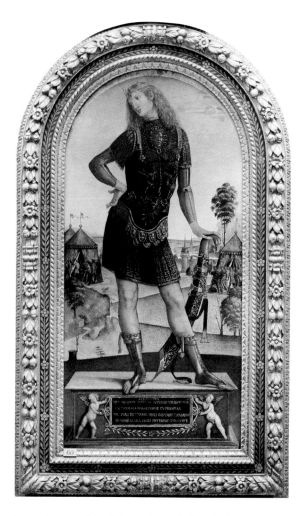

FIG. 1 Master of the Griselda Legend, *Alexander the Great*, oil on panel. The Barber Institute of Arts, The University of Birmingham.

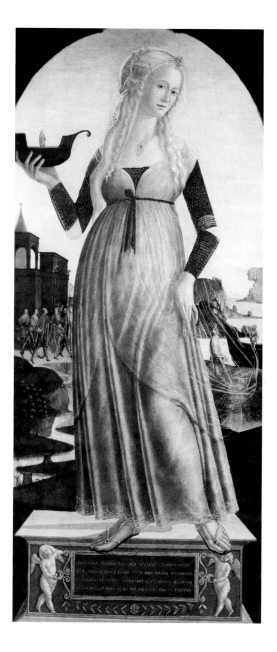

FIG. 2 Neroccio de' Landi, *Claudia Quinta*, ca. 1490–95, tempera on panel. Washington, D.C., National Gallery of Art, Art, 1937.1.12.

[fig. 2], and possibly Judith).[5] Cycles of virtuous men were popular forms of decoration in both civic buildings and private homes from the Middle Ages into the sixteenth century.[6] This fashion in wall decoration parallels a corresponding interest for collections of short biographies of great individuals—both ancient and contemporary—to serve as examples to following generations.

The present cycle was probably painted in Siena to be inserted in the wainscoting of a large receiving room in a private Sienese palace.[7] On the basis of the small crescent moons visible on several of the pedestals, it has reasonably been proposed that the panels were commissioned by a member of the illustrious Piccolomini family, whose coat of arms contained this symbol. As the palace of Giacomo di Nanni Piccolomini was being constructed in the 1490s, the series may have been planned to decorate one of his parlors. The emphasis on chastity and female virtue represented by the inclusion of Sulpicia, Artemisia, and Claudia Quinta supports the suggestion that this series was commissioned as decoration in celebration of the wedding of Silvio di Bartolommeo Piccolomini on 18 January 1493.[8]

Scholars have long recognized that there were multiple artists involved in the series, four panels by Signorelli's as yet unidentified but brilliant assistant, now known as the Master of the Griselda Legend,[9] with further contributions by Francesco di Giorgio (1439–1501), Orioli, Neroccio de' Landi (1447–1500), and possibly Matteo di Giovanni (ca. 1430–95). One proposal put forth for the variety of painters is that Signorelli, then so much in demand and active in Siena,[10] was offered the commission, but that he left Siena before doing more than organizing the project and handing over responsibility for individual panels to others.[11]

Had Orioli not died so young, he would have become one of the premier Sienese artists of the early sixteenth century. A member of the lay order of San Girolamo sotto l'ospedale and praised for his high morality, his death occasioned an elaborate funeral procession.[12]

MWG

Kanter, and Strehlke 1988, no. 74.

11 Boskovits and Brown 2003, 501, with earlier sources. The large number of artists involved in completing the series can also be explained by several deaths combined with other circumstances. If the commission passed from Signorelli to Francesco di Giorgio Martini, he probably produced the *Scipio Africanus* before being called away to work on other more urgent defense projects in Naples. Pietro di Francesco degli Orioli, who had worked with Francesco on other occasions, could then have stepped in and painted the *Sulpicia* but then he died an untimely death in 1496 at the age of 37. Although Francesco di Giorgio returned to Siena in 1496, he was by then heavily engaged in casting the bronze doors of the cathedral so the "heroes" commission was probably passed to his brother-in-law, Neroccio de' Landi, who, after painting the *Claudia Quinta*, gave the remaining panels to his assistant, the enigmatic Master of the Griselda Legend.

12 Recorded in Sigismondo Tizio's *Historiarum Senensium ab initio urbis Senarum usque ad annum 1528*. The book exists in several later manuscripts in Italian libraries including the Biblioteca Comunale in Siena (B.II.6) and the Biblioteca Nazionale, Florence.

FRA CARNAVALE (BARTOLOMEO DI GIOVANNI CORRADINI), ATTRIBUTED TO, ACTIVE BY 1456–84

The Ideal City, ca. 1480–84

THIS MAJESTIC VIEW of an idealized urban square is one of the icons of the Italian Renaissance. *The Ideal City* celebrates the values embodied in a well-ordered society ruled by a virtuous prince. Architecture is here a metaphor of good government, while the perspective system, embracing the whole scene, can also be read as a metaphor for the role of rationality and order in the ideal city/state. With a closely related *Ideal City* in Urbino (fig. 1) and a similar *Urban Perspective* in Berlin (fig. 2),[1] the Walters' *Ideal City* can be understood as a distillation of the unique environment created at the court of Urbino, chiefly by the humanist values of Leon Battista Alberti (1404–72) and of Federico da Montefeltro, duke of Urbino (1422–82).[2] Both sought to express the well-led, noble life through architecture.

The principles behind *The Ideal City* are found in Alberti's treatise *On Painting* (1435), with its exposition of linear perspective, and his *On Building* (1483), drafted in the 1440s after he began working as an architect. This was the first treatise on the subject since *On Architecture* by Vitruvius in the first century. Alberti drew on his great predecessor for principles of Greek and Roman architecture as models for noble structures in an ideal city that benefit the citizenry and honor the patron.[3] *On Building* was addressed to princely patrons as well as to architects, and Alberti dedicated it to Federico, whose hospitality and conversation about architecture he enjoyed in Urbino.[4] It owes much to humanist writings concerning human potential; for a nobleman this meant virtù, an elusive quality encompassing (manly) excellence in moral, physical, and mental achievement.

Federico's sense of virtù[5] was expressed in renovations of the ducal palace in the new neo-antique style carried out with his architects—Fra Carnavale, Luciano Laurana, and Francesco di Giorgio. In the central court of honor, his son and successor had engraved Federico's titles and military deeds, ending with a declaration that resonates throughout his life and the art he commissioned[6]: "His justice, magnanimity, liberality, and piety in time of peace are equal to and complement his victories in war."[7] It is for this palace that the Walters' *Ideal City* was surely executed; however, there is today no documentation indubitably tying it to Federico's court.[8]

Nevertheless, the Walters' painting may be the "long rectangular painting depicting an antique but beautiful perspective from

PROVENANCE

Don Marcello Massarenti, Rome, by 1881 (noted in 1881 catalogue as Pintoricchio); Henry Walters, 1902

SELECTED BIBLIOGRAPHY

Zeri 1976, 1:143–51 (with earlier literature); Sangiorgi 1976, 43, 63, 170; Conti 1976, 1193–234; Bernini and Bernini, eds. 1978, 3, 5, 8–12, 37; Ciardi Dupré Dal Poggetto 1983; Trionfi 1983, 38–50; Bober and Rubenstein 1986, under no. 182; Damisch 1987, 157–386 (English edition, Damisch 1994a, 169–405); Zafran 1988a, 42–43; Kemp 1991, no. 148; Battisti 1992, no.d.3; Parrocchi 1992, 100–107; Dal Poggetto, ed. 1992; Morolli in Dal Poggetto, ed. 1992, 215–29; Salvi in Dal Poggetto, ed. 1992, no. 42; Spicer 1994, 2–3; Millon and Magnago Lampugnani, eds. 1994; Damisch 1994b, 538–39; Weil-Garris Brandt in Millon and Magnago Lampugnani, eds. 1994, 85–86; Krautheimer in Millon and Magnago Lampugnani, eds. 1994, 233–58; Barriault 1994, 19; Butterfield 1997, 127, 250; Cieri Via 1999, 240–45; Ciccuto 2000, 235–44; Dal Poggetto, ed. 2001; Ciardi Dupré Dal Poggetto in Dal Poggetto, ed. 2001, 73–85; Lauts and Herzner 2001, 382–84; Calvesi in Dal Poggetto, ed. 2001, 86–93; Dal Poggetto in Dal Poggetto, ed. 2001, 97–98; Eaton 2001, 15, 49–50; Grafton 2002, 263–64; Jacks 2002, 115–33

NOTES

1 For the Urbino and the Berlin panels, Bernini and Bernini, eds. 1978, Damisch 1994a, Krautheimer in Millon and Magnago Lampugnani, eds. 1994, and Ciardi Dupré Dal Poggetto in Dal Poggetto, ed. 2001.

2 This view has often been expressed, eloquently by Kemp 1991, but how the constituent parts contribute to this vision has been incompletely articulated; this brief essay proposes some missing parts, assembled with the assistance of my intern Denva Jackson. On Alberti, Morolli in Dal Poggetto, ed. 1992 and Grafton 2002.

3 Alberti, "Prologue," *On Building* (*De re aedificatoria*), first printed in 1486. See J. Rykwert et al., *Leon Battista Alberti, On the Art of Building in Ten Books* (Cambridge, Massachusetts, 1988).

4 G. Morolli, "Federico da Montefeltro e Salome. Alberti, Piero e l'ordine architettonico del principi-construttori ritrovato," in C. Cieri Via, ed., *Città e Corte nell'Italia di Piero della Francesca, Atti del Convegno Internazionale di Studi Urbino, 4–7 ottobre 1992* (Urbino, 1996), 319–45.

5 For Federico, Lauts and Herzner 2001.

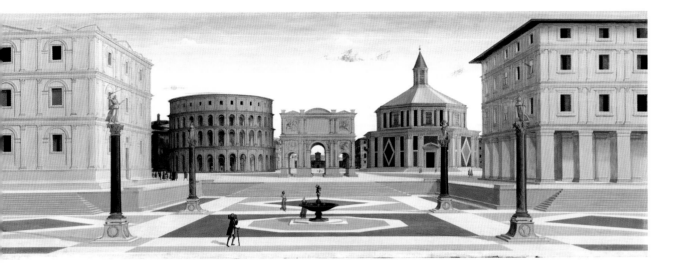

The Ideal City, ca. 1480–84
Oil on panel, 31 ⅝ x 86 ⅝ in. (80.3 x 220 cm)
37.677

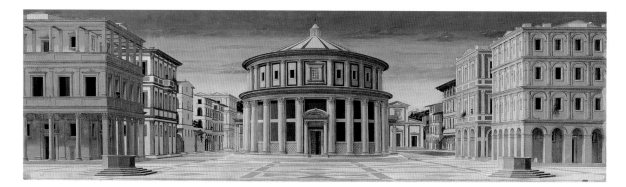

the hand of Fra Carnavale" cited in an inventory of the palace in 1599.[9] The painter and architect Fra Carnavale, as Bartolomeo di Giovanni Corradini was known after he became a Dominican monk, was born in Urbino, was by 1445 in the Florentine workshop of Fra Filippo Lippi (cat. no. 10), and was later listed among Federico's architects. The outline and characteristics of his oeuvre as a painter are only now emerging,[10] including his use of Roman architecture. Given the uniqueness of the "Urbino perspectives," many scholars suppose that all three are by the same artist.[11] This is unlikely, but all may be from the same project.

These long, rectangular panels are *spalliera* (shoulder-height) paintings, incorporated singly or in series into wooden wainscoting or furnishings (as a sideboard or bench back).[12] In his *Lives of the Most Eminent Painters...* (1568), Giorgio Vasari describes the taste for *spalliera* paintings as widespread in the fifteenth century but no

FIG. 1 Central Italian (after designs by Luciano Laurana?), *Ideal City*, oil on panel. Urbino, Galleria Nazionale delle Marche. Scala/Art Resource, NY.

6 Lauts and Herzner 2001, 217–392. The palace was extensively decorated with tapestries, frescoes, sculptural ornament, trompe l'oeil intarsia, as well as paintings.
7 Lauts and Herzner 2001, 276.
8 The Urbino painting bears the mark of the convent of Santa Chiara in Urbino, founded by Federico or his daughter who lived there after 1482. She is known to have shared her father's tastes and it is suggested (Damisch 1994a, 182) that she may have taken the painting with her. See the following note. The Berlin painting is only associated with Urbino by its character.
9 "Un quadro longo d'una prospetiva antica ma bella di mano di frà Carnavale" (inventory of contents of Palazzo Ducale in 1599 [Sangiorgi 1976, 63]). If "antica" implies antiquity, then this is the Baltimore painting; if it simply means "old," then it could be the Walters' or a similar painting such as the Urbino panel, unless the latter was already removed to the convent of Santa Chiara. There is another citation of a "perspective" in a 1582 inventory (Sangiorgio 1976, 43).
10 The Walters' painting is attributed to Fra

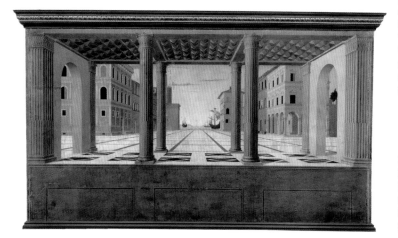

FIG. 2 Central Italian (also attributed to Francesco di Giorgio Martini), *Urban Perspective*, tempera on panel. Berlin, Gemäldegalerie, Staatliche Museen zu Berlin. Bildarchiv Preussischer Kulturbesitz/Art Resource, NY.

longer in fashion by his time. The removal of the wainscoting in later redecorating makes it difficult to appreciate the original impact of such arrangements. The Berlin *Urban Perspective* is the closest to this type, retaining a painted "paneled" extension; in addition, its simple perspectival composition—not really an ideal city—is close to those created in inlaid wood on the doors to the palace's principal rooms in 1474–82.[13]

Marveling at how linear perspective shapes a view is one of the pleasures of the Walters' painting.[14] Laid out in Alberti's *On Painting*, this mathematically derived system is fifteenth-century Italy's contribution to the challenge of projecting a three-dimensional space onto a two-dimensional surface. In the city gate, quite visible in an x-ray of the central opening in the arch (fig. 3), is a tiny hole in the panel, equidistant from both sides; this is the point of convergence (vanishing point) for the orthogonals that fan out, defining lines of recession throughout the composition. As seen in the x-ray, many of these lines and others indicating windows or even figures are incised (white, in the x-ray), while there is a further network of lines drawn on the gesso in black pigment, visible through infrared reflectography. Complexities were introduced through secondary focal points, and changes were made throughout.[15]

The square is as serenely beautiful as it is mentally engaging. Nearly empty of human activity,[16] this monumental, symmetrically laid-out space is luminous in the morning light.[17] For Alberti, a city's squares are among its principal ornaments. They must be carefully planned, "for without order there can be nothing commodious, graceful, or noble."[18]

Five structures define the square; three are featured. A Roman triumphal arch is at the center of the square; through it is visible a gate in the city's protective walls. The arch recalls that built in 312 in Rome to honor Emperor Constantine[19] for military victories that brought stability to the empire. Its prominent position and narrative reliefs[20] underline the importance of military leadership in securing the state and expanding its fortunes. This is one of the chief public, commemorative structures that Alberti thought desirable. Federico was the greatest military commander of his day; his successes secured the stability, expansion, prosperity, and fame of the duchy. The place on the arch for the dedication is blank, perhaps to be filled by Federico's imagination.

Carnavale by Ciardi Dupré Dal Poggetto (2001) without discussion. The authors of the exhibition catalogue on Fra Carnavale (Christiansen et al. 2004) apparently decided not to include *The Ideal City* at least in part due to the dating issue raised by the detailing of the palace at the left. However, see below and note 28.

11 As Kemp 1991.

12 For *spalliera* painting, Barriault 1994. The condition of the Walters' panel is consistent with its having been removed from molding. The panel (three pieces of wood joined) was apparently cut down slightly but symmetrically at the sides, but on the top and bottom edges, the priming extends to the edge, leaving about a $7/10$ inch (one-cm) strip free of paint. There are nail holes on the right edge.

13 In Urbino the taste for optical designs in inlaid wood turned early to urban views (M. Trionfi Honorati, "La prospettiva nelle Porte del palazzo," in Dal Poggetto, ed. 1992, 232–39.

14 Piero della Francesca dedicated his treatise *On Perspective in Painting* to Federico.

15 These and other aspects of the preparation, such as the numbers along the lower edge of the panel: 1 to 30 (not all are legible), thus 31 segments, each about 73 mm, possibly meant as a Vitruvian unit of measure (Krautheimer 1994, 255; Jacks 2002, n. 40) will be considered in a future study in collaboration with the Department of Paintings Conservation. Damisch 1994a has raised issues regarding the perspective, which can better be addressed in that context.

16 Over the completed cityscape the artist painted tiny figures in fifteenth-century attire including a man carrying a barrel and others from the middle or leisured classes, perhaps simply to animate a vast, open space. There are no figures in the Urbino or Berlin painting.

17 Cast shadows reflect the sun's position outside the pictorial space to the right, while a pink moon fades from view over the amphitheater. Peter Stockman (Hubble Space Telescope Center) confirms that it is the moon and not the sun, as some (for example, Zeri 1976) have thought.

18 Alberti, Bk. VII, Ch. 1.

19 Bober and Rubenstein 1986, no. 182.

20 Alberti, Bk. VIII, Chs. 4, 6, for which see Brandt 1994, 85–86; Jacks 2002, 128–29.

21 R. Luciani, *The Colosseum* (Novara, 1990).

22 Alberti, Bk. VIII, Ch. 8.

23 The building's upper level initially extended out further (in underdrawings and incisions).

24 A. Paolucci, ed., *The Baptistery of San Giovanni, Florence* (Modena, 1994).

At each corner of the square is a building. The amphitheater in the far left corner recalls the most imposing monument in Rome, the first-century Colosseum, its crumbling porticos made whole.[21] It may represent the importance of attending to the well-being of the populace by providing places of diversion, such as theaters or amphitheaters, described by Vitruvius and Alberti as a major category of public architecture in a well-ordered city.[22]

The octagonal building with a small cross atop its lantern (see detail on back cover) is the only featured structure that is not obviously Roman. Scholars have long recognized that it is derived from the baptistery in Florence (fig. 4), built in the Tuscan Romanesque style.[23] There is little agreement today whether the actual baptistery, dedicated to Saint John the Baptist, actually incorporates a Roman temple on the site,[24] but historians from Giovanni Villani in the fourteenth century to Giorgio Vasari in the sixteenth celebrated it as a Roman temple, adapted to Christian use, and as the example of Roman architecture to which Florentine architects should look. Villani describes it as "a marvelous temple,"[25] commissioned by the rulers of Roman Florentia from the "subtlest minds."[26] To Vasari, "the very ancient temple of San Giovanni" exemplified "the good ancient style."[27] To Fra Carnavale, trained in Florence, this would also be so. Clarifying the baptistery's role makes possible the reading of this *Ideal City* as a cohesive narrative. These Roman structures are central to a well-ordered city and, through their functions, can be read as representing the good government of a virtuous prince.

These ancient edifices are complemented by neo-antique, "modern" buildings. That on the left follows the lines of mid-fifteenth-century Florentine palaces of the Medici and others; the distinctive arch around the windows[28] is adapted from the Colosseum. The palace's grandeur and dignity fulfill Vitruvius' and Alberti's characterization of a residence appropriate to the ruling classes.[29] The arcaded building on the right with paper or cloth-covered screens is apparently also residential, though slightly less elegant. Other fifteenth-century buildings, such as a warehouse with brackets for hoists, are visible behind the arch (see detail, p. 40).

Virtues conveyed through architecture are complemented by "Roman" allegorical sculpture. While ornamentation in the Urbino composition is limited to architectural detailing, in the

FIG. 3 *Ideal City*, x-ray of central section showing point (white) marking convergence of recessional lines.

25 Giovanni Villani, *Cronica*, ed. F. Dragamanni (Florence, 1844–45), 1:Ch. 42.
26 As altered for Christian use: Villani 1844–45, 1:Ch. 60.
27 Vasari 1906, 1:236.
28 That this motif has not been identified on a built building before the Cocchi-Donati palace in Florence attributed to Giuliano da Sangallo has led scholars to a dating of ca. 1490 or later.
29 Vitruvius, Bk. VI, Ch. 5; Alberti, Bk. V.
30 Alberti VII, Chs. 16, 17; VIII, Ch. 3. See Weil-Garris Brandt 1994, 85–86.
31 C. Dempsey, *Inventing the Renaissance Putto* (Chapel Hill, 2001); for Verrocchio's similar *Putto with a Dolphin* (Palazzo Vecchio, Florence), and the cylix fountain, see Butterfield 1997, 126–35, 250, no. 20.
32 Kemp 1991.
33 Scholars assume that this innovative design must be by an architect, such as Luciano Laurana (Ciardi Dupré Dal Poggetto 2001) or Giuliano da Sangallo in Florence (for example, Kemp 1991). Also Damisch 1994a, 244, 538–39 and Jacks 2002, 122–24.
34 For utopian designs, Eaton 2001.

Walters' *Ideal City*, ornament is provided by sculpture, recommended by Alberti because it lends dignity and meaning to civic spaces.[30] In the foreground are four marble statues, in Roman fashion, on top of columns. They represent personifications of virtues of good conduct or rule according to ancient philosophy: Justice with her scales, Moderation with her pitcher of water to mix with her basin of wine, Liberality with a cornucopia, and Fortitude or Courage with a column. Prudence, the traditional fourth virtue of good conduct, is replaced by Liberality, critical to princely magnificence and stressed in the inscription recording Federico's virtues in the court of honor of the ducal palace. The "Roman" fountain, graced by a bronze winged putto or sprite (a typically Renaissance response to a Roman motif),[31] is a functional source of water, as indicated by the women filling jugs from it. Prominently placed, it complements the other symbols of good rule; providing the populace with good water was a traditional sign of magnanimity.[32]

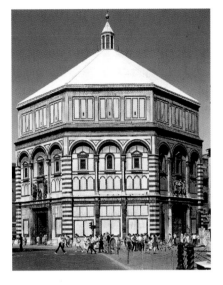

FIG. 4 East view of Baptistery, Florence. Scala/Art Resource, NY.

The *Ideal City* paintings in Urbino and Baltimore offer complementary visions. That in Urbino is a design for a beautiful and harmonious urban center, based on antique principles;[33] it manifests good rule and calls to mind various utopian projects of these years for new cities.[34] In the Walters' *Ideal City*, monuments of an heroic Roman past suggest exemplary models of conduct for a prince who sees himself as the architect of the state.

JS

further suggesting the desolation of his retreat. A scorpion and lizard scurry about, but the lion is domesticated, alluding to the miracle of Jerome's taming of a wild lion that appeared at the gate of his monastery near Bethlehem. The lion is a metaphor for Jerome's taming of "bestial" passions and evidence of the supernatural agency required for sainthood.[7] Similarly, the cardinal's hat reminds the viewer of his future translations of the Bible because it was for them that the medieval church symbolically awarded him this status.

Privation ages people, but this Jerome is significantly older than thirty: a pivotal experience of the younger man is conflated with an appearance associated with the achievements of the older scholar. Stripped of his penitent's "shapeless sackcloth" to the waist, Jerome "subjugates his rebellious flesh," reducing it to the "insensibility of stone" by fasting and beating his breast with a rock, "dashing" sensual thoughts. Declaring that "the Rock is Christ,"[8] Jerome beats himself with an object that represents for him the supreme model of physical suffering. The skull in the cave further reminds him of the frailty of human life. Jerome looks yearningly towards a crucifix, tied to a sapling, and gestures towards an open book (fig. 1). The text is neither Scripture nor his own writings, as the quill and inkpot might suggest. It is prophecy.

This remarkable text is the key to the painting, distinguishing it from other treatments of the subject.[9] It is largely adapted from a letter celebrating Jerome's holiness, said to have been written *after* Jerome's death by his great contemporary Saint Augustine.[10] The letter was concocted in the Middle Ages to add Augustine's authority to the campaign to raise Jerome's status. This quest reached a crescendo in the Renaissance, and the apocryphal letter was appended to various widely circulated, printed writings on Saint Jerome, its legitimacy unquestioned.[11] The passage describes a vision experienced by Augustine after Jerome's death: Jerome and John the Baptist appear to him, and the Baptist, acknowledged as unsurpassed in sanctity, says that Jerome, also a virgin and a hermit, is his equal. There is no greater recommendation, and Jerome's asceticism is here fused to his scholarship. Since the painting is of medium size and on canvas[12] (cheaper than wood), with an inscription to be read up close, it was probably commissioned for personal use by a member of a congregation or religious order such as the Gesuati devoted to Jerome.[13]

JS

Renaissance City, 1450–1495 (New Haven, 1997), 80–90, "Giovanni Tavelli and Tura's St. Jerome."
4 *Selected Letters of Jerome*, English trans. F. A. Wright (Cambridge, Massachusetts, 1980). On the desert, see *Letters*, nos. 2, 3, 7, and 14.
5 Most prominently, the thirteenth-century commentary of Jacobus da Voragine, *Legenda sanctorum* (Golden Legend). See Rice 1985, 24.
6 Especially *Selected Letters*, no. 22.
7 See Rice 1985, 39.
8 The desires to be subdued were not only those of the flesh but those of the heart, so Jerome beats his breast as the seat of these emotions (*Selected Letters*, no. 14).
9 Since Zeri's misleading reading, implying that the inscription contradicts the famous letter, no scholar has cited it.
10 See Rice 1985, 52–53; for the vision, see J. P. Migne, *Patrologia Latina* (Paris, 1877), 22:281–89.
11 Renaissance authors celebrating Saint Jerome made ample use of this letter, but searches for a source including both the derivation of the name and the vision have not been successful.
12 See H. Dubois, "Fragile devotion: two late fifteenth-century Italian Tüchlein examined," *The Fabric of Images: European Paintings on Textile Supports in the Fourteenth and Fifteenth Centuries* (London, 2000), 67–75.
13 Rice 1985, ch. 3. For an altarpiece from 1476 and devoted to the theme, Matteo di Giovanni's *Madonna Enthroned with Angels, Saint Jerome and Saint John the Baptist* in San Domenico, Siena, see E. Trimpi, "'Iohannem Baptistam Hieronymo aequalem et non maiorem': a predella for Matteo di Giovanni's Placidi Altarpiece," *Burlington Magazine* 125 (1983): 437–66.

Opposite page
Fig. 1 Detail of open book.

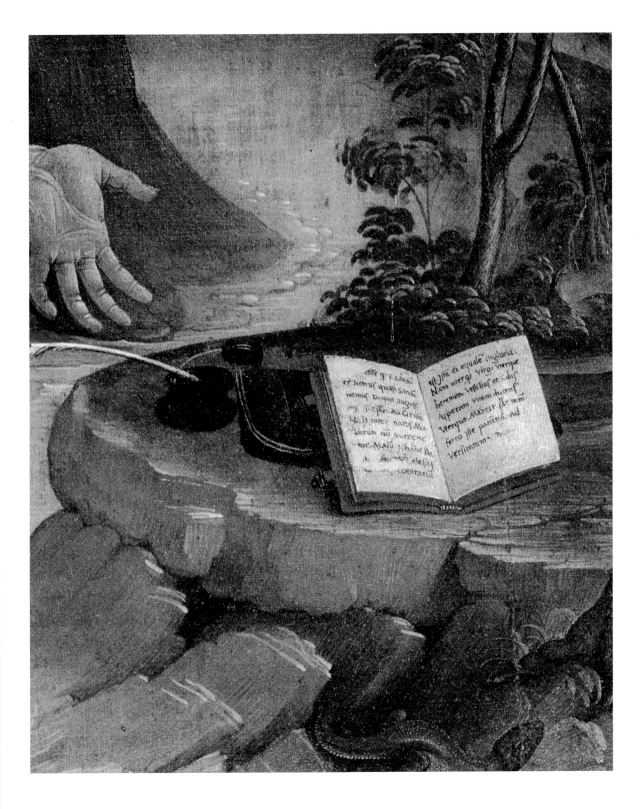

GIORGIO SCHIAVONE (JURAJ ĆULINOVIĆ), CA. 1433–1504
Madonna and Child with Angels, 1459–60

JURAJ ĆULINOVIĆ, called Schiavone ("the Slavonian"), was along with Mantegna (1430–1506) and Marco Zoppo (1433–78) one of many important artists to have apprenticed in the "academy" established by the Paduan painter and antiquarian Francesco Squarcione (ca. 1395–ca. 1468).[1]

Born in Scadrin on the Dalmatian coast (now Croatia), Schiavone entered Squarcione's shop in 1456 and remained there at least three years before returning to his native land. The majority of his known works, primarily depictions of the Madonna and Child surrounded by a rich array of Christian symbols in antique settings, belong to this period. Schiavone's paintings often contain signatures written on trompe l'oeil scraps of paper (cartellini). On the Walters' panel, the paper reads, "Giorgio Dalmaticus, pupil of Squarcione, painted this."

The painting's elegant lines and sure, graceful handling suggest that it was executed towards the end of his apprenticeship. Unlike the majority of Schiavone's Madonna and Child images made for private devotion, this example does not have an elaborate architectural backdrop. Instead, the intensely colored figures, trompe l'oeil parapet, and fruit festoon appear dramatically in front of a plain black background. The Christ Child and the music-making angels are poised as if to mediate between the heavenly world and our own, the latter being represented by the cartellino and the fly that appears to have alighted on the painting.

The closest comparative image is the central panel of Schiavone's most grand work—a polyptych probably commissioned for the church of San Nicolò in Padua (fig. 1). Both images include symbolic fruits, a coral rosary around Christ's neck, and a fly near the artist's signature. The coral is meant to ward off evil, here only represented possibly in the form of the fly.[2] A motif often used by Squarcione's pupils, the fly refers to the artist's skill at illusion. According to Giorgio Vasari, when Giotto was still training in Cimabue's workshop, he painted a fly on the nose of one of his master's figures, which Cimabue attempted to shoo away before realizing his error.[3] Might not Schiavone have intended the same trick while also encoding the symbolism of evil that attempts to enter the spiritual world from the margins of our own?

MWG

INSCRIPTION
On the paper at the bottom: "HOC PINXIT GIORGIUS DALMATICUS DISCIPULUS SQUARCIONI S"

PROVENANCE
A. S. Drey, Munich and New York, 1922–24; Robert Lehman, New York; Henry Walters from A. S. Drey, 1925

SELECTED BIBLIOGRAPHY
Zeri 1976, 1:206–7 (with earlier literature); De Nicolò Salmazo 1987, 1:179–80, 2:753; Zafran 1988a, 34–35; Kokole 1990, 50; De Nicolò Salmazo 1990, 525; De Marchi 1996, 76; Prajatelj 1996, 23

NOTES
1 Squarcione appears to have possessed a collection of ancient and modern sculpture, which he used for teaching purposes. On Squarcione and his extraordinary "school", see M. Boskovits, "Una ricerca su Francesco Squarcione," Paragone 28 (1977): 40–70, and Francesco Squarcione "Pictorum gymnasiarcha singularis" (Padua, 1999). Squarcione was also personally acquainted with Filippo Lippi (see cat. no. 10), and echoes of the Florentine master's art appear in his students' works, especially Schiavone's.
2 According to Matthew 12:24, Beelzebub is the devil, and Beelzebub in Hebrew means "lord of the flies."
3 On the fly as a symbol of the artist's ability at illusion in Schiavone's immediate context, see N. Land, "Giotto's Fly, Cimabue's Gesture and a Madonna and Child by Carlo Crivelli," Source 15 (1996): 11–15. Similar stories may be found in Pliny's Natural History (for example, XXXV, 65).

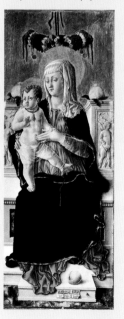

FIG. 1 Giorgio Schiavone, The Virgin a Child Enthroned with Sai 1458–60. London, National Gallery, NG630.1.

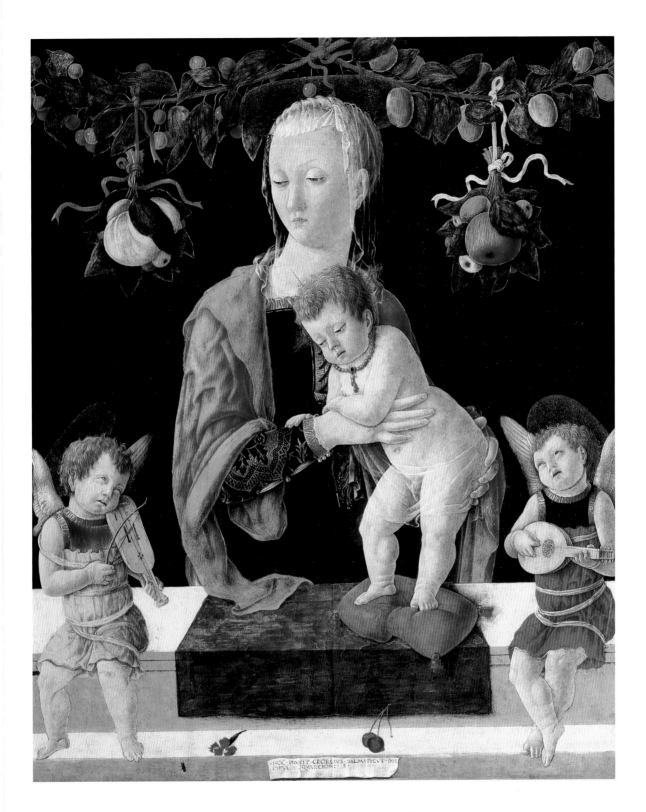

Madonna and Child with Angels, 1459–60
Oil on panel, 27 ³/₁₆ x 22 ⁵/₁₆ in. (69 x 56.7 cm)
37.1026

CARLO CRIVELLI, 1430/35–95

Virgin and Child with Saints and Donor, ca. 1485–90

THE VIRGIN MARY stands in a stately pose inside an architectural opening and embraces the Christ Child. The pair is flanked by Saints Francis of Assisi (d. 1226) and the Franciscan Bernardino of Siena (d. 1444). The former can be identified by the mark on the skin of his hand indicating the stigmata, while the saint on the right holds a desk with the letters IHS, the Latin initials for Christ. Saint Bernardino had promoted the cult around those initials. A tiny figure of an Observant Franciscan friar kneeling in front of Mary and Jesus must represent the patron. The letters FBDA on the front of the ledge allude to his name, meaning that the friar's name began with a B and that he came from a city beginning with an A. Stylistic evidence suggests that the work dates to late in the artist's career. Because of its modest size, it has been suggested that the painting was executed for a private oratory or a chapel in a convent in the Marches.[1]

Most Renaissance images of the Christ Child represent him naked to call attention to his humanity. Crivelli, on the other hand, has dressed the infant in a lavish, gold-trimmed costume with a strand of pearls wrapped around his hair. The Virgin's mantle is made of precious golden brocade, and she is wearing a jeweled crown. These regal attributes indicate their status as King and Queen of Heaven, a symbolism that is enhanced by the light blue silk cloth suspended behind them. The affectionate embrace of Christ and his mother also signals their status as the bride and groom of the Old Testament Song of Songs.

The pair's rich dress, the precious fabrics surrounding them, and the marble pillars are in stark contrast to the humble attire of the saints. Instead of the smooth, pale skin and elegance of the Virgin and Child, the saints are portrayed with furrowed, bony features. Veins protrude at their temples, and Bernardino is toothless. These features are enhanced by Crivelli's characteristic incisive contours. The combination of these two extreme physical types is a paradoxical expression of the nature of Christian humility. Through physical deprivation and asceticism, the saints have reached glory and sanctity.

MSH

PROVENANCE
Don Marcello Massarenti, by 1897; Henry Walters, 1902

SELECTED BIBLIOGRAPHY
Zeri 1976, 1:242–43 (with earlier literature); Zampetti 1986, 287; Zafran 1988a, 40–41; Lightbown 2004, 375–77

NOTES
1 B. Berenson, *Venetian Painting in America: The Fifteenth Century* (New York, 1916), 21; A. Bovero, *L'opera completa del Crivelli* (Milan, 1975), 99–100; Zeri 1976, 1:242–43; Zampetti 1986, 287; Lightbown 2004, 375–77. Lightbown hypothesized that the patron might be Bernardino Ferretti, also known as Fra Bernardino da Ancona. Twentieth-century writings on Crivelli have especially focused on the artist's style in terms of its sources, a tradition that is summarized by Zampetti 1986. A recent example of this type of inquiry is L. Geroni, "Carlo Crivelli e il Monogrammista E.S.," *Mitteilungen des Kunsthistorischen Institutes zu Florenz* 40, nos. 1–2 (1996): 223–31.

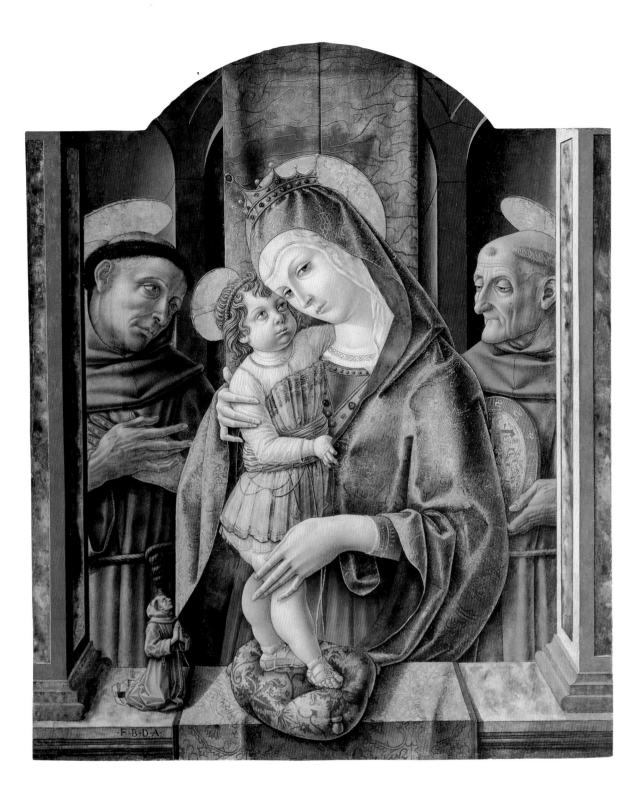

Virgin and Child with Saints and Donor, ca. 1485–90
Tempera and oil on panel, 38 ⁹⁄₁₆ x 32 ³⁄₁₆ in. (98 x 81.8 cm)
37.593

GIOVANNI BELLINI, 1430–1516, AND WORKSHOP
Madonna and Child with Saints Peter and Mark and Three Venetian Procurators, 1510

GIOVANNI BELLINI, the leading painter in Venice around 1500, received many government commissions from the Venetian Republic; this painting is one of the few to survive. Here, Saints Peter and Mark solemnly recommend three kneeling officials to the Virgin and Child. These are procurators, important administrators responsible for overseeing the construction and maintenance of Saint Mark's Basilica and its properties.

The first reference to the painting is in a 1602 book about the procurators of Saint Mark's; it identifies the officials and when they took office: Domenico Trivisano (1503), Luca Zeno (1503), and Tomaso Mocenigo (1504).[3] In 1602, the painting hung over one of the innermost doors inside the quarters of the procurators for the zone beyond ("de ultra") the Grand Canal across from Saint Mark's. It was still there in 1646 when the writer Carlo Ridolfi admired it, noting that it was by Bellini.[4] By 1602, the procurators had moved to a new building, so there is no proof that Bellini's painting was commissioned for this specific location.

Nevertheless, paintings composed like altarpieces, with officials kneeling before the Virgin and accompanied by Saint Mark, protector of the republic, and installed above a door or in another position, are commonly found in civic buildings in late medieval and Renaissance Italy. There are several examples in the ducal palace in Venice. They serve a votive function, thanking the Virgin for her protection of state affairs.[5] They are commemorative, not accompaniments to worship.

Bellini signed and dated (1510) the painting on an illusionistically painted piece of paper (cartellino) attached to the steps below the throne, according to an 1828 engraving of the painting, then in the Wendelstadt collection. The painting was later cut down, eliminating the cartellino; the lower portion was replaced, and the steps restructured.[6] The style is consistent with Bellini's work of 1505–10. The original style of the throne recalls that of the San Zaccaria Altarpiece (1505, Venice, church of San Zaccaria),[7] while the images of the Madonna and Child suggest the Brera Madonna, dated 1510 (Milan, Pinacoteca di Brera). X-rays clarify that the saints were added by assistants after the rest of the composition was in place.[8] The paint surface has suffered, but Bellini's role remains clear in the overall design, the portraits, the Virgin's luxurious blue drapery, and the soft, atmospheric effects—his greatest legacy to Venetian painting.

MWG and JS

PROVENANCE
Procuratia di Ultra, Venice, 1510–at least 1792;[1] Baron C. F. Wendelstadt, Frankfurt, by 1828;[2] Wolsey Moreau, by 1868; Raymond Balse, by 1873; Henry Walters, shortly before 1916

SELECTED BIBLIOGRAPHY
Zeri 1976, 1:248–52 (with earlier literature); Zafran 1988a, 46–47; Goffen 1989, 99; Heinemann 1991, 18; Tempestini 1992, no. 101; Tempestini 1999, 231, no. 118

NOTES
1 Cited in A. M. Zanetti, Della pittura veneziana e delle opere pubbliche de' veneziani maestri (Venice, 1792), 76.
2 Date of the collection catalogue.
3 F. Manfredi, Degnità procuratia di S. Marco di Venezia (Venice, 1602) cites the painting, 28 (without identifying the artist), and lists the procurators, 72. Zeno and Mocenigo remained in office until 1516 and 1517, respectively. When Manfredi was writing, the procurators, nine in total, mostly lived in the New Procuratia (procuratia nuova) on the south side of Saint Mark's square begun in 1588. The painting was probably commissioned for the Old Procuratia (procuratia vecchia) on the other side of the square. The move of quarters took place sometime towards the end of the century.
4 The painting was first attributed to Giovanni Bellini by C. Ridolfi in Le meraviglie dell'arte of 1648. It was also cited as by Bellini in M. Boschini, Le ricche minere della pittura veneziana (Venice, 1674), 73.
5 Goffen 1989, 99.
6 See E. Packard, "A Bellini Painting from the Procuratia di Ultra, Venice: An Exploration of its History and Technique," Journal of the Walters Art Gallery 33/34 (1970/71): 64–84. Heinemann 1991 declared the signature and date to be false and to have disappeared in cleaning. He attributes the execution to Vittore Belliniano based on a project by Bellini.
7 Zeri 1976, 1:248–52.
8 F. Gibbons, "Giovanni Bellini and Rocco Marconi," Art Bulletin 44 (1962): 129–31.

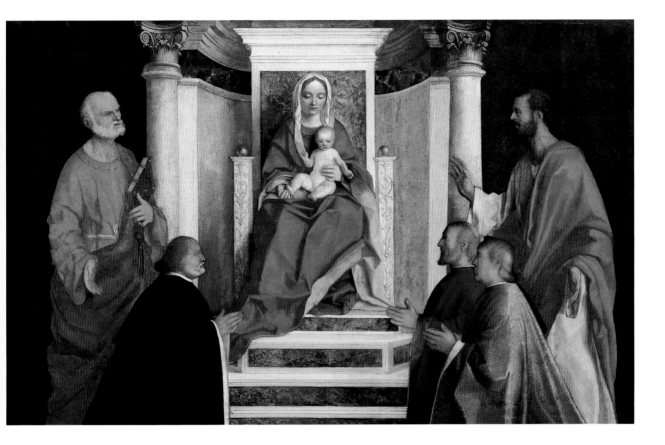

Madonna and Child with Saints Peter and Mark and Three Venetian Procurators, 1510
Oil on canvas mounted on wood, 36 x 58 in. (91.7 x 150 cm)
37.446

The Sixteenth Century

In around 1500, the styles of the early Renaissance gave way to those of the High Renaissance. In painting, the human figure, nude or draped, was imbued with a new sense of monumentality and three-dimensional presence through gracefully balanced movements influenced by classical sculpture. Tempera, the preferred medium of fifteenth-century panel painting, was replaced by oil paints, which permitted the exploration of unified color schemes and chiaroscuro (modeling in light and shade). Atmospheric effects, subtle gradations of colors, transparent shadows, and reflected lights, all studied in nature, were captured with the artist's brushes, while hair and skin were represented as soft and appealing to the touch.

In Rome during the first decades of the century, the papacy carried out a grand project of urban renewal that included significant patronage of architecture and art. The desire to re-create the splendor of the former center of the Roman Empire was rooted in a desire for continuity between the power of the ancient caesars and the spiritual and political authority of the Renaissance popes. In this context, classical history, art, and architecture were studied intensely by the educated class. The rebuilding of Saint Peter's, modeled after classical architectural styles, was begun in 1506 under Pope Julius II (r. 1503–13), and it resulted in its transformation into the world's largest church. The perfection of the human figure in Michelangelo's ceiling frescoes in the Sistine Chapel (see fig. 1, p. 100) and Raphael's frescoes in the Vatican Stanze quickly became standards for later generations of artists.

By 1520, some artists had begun to transform the High Renaissance figural ideal by elongating the proportions. A painter like Rosso Fiorentino (cat. no. 25) created strange and haunting works that departed from the classical canon, while others (for example, Giulio Romano, cat. no. 23) painted elegant figures that resembled finely polished marble, echoing ancient sculpture. A predominant feature of Mannerism, as this latter style came to be known, was its emphasis on artificiality, foregrounding the crafting of the work of art as a demonstration of skill. The term Mannerism itself is derived from the Italian word *maniera*, which in the Renaissance suggested both something done with a certain stylishness and something created in a particular, distinctive style.

The rich visual culture of Italy was described systematically for the first time in the history of Italian art that was published in 1550 by Giorgio Vasari, the painter and architect to Cosimo I de' Medici, duke of Florence. Vasari considered the arts of his own time to be a rebirth of those of antiquity. The intervening centuries, according to Vasari's highly biased and simplified historical account, had been characterized by a neglect of what was good and true in art, resulting in the "Greek" (Byzantine) and "German" (Gothic) styles that lacked harmony, order, beauty, and grace. In keeping with Vasari's own artistic practice (cat. no. 27), he argued that imitation of the works of Raphael and Michelangelo was the way for later artists to convey perfect beauty in their own works.

Vasari's history of art privileged *disegno* (meaning both drawing and design) as practiced by the painters in Rome and Tuscany over color, the strength of the painters of Venice. These Venetian artists explored the coloristic potential of the oil medium in the representation of surface textures and the play of natural light (see cat. nos. 31 and 32). The unparalleled and unquestioned master of color was Titian (1485/90–1576), whose fame spread throughout Europe during his lifetime.

MSH

RAPHAEL (RAFFAELLO SANZIO), 1483–1520, AND WORKSHOP

Madonna of the Candelabra, ca. 1513

THE ITALIAN HIGH RENAISSANCE master Raffaello Sanzio, known as Raphael Santi, whose painting style has epitomized the classical values of harmony and ideal beauty for centuries, was born in Urbino in 1483. As a young boy, he trained in his father Giovanni's painting workshop, where he learned basic techniques and became conversant with the most recent developments in Italian painting. This was followed by an important association with the famous Umbrian artist Pietro Vannucci ("Perugino"), probably very early in the sixteenth century. Perugino had invented a painting style known as the *maniera devota* ("devout manner"), which was characterized by simple, placid compositions, sweet human figures, and rich colors, and was intended to aid pious devotional prayer. Raphael, who was famous in part for his immensely popular paintings depicting the Virgin and Child, became a master of that tradition, as can be seen in the tender human interaction between the divine figures and the rich colors of the *Madonna of the Candelabra*. Painted in a *tondo*, or circular, format, this Madonna painting belongs to the final phase of his career (1508–20), which was spent in Rome. During this period, Raphael was preoccupied with the study of antiquities and ran a flourishing workshop engaged in numerous prominent commissions for the papal courts of Julius II and Leo X.

When the *tondo* was acquired by Henry Walters in 1901, it was celebrated as the first Raphael Madonna to enter the United States. Yet because of the extensive participation of his workshop in his Roman pieces, it is often difficult to determine if a work may be attributed solely to Raphael. Indeed, although the *Madonna of the Candelabra* correlates to the artist's other paintings of this time, several discrepancies complicate a direct attribution.[1] The Walters' *tondo* has been connected most directly to the *Madonna of the Fish* of ca. 1512, also a workshop painting arguably with some degree of intervention by the master (fig. 1). There is a particularly strong resemblance between the paintings' finely featured Madonnas.[2] The oval faces with downcast eyes, delicately contoured chins, slender, arched eyebrows, and hair rather severely parted in the middle are very close, and also recall other works, like the contemporary *Madonna di Foligno*, now in the Vatican Museums. While the Madonna may be compatible with works of ca. 1512, the Christ Child is more evocative of Raphael's Florentine period (1504–8). The most compelling comparison is offered by a juxta-

PROVENANCE

The Princes Borghese, Palazzo Borghese, Rome; Lucien Bonaparte, by 1812; sold to Maria Luisa, queen of Etruria, in Lucca; by descent to Charles Louis, duke of Lucca; sale, Phillips, London, 5 June 1841, lot no. 51; Hugh Andrew Johnstone Munro, Novar, Scotland; sold by Christie's, London, 1 June 1878, no. 153; Henry Alexander Munro Butler-Johnstone; Sydney Edward Bouverie-Pusey, 1882–1900; Ichenhauser, London, 1900; Henry Walters, 1901

SELECTED BIBLIOGRAPHY

Zeri 1976, 2:348–54 (with earlier literature); Brown 1983, 72–79; Zafran 1988a, 48–49; Oberhuber 1999, 245–48

NOTES

1 This *tondo* is the more important of two extant versions connected to a 1693 inventory of the Borghese Palace, Rome. The location of the second version, formerly in the collection of Sir Charles Robinson, is currently unknown. See the discussion in the two principal twentieth-century evaluations of the Walters' painting: L. Dussler, *Raphael: A Critical Catalogue of his Pictures, Wall-Paintings and Tapestries* (London and New York, 1971), 56–57 and Zeri 1976, 2:348–54, which also offers a comprehensive overview of previous literature.

FIG. 1 Raphael and workshop, *Madonna of the Fish*, ca. 1512, oil on panel. Madrid, Museo del Prado, 297.

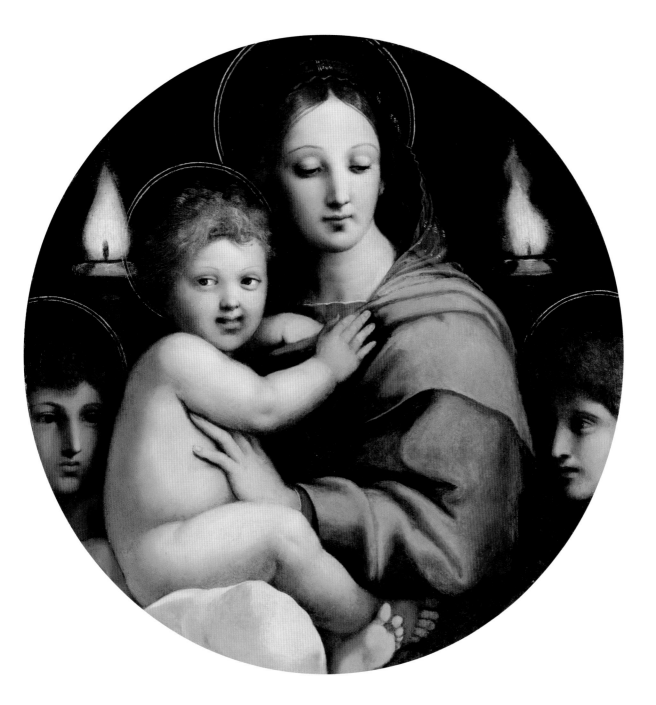

Madonna of the Candelabra, ca. 1513
Oil on panel, 25 ⅞ x 25 ¼ in. (65.7 x 64 cm)
37.484

FIG. 2 Raphael, *The Mackintosh Madonna*, ca. 1508, oil on canvas (transferred from panel). London, National Gallery, NG2069.

2 Dussler 1971, 56 and Zeri 1976, 2:351–53.
3 Reuse of the cartoon in the context of usual workshop practice offers an explanation for the atypically disengaged gaze of the Madonna; see Zeri 1976, 2:349, who proposes the original presence of a motivating Saint John to account for this discrepancy. The motif of the Christ Child's crossed ankles dates back to the *Ansidei Madonna* of ca. 1505, also in the National Gallery, London.
4 Numerous examples of this motif can be seen in Todini 1989, vol. 2.
5 See J. D. Passavant, *Rafael von Urbino und sein Vater Giovanni Santi* (n.p., 1839), *passim*, as discussed in Zeri 1976, 2:349–50.
6 For comments on the unusually rigid symmetry of the angels, see Dussler 1971, 56.
7 One issue pertains to the condition of the *tondo*. Truncation of the Madonna's halo and the angels' faces, together with abrasion and flaking along the edges of the panel, suggests that the painting has been cut down. See Zeri 1976, 2:349. The technical connections to Raphael are strong, including the use of characteristic pigments, for example the "copper resinate" green in the background, and the underpainting of the Madonna's ultramarine mantle with pink (now clearly visible through the abraded top layer), a technique particular to his paintings of the 1510s. Still, the admixture of vermilion with chalk in the flesh tones is an anomaly. On Raphael's technique in the middle Roman period, see *The Princeton Raphael Symposium: Science in the Service of Art History*, eds. J. Shearman and M. B. Hall (Princeton, 1990), 37, 75, 130. The presence of chalk in a flesh tone sample taken from the Christ Child's shoulder is cited, but not discussed, in Zeri 1976, 2:354. Regarding the generally unique use of chalk in northern paintings, see J. Dunkerton et al., *Giotto to Dürer: Early Renaissance Painting in the National Gallery* (New Haven and London, 1991), 162–64. On the controversy over the presence of chalk in a Raphael painting, see Hubertus von Sonnenberg's discussion of the debate over the two versions of the *Holy Family with the Lamb*, the first in the Prado, Madrid, the second in a private collection, in Shearman and Hall, eds. 1990, 69 n. 12.
8 See Dussler 1971, 56, who denies the presence of any trace of Raphael's hand or invention, and the comprehensive discussion in Zeri 1976, 2:349–53, who favors a potential intervention in the faces and/or upper bodies of the central figures, areas that evince more spontaneous brushwork and brilliant colorism.

position of the upper half of the design with the now-ruined and little-reproduced *Mackintosh Madonna* of ca. 1508 (fig. 2). The central figures—the Virgins share the exact tilt of the head in relation to the slight rotation of the left shoulder, and the depictions of the Christ Child have the same facial structure and positioning of the right hand—are so exact as to suggest reuse of the *Mackintosh* cartoon, which was common workshop practice.[3]

The Christ Child reaches his left arm into his mother's mantle, a gesture indicating his desire to nurse that derives from an Umbrian tradition.[4] This motif supports the basic message of the

painting: the redeeming flesh of Christ was nourished by the breast milk of his mother, which established her intercessory role in the salvation of mankind. The flanking angels hold elaborate candelabra recalling liturgical objects that stand adjacent to an altar, which symbolizes the sacrificing of Christ's flesh in the Eucharistic sacrament. This iconography also derives from Roman imperial portraiture.[5] Although such imagery is consistent with Raphael's interest in antiquities at this time and would have appealed to his learned patrons, the strictly symmetrical presentation of the angels, which appear to be painted by a different hand, is incompatible with his works.[6] Similarly, the interest in light effects generated by the candlelight, such as the chiaroscuro modeling of the bodies of the central figures, correlates to his style in the period, although the execution is not as skillful as that in other works of the time.

The technical and stylistic evidence, above all the fact that Raphael rarely reused specific figural poses to such a degree in his Madonna paintings, together with the likely reuse of a specific Florentine Madonna cartoon, precludes a direct attribution of the *Madonna of the Candelabra* to the master.[7] Scholarly opinions on the possibility of his participation, and its extent, vary, but the Walters' *tondo* is most persuasively attributed to one or more of Raphael's accomplished workshop assistants, in particular Giulio Romano, Giovan Francesco Penni, or Perino del Vaga.[8]

KEB

Recently, Oberhuber 1999, 247–48, has not ruled out Raphael's connection, suggesting the problem may be primarily the painting's poor condition or lack of finish. On the other hand, the painting was not included in S. Ferino Pagden and M. Antonietta Zancan, *Raffaello: catalogo completo* (Florence, 1989).

GIULIO ROMANO (GIULIO PIPPI), CA. 1499–1546
Madonna and Child with Saint John the Baptist, 1522–24

THIS ALTARPIECE was almost certainly done in Rome by Giulio Romano within a few years of the death of his famous teacher Raphael in 1520 and before his departure for Mantua in 1524 to become the celebrated court artist to Duke Francesco II Gonzaga.[1] The figures are depicted as if seen by a viewer standing slightly below them, a device that lends stateliness and monumentality to the scene. Holding a cross staff and wearing a camel skin, an allusion to his later ministry in the desert, the young Saint John the Baptist, Jesus' second cousin, reverently gazes at Christ. The presence of Saint John and the lamb refers to the saint's meeting with Jesus at the River Jordan, where the Baptist exclaimed "Behold the Lamb of God who takes away the sins of the world!" (John 1:29), thereby prophesying Christ's role as the sacrificial lamb.

The Christ Child's nudity emphasizes the miracle of the Incarnation: the Son of God has become flesh and blood. Christ's humanity was an important focus for the Church of Rome during the Renaissance.[2] The notion of the Incarnate God is given further emphasis through John the Baptist's intense stare. According to Christian tradition, Saint John was the greatest of the Old Testament prophets and the "sum of the law." While the earlier prophets had spoken of the advent of Christ in veiled language, John the Baptist had seen him in the flesh.[3] This distinguishing fact is emphasized through his gaze.

The prominent display of the Christ Child's body is also a reference to the Eucharist. According to the Catholic Church, during mass, Christ is believed miraculously to become present in the Host distributed during Holy Communion (by the process of transubstantiation), and the sacrament of the Eucharist is a symbolic reenactment of Christ's sacrificial death. Seen in this light, the infant Jesus and the lamb refer to this ritual.

In his early works, Giulio emulated Raphael's graceful style, and, like his teacher, he wanted to create a beautiful pictorial style based on the study of antiquity (see cat. no. 22). By adding black to his shadows and using dark backgrounds, his figures, with skin like finely polished marble, stand out in ways that recall ancient relief sculpture.[4] In this painting, the hill establishes a dark backdrop for the idealized figures.

The temple at the top of the hill is an invention based on the Belvedere Court in the Vatican built by the great architect Donato

PROVENANCE
Don Marcello Massarenti, Rome, by 1897; Henry Walters, 1902

SELECTED BIBLIOGRAPHY
Steinberg 1970, 254; Zeri 1976, 2:355–57 (with earlier literature); Verdier 1983, 45–58; Steinberg 1996, 81; Ferino Pagden 1989, 75; Gnann 1999, 330–31; Gordon 1999, 2; Droghini 2001, 47

Madonna and Child with Saint John the Baptist, 1522–24
Oil on panel, 49 ½ x 33 ⅝ in. (125.7 x 85.4 cm)
37.548

Bramante (ca. 1444–1514), but rather than portraying a modern building, the painter has depicted the structure in a state of decay, thereby blurring the distinction between the arts of antiquity and those of the early sixteenth-century popes (fig. 1).[5] Also, as the Virgin Mary is a traditional symbol of the Church, the presence of the building suggests an analogy between Mary and the temple. This metaphorical relationship is enhanced by ancient architectural theory. In Book IV of his *Ten Books on Architecture*, Vitruvius traced the origins of the orders of the columns back to human proportions. The slender, ornate Ionic—which is represented here—was equated with the female body, and, as in this painting, consequently could be compared to the Virgin Mary.[6]

The Virgin's beauty—her golden curls covered by a transparent veil, her finely arched eyebrows, her small mouth with full lips, and her cheeks like "ivory flushed with vermillion,"—corresponds to the ideals of female beauty that flourished in the lyric poetry of the period.[7] The biblical text that Giulio's painting is referring to is the Old Testament Song of Songs. According to Christian tradition, the bride and groom of the biblical poem were identified with Mary and Christ, signifying the union between the Church and God. The symbolically erotic union between the pair is indicated by the motif of the Christ Child's leg placed over Mary's.[8] The amorous metaphors underlying Giulio's painting expressed the belief that beauty could transform the beholder through love and raise the soul towards God.

MSH

NOTES

1 Another version of the *Virgin and Child* is painted underneath. The painting has also been attributed to Raffaello dal Colle (ca. 1490–1566), Giulio Romano's chief assistant in Rome following Raphael's death. For the attribution to Giulio Romano, see Ferino Pagden 1989, 75; Gnann 1999, 330–31; and to Raffaello dal Colle, see Zeri 1976, 2:355–57, and, most recently, Droghini 2001, 47. See Zeri 1976, 2:355–56, for derivative versions of the painting. See also P. Joannides, "The Early Easel Paintings of Giulio Romano," *Paragone* 36, no. 425 (July 1985): 17–46.
2 J. F. D'Amico, *Praise and Blame in Renaissance Rome: Humanists and Churchmen on the Eve of the Reformation* (Baltimore and London, 1983); Steinberg 1996.
3 For Saint John the Baptist in Italian art, see M. Fumaroli, *L'école du silence: Le sentiment des images au XVIIe siècle* (Paris, 1994), 203–322.
4 Vasari greatly admired Giulio Romano but censored his use of black in his early Roman works. Vasari 1906, 5:529. For Giulio's style, see E. H. Gombrich, "The Style *all'antica*: Imitation and Assimilation," in *Norm and Form: Studies in the Renaissance* (London and New York, 1971), 122–28.
5 Verdier 1983, 45–58.
6 The section on Giulio's engagement with Vitruvius, lyric poetry, and the Song of Songs is based on E. Cropper, "On Beautiful Women, Parmigianino, *Petrarchismo*, and the Vernacular Style," *Art Bulletin* 3, vol. 58 (1976): 374–94.
7 Ibid.
8 Steinberg 1970, 231–85, esp. 254.

FIG 1 Detail of architectural structure from top left of the painting.

ROSSO FIORENTINO (GIOVANNI BATTISTA DI JACOPO), 1495–1540

The Holy Family with the Infant Saint John the Baptist, ca. 1521

ROSSO FIORENTINO'S EXPRESSIVE STYLE—now considered very original—was not immediately appreciated by his Florentine contemporaries. Giorgio Vasari, in his 1550 biography of the artist, described Rosso as an eccentric man with an eccentric style. About one of the artist's early works, he noted, "if he was not much praised for it at the time, people subsequently recognized its good qualities little by little…for it would be impossible to surpass its harmony of colours, since the clear lights at the top, where the greatest light falls, gradually move with the less bright lights to merge so softly and harmoniously with the dark parts…that the figures stand close up against one another, each setting the other into relief by means of chiaroscuro."[1] Rosso's "eccentricity" lies primarily in the way he compresses space and his figures, and in a style that lends abstraction and artificiality to his compositions. They place him at the beginning of a stylistic movement today known as Mannerism.

The compression of the space results in the figures' uneasy relationship to each other and to the picture plane. Spatial depth is only implied by their overlapping bodies, so that Vasari's comment about Rosso's creation of relief rather than perspective depth also rings true here. The unfinished state—especially visible in the broad brush strokes of Saint Joseph's hair, and in the black underdrawing defining the figure and drapery outlines—accentuates the painting's sharp, angular light patterns, and its limited palette. Had it been completed, these aspects would have been toned down, but not eliminated.

The scale of this work indicates that it was made for a private patron, probably during the artist's sojourn in Volterra (ca. 1520–22). Christ's upper body and head and the Madonna's face are paralleled in his 1521 altarpiece for a church in Villamagna, near Volterra (fig. 1). In the *Holy Family*, the pillow on which Christ stands substitutes for the more standard ledge motif seen, for example, in Filippo Lippi's *Madonna and Child* (cat. no. 10). This pillow may rest on the arm of the Virgin's throne, as does an analogous cushion in the altarpiece. The vine or ivy garland crowning the youthful figure of Saint John is curious; it probably has Eucharistic significance, and most certainly derives from a slightly earlier representation of Saint John by the artist's mentor, Andrea del Sarto (1486–1530).[1]

MWG

PROVENANCE
Don Marcello Massarenti, by 1897; Henry Walters, 1902

SELECTED BIBLIOGRAPHY
Zeri 1976, 2:323–24 (with earlier literature); Zafran 1988a, 52–53; Ciardi and Mugnaini 1991, 62–63, no. 9; *Il Rosso e Volterra* 1994, 161, no. 15; Franklin 1994, 73–76; Von Gaertringen 2004, 475

NOTES
1 Vasari 1906, 5:158–59, 347. On Sarto's painting, see S. Freedberg, "A recovered work of Andrea del Sarto with some notes on a Leonardesque connection," *Burlington Magazine* 124 (May 1982): 281–88, and M. Lavin's letter, "Andrea del Sarto's St. John the Baptist," *Burlington Magazine* 125 (March 1983): 162. Both authors emphasize connections to Bacchus, but the vine leaves could carry the same interpretation without direct reference to the pagan wine god. A similar ivy garland crowns the figure who leads the donkey in Giotto's *Flight into Egypt* in the Arena Chapel, Padua.

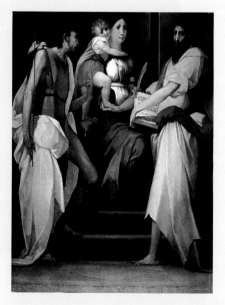

FIG. 1 Rosso Fiorentino, *Virgin and Child Enthroned with Saints John the Baptist and Bartholomew*, 1521, oil on panel. Volterra, Museo Diocesano.

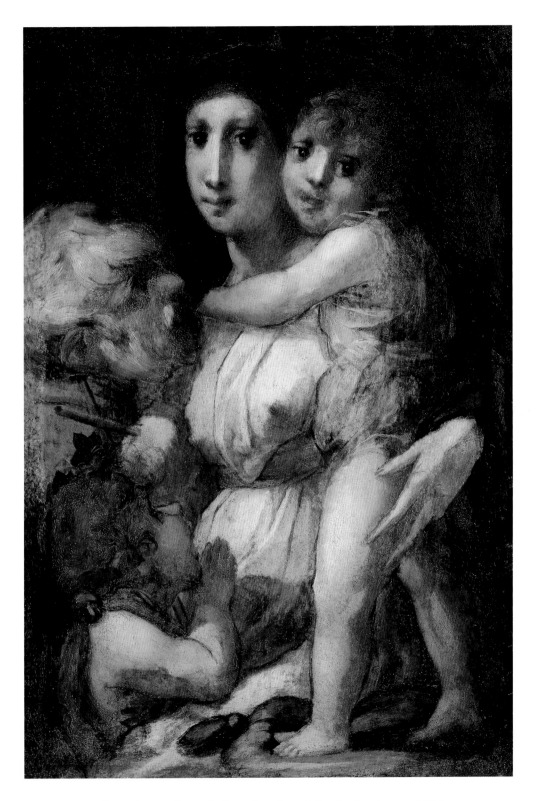

The Holy Family with the Infant Saint John the Baptist, *ca. 1521*
Oil on panel, 25 x 16 ¾ in. (63.5 x 42.5 cm)
37.1072

JACOPO DA PONTORMO (JACOPO CARUCCI), 1494–1556

Portrait of Maria Salviati de' Medici with Giulia de' Medici, ca. 1539

THE STUNNING IMAGE we have of the sixteenth-century Medici court in Florence is owed in part to the elegant portraits by Jacopo da Pontormo and Agnolo Bronzino of Alessandro de' Medici, duke of Tuscany, his successor Cosimo de' Medici, and their families and courtiers—exemplified by this portrait of Cosimo's mother Maria Salviati de' Medici with his cousin Giulia.

The identification of the subjects has taken curious turns. In a 1612 inventory, they were called "Maria Medici with a little girl," but by 1810, even Maria's identity had been forgotten. When the painting resurfaced in 1881 (collection of Don Marcello Massarenti, from whom Henry Walters acquired it in 1902), the child was painted out (fig. 1) and the woman was said to be the poet Vittoria de Colonna (1492–1547).[2] A cleaning in 1937 revealed the child and prompted research that identified the woman as Maria Salviati de' Medici (1499–1543),[3] granddaughter of Lorenzo de' Medici, il Magnifico, thus from the powerful, "elder" branch of the family that ruled Tuscany. She married a cousin from the "younger" branch who died in 1526.[4] It was assumed that Maria was depicted with her only child, Cosimo (1519–74), created duke of Florence in 1537, after the assassination of Alessandro de' Medici (of the elder branch), who had no legitimate heir. It was proposed that the painting was commissioned after Cosimo became duke and was meant to idealize his mother's responsibility for his rigorous education, preparing him for leadership and indirectly celebrating his descent through her from Lorenzo il Magnifico. This would then be the first of many portraits that Cosimo commissioned of himself celebrating dynastic continuity.[5] This reasoning remains attractive for some scholars.[6]

Soberly attired as a widow, Maria is represented with the elegant, improbable proportions then favored by artists. She leans protectively over a child who grasps two of her long, seemingly boneless fingers. In her other hand, Maria holds a portrait medal; given the abrasion, especially in this area of the painting, proposals as to the identity of the person represented are speculation. This sympathetic image of the duke's mother became a model for other portraits. For example, in 1556 Giorgio Vasari used it for his portrait of Maria in a fresco, commissioned by Cosimo, celebrating Cosimo's father.[7] At a time when women in powerful families were valued primarily for their youth and fertility, this is a rare portrait of a dignified, older woman.[8]

PROVENANCE

Medici collections; Riccardo Romolo Riccardi, Palazzo Gualfonda, Florence, by 1612 (inventory of 1612, Florence, Archivio di Stato, Carte Riccardi, fil. 258, c. 21r–23r, as "un quadro di br.a uno e mezzo della Sig.ra D. Maria Medici con una puttina per mano di Jacopo da Pontormo"), until after 1814 (Florence, Archivio di Stato, Carte Riccardi, fil. 278: "no 147 un quadro rappresenta un ritratto di donna con una bambina"[1]; Don Marcello Massarenti, Rome, by 1881; Henry Walters, 1902

SELECTED BIBLIOGRAPHY

Zeri 1976, 2:325–28 (with earlier literature); Allegri and Cecchi 1981, 157; Langedijk 1981, 431, 1262–64 n. 5; Cox-Rearick 1981, 357–59; Cox-Rearick 1982, 74, 79; Simon 1982, 187–200; Cox-Rearick 1984, 236–37, 260; Costamagna and Fabre 1986, 2:374–77; Zafran 1988a, 54–55; Cox-Rearick 1989, 18–21; Berti 1990, 45-46, 48 n. 7; Langdon 1992, 20–40; Cox-Rearick 1993, 261–63; Costamagna 1994, 90, 236–38, 285, no. 77; Falciani 1995, 120–22; Cropper 1997, 3; Spicer 2001, 4–6; Scalini, ed. 2001, 235; Pilliod 2001, 236; Cropper 2001, no. 40; Costamagna 2002a, no. 33; Costamagna 2002b, 206; Musacchio 2004, 311–12; Pinelli 2004, 129, 132, 136–37; Strehlke 2004, no. 30

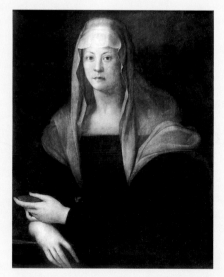

FIG. 1 Image of painting before cleaning in 1937.

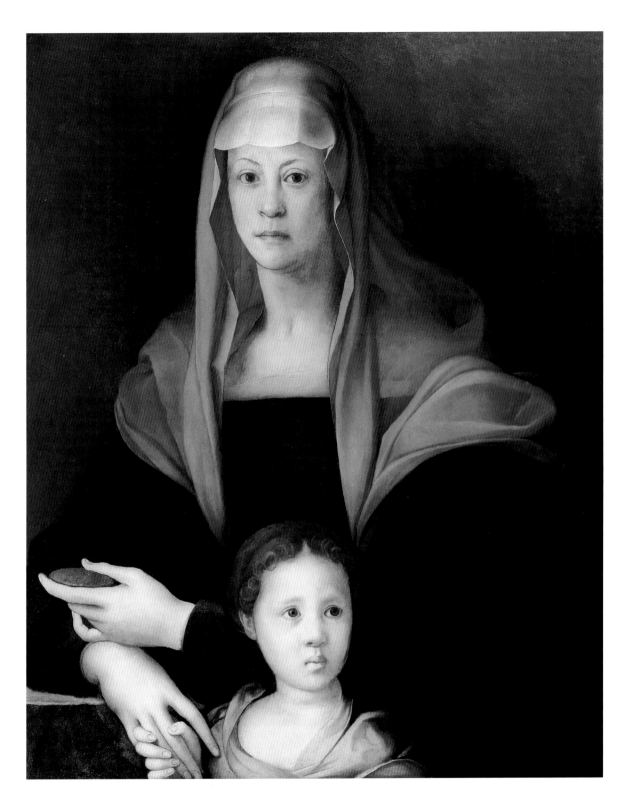

Portrait of Maria Salviati de' Medici with Giulia de' Medici, ca. 1539
Oil on panel, 34 ⅝ x 28 ¹⁄₁₆ in. (88 x 71.3 cm)
37.596

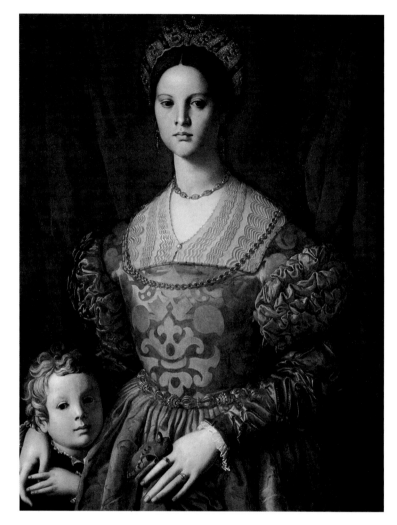

FIG. 2 Agnolo Bronzino, *A Young Woman and Her Little Boy*, ca. 1540, oil on panel. Washington, D.C., National Gallery of Art, Widener Collection, 1942.9.6.

NOTES

1 For inventories of the Riccardi family, see Costamagna 1994.

2 Attributed to Sebastiano del Piombo in 1881, reattributed to Pontormo in 1916 (see Zeri 1976).

3 Identified by E. King in the *Journal of the Walters Art Gallery* 3 (1940): 75–84, by comparison with a portrait, based on the present one, by Giorgio Vasari in the fresco decorations of 1556 in the Palazzo Vecchio, Florence, commissioned by Cosimo in celebration of his family. King identified the child as young Cosimo. For the sitters, see Langdon 1992 and Langedijk 1981. In the same 1612 inventory, there is a portrait sometimes identified as Maria's sister Francesca (Frankfurt, Städelsches Kunstinstitut), by Pontormo (Costamagna 1994, 296; Brown et al. 2001, no. 39) or by Bronzino (Strelke 2004, no. 24) with the same dimensions as the present portrait.

4 Giovanni de' Medici, "delle Bande Nere" (after his soldiers, the "black bands").

5 See Cox-Rearick 1984.

6 For example, Costamagna 2002a.

7 See note 3 and Langedijk 1981.

8 As underlined in Brown et al. 2001, especially E. Cropper's entry on the Walters' painting, which was the point of departure for a *Portrait of a Widow* (Florence, Galleria degli Uffizi) that is sometimes called Maria Salviati (see Costamagna 2002a, no. A34).

9 See Langdon 1992, Spicer 2001, Cropper 2001, Musacchio 2004.

10 See Brown et al. 2001, no. 41.

11 Bia de' Medici, Cosimo's natural daughter, was born in 1537; the portrait by Bronzino (Galleria degli Uffizi) depicts a different child; Maria de' Medici, Cosimo's daughter born in 1540 (thus too late) to his wife Eleonora de Toledo; and Giulia de' Medici (see Langdon 1992). Her birth date is not documented; thus it is not excluded that Vasari's reference (1906, 6:282) to a portrait of Maria Salviati painted by Pontormo in 1537 is the Walters' portrait.

12 Correspondence with Mario de Valdes y Cocom prompted a close reading of Langdon 1992; thereafter, the Walters' title has acknowledged Giulia.

13 For this letter and other citations, see G. Pieraccini, *La Stirpe de' Medici di Cafaggiolo* (Florence, 1986), I:397–411. All documents are open to interpretation.

14 On slavery in Italy, see S. A. Epstein, *Speaking of Slavery: Color, Ethnicity, and Human Bondage in Italy* (Ithaca, 2001). Many female slaves were

The child is a girl.[9] Boys in such aristocratic circles wear short hair and fitted jackets (fig. 2);[10] this child has the part, curls, and braids of the girl in Veronese's *Countess Livia da Porto Thiene and Her Daughter Porzia* (cat. no. 31). Moreover, Cosimo, raised to equate toughness with honor, would not have had himself portrayed anxiously grasping his mother's fingers.

In 1539–40, there were three small girls in Maria's care,[11] but only one in the age range of the girl in the painting: Giulia de' Medici, born about 1535, the natural daughter of Alessandro de'

Medici, himself the natural son of Cardinal Giulio de' Medici (later Pope Clement VII) for whom Giulia may have been named.[12] Alessandro's murder made it possible for Cosimo, from the younger branch of the family, to claim the dukedom. Given the power of Alessandro's branch, Cosimo had to show that Alessandro's children, Giulia and her brother Giulio (candidate of the elder branch to inherit the dukedom), were cared for until he could produce a male heir, which he did in 1541.

Giulia herself is interesting. Her father's mother was a servant or slave in a Medici household in Rome, who, according to a letter of 1529 addressed to Alessandro as "dearest son," was living in poverty,[13] as did many former servants or slaves released from servitude late in life. Slaves were generally Slavic or African, and according to later tradition she was a Moor (African).[14] Alessandro's appearance in many of his portraits, particularly one done after his death (fig. 3), would support this tradition. His long nose resembles his father's, but he was described as having brown skin, tightly curled black hair, and full lips. Political opponents taunted him for the "ignominy of his blood." They could have been referring to the social status of his mother, but many prominent citizens were illegitimate, so that this alone was unlikely to prompt such a jibe.[15] Giulia shares his eyes and distinctive mouth, though she must have inherited her reddish hair from her as yet unidentified mother. Her pallor reflects a Florentine portrait convention of refinement. Although Giulia's ancestry is not resolved, it remains likely that this is the earliest formal portrait of a girl of African descent in European art.

JS

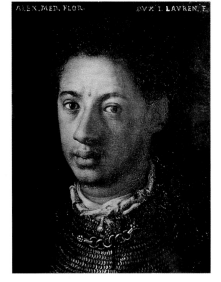

FIG. 3 Agnolo Bronzino (workshop), *Alessandro de Medici*, 1555–60, oil on tin. Florence, Museo Mediceo, Galleria degli Uffizi.

purchased for pleasure by members of ruling families; these young women obviously had children. The issues raised are fascinating and worthy of further study.
15 In Renaissance Italy, slaves were drawn from Africa, but also from Russia and the east. Maria of Aragon, the illegitimate daughter of Alfonso the Magnanimous, duke of Naples, by an African woman, married the lord of Ferrara (himself of illegitimate birth), one of the most admired rulers of his time. Giulia herself married very well.

SOFONISBA ANGUISSOLA, CA. 1535/40–1625

Portrait of Marquess Massimiliano Stampa, 1557

SOFONISBA ANGUISSOLA, the most famous woman artist of her century,[1] was a sensitive interpreter of children. This sophisticated portrait of a child represents Massimiliano Stampa, marquess of Soncino, painted in 1557, when he was nine and she was about twenty-two. It may have been her first major commission from outside her circle of family and friends in Cremona (in Lombardy, near Soncino), and its crafting shows her ability as an artist—and an aristocrat—to convey the dignity of her subject. Her family, though noble, lived in straightened circumstances, so it was critical that she establish herself as a portraitist to the powerful.[2] The success of this painting may have aided the sudden improvement of her fortunes. The next year she was called to the court of Philip II of Spain.

The identity of this boy is known from an inscription in Latin on the reverse that translates "Massimiliano Stampa, the 3rd marquess of Soncino, in his ninth year, 1557."[3] He was the only son of Ermes, 2nd marquess of Soncino, who died in 1557; this painting was likely commissioned to mark Massimiliano's investiture as marquess in July of that year.[4] Its execution reflects the Lombard naturalism of Giovanni Battista Moroni (ca. 1525–78).

In the mid-sixteenth century in Italy, the formal, standing, full-length portrait was largely reserved for rulers and their spouses. It remained rare for a child, even an aristocrat, to be shown alone in full length. In Veronese's *Portrait of Countess Livia da Porto Thiene and Her Daughter Porzia* (cat. no. 31), the little girl is not included on her own account and is permitted child-like behavior. However, Massimiliano is presented as an adult male: his black garments, gloves, ring, dagger, and sword together signal him as a gentleman ready to defend his honor.[5] While an adult figure leaning against a massive pedestal and column was a common device for conveying prerogative, the height of this pedestal is subtly scaled to the child, conferring on Massimiliano a surprisingly commanding presence in spite of his slight build.[6] But at the same time this is a boy who has lost his father and looks at us with big, watchful eyes. He is accompanied by a sleeping spaniel.[7] A hunting dog is a typical manly attribute for male aristocrats, but this spaniel is for now a faithful companion waiting for his master to complete one of the tasks of adulthood.

JS

NOTES
1 See Ferino-Pagden and Kusche 1995.
2 Drawing and painting were suitable pastimes for the nobility, but it was unthinkable that she, as a noble, would expect payment. However, she could exchange "gifts" or expect other benefits.
3 *Max[imilianus] Sta[mpa] Mar[chio] Son[cini] III-Aet[atis] An[norum] VIIII-1557.* The inscription on the reverse of the original canvas was discovered in 1986 when the painting was relined (Simon 1986). The adaptations of this portrait by Joseph Cornell (1902–72) assume that the boy is a member of the Medici family.
4 The commission was surely arranged by her teacher, Bernardino Campi, who had worked for the 2nd marchese (Mini Gregori, ed., *I Campi e la cultura artistica cremonese del Cinquecento* [Cremona, 1985]). Four copies are known (Zeri 1976, Caroli 1987); they were probably made for family and political purposes.
5 For black garments, see Garrard 1994. The sober palette is played off against the green backdrop that has suffered surface loss, as has the rest of the painting (examined with Walters' conservators Eric Gordon and Karen French) and probably was originally softened with a darker glaze, as in other of her portraits.
6 Although the rendering of recession is insecure, it appears intentional that the boy is depicted from an angle that places the viewer (and therefore the artist) close by and slightly below him. The viewer is obliged to look up into the child's face.
7 The repeated assertion that the dog is derived from Albrecht Dürer's engraving *Melancolia* cannot be supported.

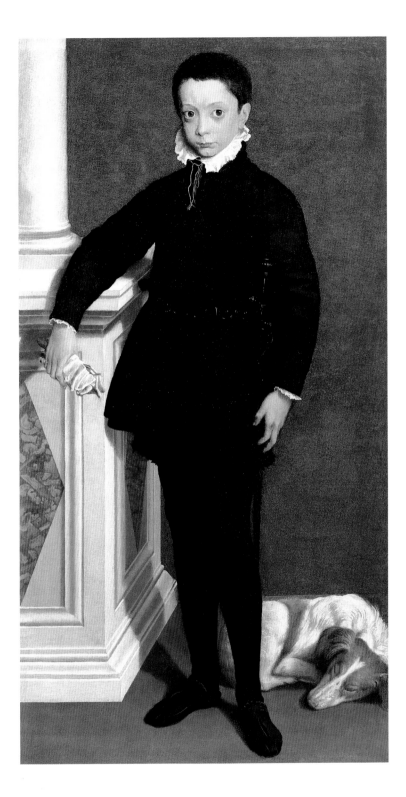

Portrait of Marquess Massimiliano Stampa, 1557
Oil on canvas, 53 ⅞ x 28 ⅛ in. (136.8 x 71.5 cm)
37.1016

LAVINIA FONTANA, 1552–1614
Portrait of Ginevra Aldrovandi Hercolani, ca. 1595

SOME TIME AFTER the death of Senator Ercole Aldrovandi in 1593, his wife Ginevra commissioned Lavinia Fontana to commemorate her status as a widow.[1] Ginevra wears a precious, dark mourning costume with a veil of gold-trimmed gauze bedecked with pearls. Her sad expression tells of her grief, and the handkerchief in her left hand alludes to the tears she has shed. The little bejeweled lap dog, whose paw she holds, was fashionable among sixteenth-century noblewomen, and Bologna was famous for this breed. The dog also serves a symbolic function. In treatises of the period on the ideal behavior for women, a widow who did not remarry, staying true to her husband's memory, was compared to a faithful dog.

Sixteenth-century literature on widowhood, addressed to the upper social classes, recommended a secluded and pious life. Shunning the outside world whenever possible, the widow should remain in quiet mourning for the rest of her days. Lavinia's portrait only partly conforms to such an ideal. While the representation places emphasis on mourning rituals, it also conveys the sitter's authority. With the death of her husband, Ginevra gained control of the family estate and earned increased responsibility and power: the commissioning of the portrait was in itself a mark of this. Ginevra meets the beholder with a firm, almost hard gaze, which in a literal sense speaks of her engagement with the outside world. Moreover, her minutely detailed costume is intended to be seen and admired.

Lavinia Fontana was among the most sought-after painters in her native Bologna.[2] Among her many commissioned portraits, two groups stand out: images of scholars (the University of Bologna was then the largest in Europe) and portraits of the city's noblewomen. To the first group belongs the portrait of the doctor Gerolamo Mercuriale, who taught at the University, pictured with a copy of Vesalius's book of anatomy (fig. 1). Because of the social structure, it was extremely rare for women to become professional artists.[3] To the scholars of Bologna, Lavinia would, therefore, have been something of a marvel of nature. Among the noblewomen of the city, to have a portrait executed by Lavinia was indicative of one's standing.

MSH

PROVENANCE
Hercolani collection, Bologna; Don Marcello Massarenti, Rome, by 1881; Henry Walters, 1902

SELECTED BIBLIOGRAPHY
Zeri 1976 2:384–85 (with earlier literature); Cantaro 1989, 181–82; Ferriani 1994, 119, 188–89; Biancana 1998, 96–97; Murphy 1997, 134–37; Murphy 2003, 142–46

NOTES
1 This entry is based largely on the information in Murphy 2003, esp. 139–46. Lavinia was the daughter of the painter Prospero Fontana (1508–96), from whom she received her training as a painter. In 1577, she married and took the name of Lavinia Fontana de Zappis. The image might have been cut on the upper, lower, and left side, so the dog might have previously been visible in its entirety. Zeri 1976, 2:383–85.
2 In 1675, Carlo Cesare Malvasia could tell his readers that Lavinia was able to charge prices comparable to those asked by Anthony van Dyck and Giusto Sustermans, the court painter to the Medici family in Florence. C. C. Malvasia, *Felsina pittrice: Vite de' pittori bolognesi*, ed. Giampietro Zanotti et al. (Bologna, 1841), 1:177.
3 See also L. Nochlin, "Why Have There Been No Great Women Artists?" in *Women, Art, and Power and Other Essays* (New York, 1988), 145–78.

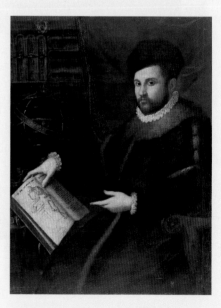

FIG. 1 Lavinia Fontana, *Portrait of Gerolamo Mercuriale*, ca. 1587–90, oil on panel. Baltimore, The Walters Art Museum, 37.1106.

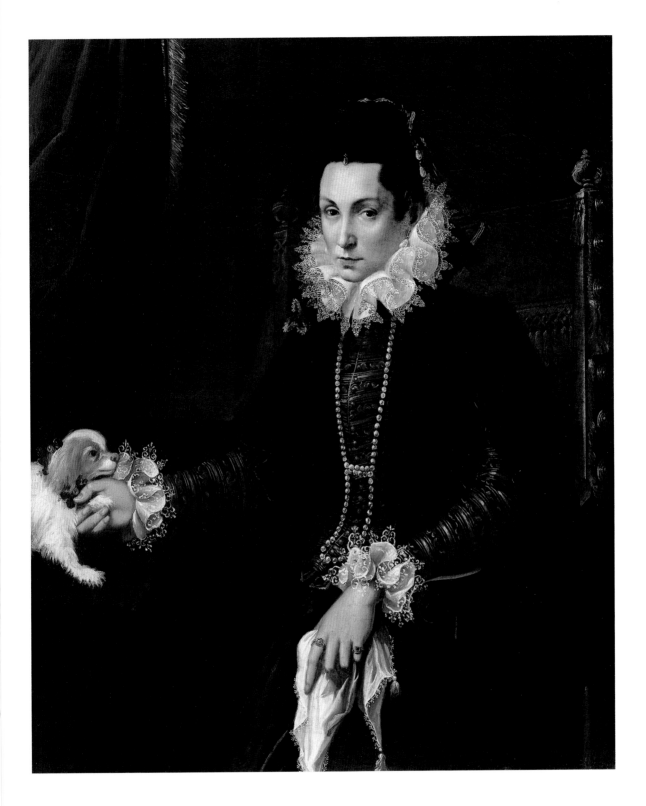

Portrait of Ginevra Aldrovandi Hercolani, ca. 1595
Oil on canvas, 45 ¼ x 37 ⅜ in. (115 x 95 cm)
37.1915

LEANDRO BASSANO, 1557–1622

Allegory of the Element Earth, ca. 1580

JACOPO DA PONTE (ca. 1510–92), also known as Bassano after his native town in the Veneto, was the head of a productive workshop that included his sons, Francesco (1549–92), Leandro, and Gerolamo (1556–1621), all trained in the pictorial style of their father. This allegorical painting of the element earth is believed to be a replica (a copy executed in the studio) by Leandro after Jacopo's original, and the latter may even have assisted his son in executing the painting. Carlo Ridolfi in his 1648 work on the painters of Venice records that Jacopo executed a series of allegories of the four elements, each with a pagan deity in the sky, for a "great prince."[1] The series was probably installed in a single room as part of the splendid decoration for the prince's palace or villa.

During the sixteenth century, the world was thought to consist of four elements, which were associated with the four seasons: air/spring, fire/summer, earth/autumn, and water/winter. This painting represents earth as an autumnal scene, in which several workers at the break of dawn gather and carry fruits, vegetables, and game. In keeping with the abundance of the scene, the ancient Roman goddess of fertility, Cybele, drives across the sky in a wagon pulled by lions. When viewed together (figs. 1–3), the four allegorical paintings could be interpreted as an allusion to the

PROVENANCE
The Walters Art Museum from David M. Koetser, London and New York, 1951

SELECTED BIBLIOGRAPHY
Zeri 1976, 2:409–10 (with earlier literature); Rearick 1992, 187–90; Aikema 1996, 138–40

NOTES

1 It is generally believed that a series of the *Four Elements* was conceived by Jacopo Bassano in the late 1570s and executed in several versions in his workshop, but there is some disagreement as to when exactly the four known canvases were done, and by whom. Zeri 1976, 2:409–10; Rearick 1992, 187–90.

2 See also T. DaCosta Kaufmann, "Arcimboldo's Imperial Allegories: G. B. Fonteo and the Interpretation of Arcimboldo's Paintings," *Zeitschrift für Kunstgeschichte* 39, no. 4 (1976): 275–96, esp. 286–87. For a Christian moralizing interpretation of the Bassano allegories, see Aikema 1996, 138–40.

3 Pliny, *Natural History*, XXXV and XXXVII, 112.

4 For a northern example of an artist fashioning his style in the image of the "low" style of ancient painting, see M. A. Sullivan, "Aertsen's Kitchen and Market Scenes: Audience and Innovation in northern Art," *Art Bulletin* 81, no. 2 (June 1999): 236–66. Jacopo Bassano was compared to Piraeicus, though unfavorably so, for the first time in the early seventeenth century in the treatise of Giovanni Battista Agucchi. D. Mahon, *Studies in Seicento Art and Theory* (London, 1947), 256; Aikema 1996, 3.

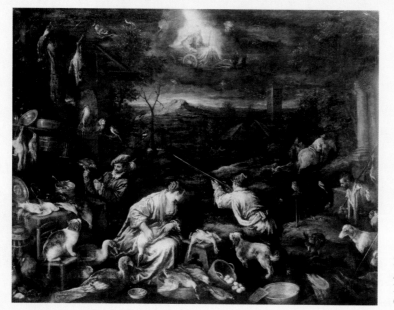

FIG. 1 Jacopo Bassano, *Allegory of the Element Air*, oil on canvas, formerly Berlin, Kaiser Friedrich Museum, since destroyed. Photo: Courtauld Institute of Art, London.

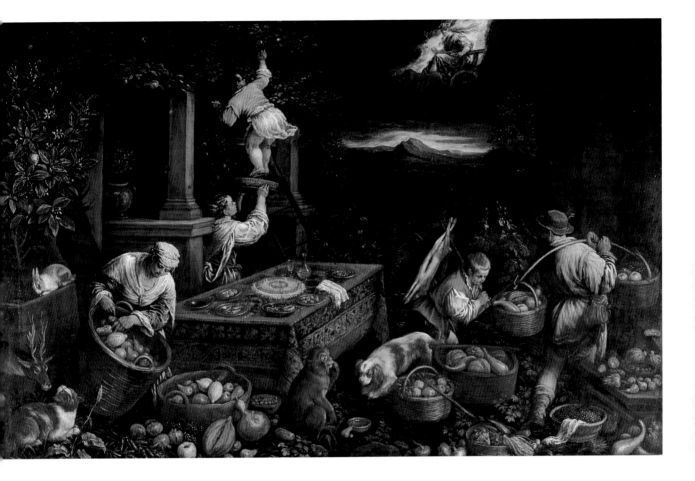

Allegory of the Element Earth, ca. 1580
Oil on canvas, 58 ¼ x 92 ¼ in. (148 x 234.2 cm)
37.2363

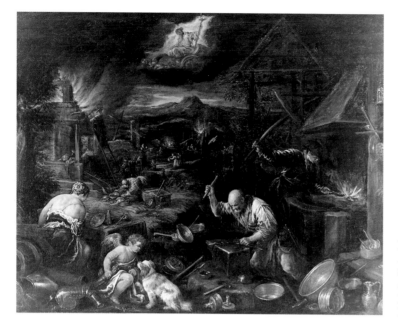

Fig. 2 Francesco [or Jacopo] Bassano, *Allegory of the Element Fire*, oil on canvas. Sarasota, Bequest of John Ringling, Collection of The John and Mable Ringling Museum of Art, the State Art Museum of Florida, Florida State University SN86.

prince. If God is the ruler of the cosmos, then the prince, whose own earthly rule was believed to be bestowed from above, could claim that his role in the world paralleled that of God. He might, therefore, be said to be the earthly center of the elements and the seasons.[2]

The architectural structure on the left at once points to the garden of a nobleman's villa and classical antiquity. The table covered with a precious oriental carpet and filled with sweets, fruits, and wine also indicates that the land worked by the servants is not their own: the earth brings forth its fruits in honor of the prince, whose rule is characterized by great prosperity. In addition, the lush scenery evokes the Golden Age, an ideal time described in *The Metamorphoses* by the Roman poet Ovid. The fictive coexistence of the different animals in the foreground hints at this poetic, Eden-like state.

The evocation of classical ideals, mythology, and architecture suggests that the work was created for an audience familiar with humanism's focus on the ancient world. The humanists of the Renaissance were professional scholars engaged in the study of ancient letters, and they were typically affiliated with the courts.

Jacopo Bassano and his sons were the first in Italian art to specialize in filling their works with so-called low-life subjects

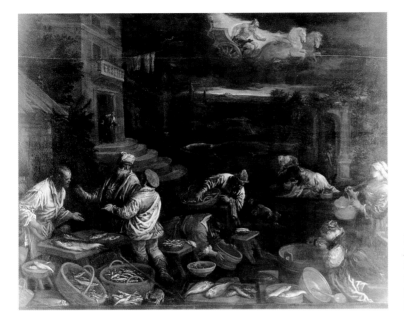

FIG. 3 Francesco [or Jacopo] Bassano, *Allegory of the Element Water*, oil on canvas, Sarasota, Bequest of John Ringling, Collection of The John and Mable Ringling Museum of Art, the State Art Museum of Florida, Florida State University SN87.

and natural details. Moreover, the work is executed in a painterly style that was then identified with pictorial naturalism. The dark scenery has provided the artist with the opportunity to create dramatic modeling in light and shade with rich oil paints, and hues stand out brilliantly against the dark shadows. This technique was known as chiaroscuro, and it was characteristic of Venetian sixteenth-century painting.

The audience of the *Allegory of the Element Earth* would have understood the original pictorial style and the peculiar choice of subject matter as an imitation of a particular branch of ancient painting. The original works had disappeared, but they were known through descriptions in the Roman writer Pliny's famous *Natural History*.[3] In it, he described painters such as Piraeicus who were renowned for a "minor style" and who, although adopting "a humble line...attained in that field the height of glory." Piraeicus also painted everyday subjects and animals. The Bassano family's art was a conscious imitation of the painting of antiquity, to be appreciated in particular by a courtly audience.[4] The fact that Leandro was knighted and, therefore, could sign his paintings with the Latin title "*eques*" testifies to the success of the artist among the social elite.

MSH

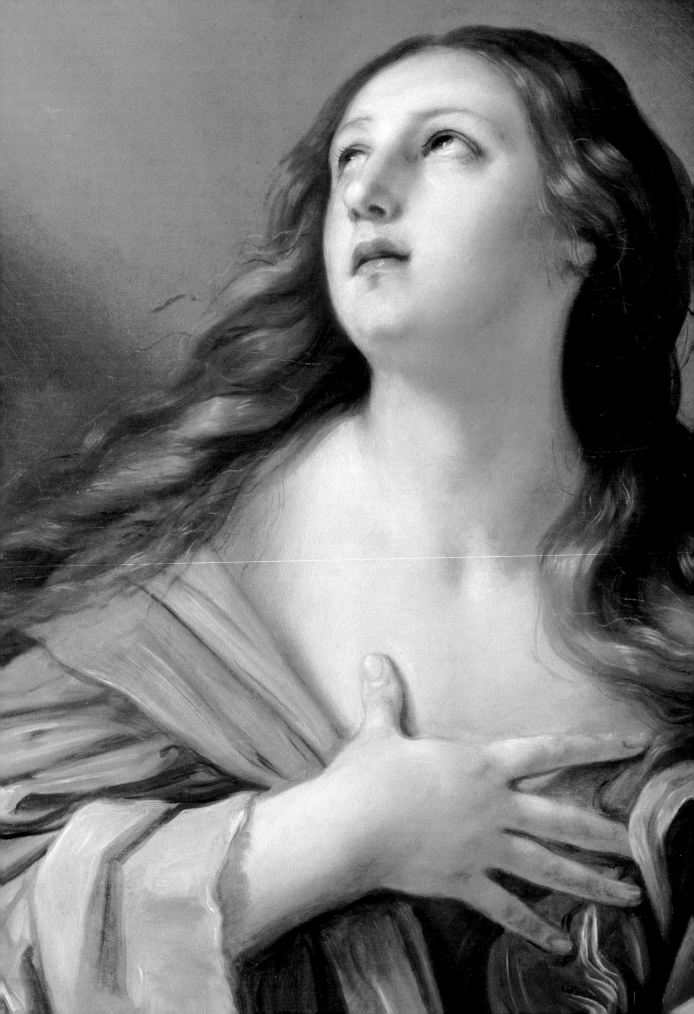

The Seventeenth Century

By the late sixteenth century, there was a general sense that painting was in a period of decline and that the art of the present was inferior to that of earlier in the century. Artists had come to privilege the study of art over that of nature, and painting, with its idealized, polished figures and artificial coloring, had lost its affective and emotionally engaging qualities. In Bologna in the 1580s, Annibale Carracci (1560–1609), together with his brother and cousin, had begun to rethink painting's relationship to the artistic tradition and to nature. They rejected their mannerist colleagues' emphasis on *disegno* over color and developed pictorial styles that were founded on the relationship between color, light, and shade as observed in nature. The three Carracci painters founded an academy in Bologna where the new baroque style was transmitted to younger generations of painters.

In Rome around 1600, Michelangelo Merisi (1571–1610), better known as Caravaggio (the name of his home town in Lombardy), introduced a radically novel way of painting. In his monumental altarpieces, he created dark spaces seemingly lit by a single, intense source (fig. 1, p. 128). His use of modeling in light and shade was then understood in terms of pictorial naturalism, and this realism was enhanced by his unidealized representations of holy figures, clearly drawn from models in his studio.

Caravaggio soon acquired numerous followers, who imitated the shaded atmosphere of his works in their genre scenes, which often depicted groups gathered around tables playing cards, drinking, and playing music (cat. no. 36). These paintings were appreciated by elite clients and purchased for their private galleries. In general, genre scenes and still-life painting recording natural phenomena and curiosities in astonishingly realistic detail became highly popular during the seventeenth century (cat. no. 40).

Some were critical of Caravaggio's unique way of painting. Among them was the papal antiquarian Gian Pietro Bellori. In his 1672 work on the modern artists, Caravaggio's painting was attacked for being artless, relying only on nature and caring neither for beauty nor decorum. Bellori instead promoted the ideal proportions of ancient sculpture and the works of Raphael (cat. no. 22), which were shaped by his encounter with antiquity. Seventeenth-century classicism imitated the most beautiful parts of nature and past art. The most excellent practitioner of baroque classicism in painting was the French artist Nicolas Poussin (1594–1665), who lived and worked in Italy.

The Roman Catholic Church explored art to give its sacred tenets grandiose and engaging visual expression. In response to Protestant attacks, the cults of the Virgin Mary and the saints, as well as the miracle of transubstantiation (the transformation of the bread and wine into the actual body of Christ during Holy Communion), were splendidly represented in vast pictorial schemes.

The term "baroque" was first introduced in the mid-eighteenth century as a derogative term to describe something irregular that departed from the classical ideal. Sevententh-century artists and architects would not have thought of themselves in those terms. Rather, when they moved away from the classical canon, it was to develop their own creative forms of the human figure and architectural elements. The baroque artists favored open and dynamic forms. In this vein, the circle and square, among the preferred shapes of the Renaissance, were replaced with the oval and the rectangle.

MSH

DOMENICO FETTI, 1588/89–1623
Christ and the Tribute Money, ca. 1618–20

THE NEW TESTAMENT relates that the Pharisees of Jerusalem, hoping to trick Christ, asked him while he was preaching at their temple whether it was just for them to pay taxes to Rome (Matthew 22:15–22; Mark 12:13–17; Luke 20:20–26). Either response, they reasoned, would lay him open to accusation: either by the Roman collectors or by the Jews, who resented the tax. Fetti portrays Christ's answer in the form of a gesture to one of the questioning Pharisees. The Gospels indicate that Christ pointed to the effigy of the emperor on a coin and asked whose likeness and names were represented on it: "They say unto him, Caesar's. Then he saith unto them, render therefore unto Caesar the things that are Caesar's; and unto God the things that are God's." Fetti highlights the Pharisees' trickery by deploying established stereotypes. In contrast to the crooked nose and dark skin of the questioner, Christ's face, with his straight nose and paler skin, highlights the ethnic and moral division between the two figures.

Fetti's painting is a copy of a work executed exactly a century earlier by Titian (fig. 1).[1] As such, it presents an interesting case of a patron commissioning a copy of an earlier work from his court painter, reinterpreted in a contemporary idiom. However, seventeenth-century viewers would not have seen this painting as a mere "copy" in a pejorative sense. Rather, they would have understood that Fetti was following an established tradition of imitation. Moreover, when baroque painters emulated Titian, they were stating their allegiance to colore (color) over disegno (drawing). While disegno was associated with the harbingers of the Tuscan Renaissance, and the medium of fresco, colore came to be associated with Venice, with its damp climate and attendant allegiance to oil painting. No Venetian master exemplified the tradition of colore more than Titian.

Fetti's work, aptly characterized as "seeing Titian through the eyes of Rubens," reveals the double cultural capital that the painting bestowed upon its patron, Ferdinando Gonzaga of Mantua.[2] Specifically, it allowed Ferdinando to possess the composition of Titian and the style of Rubens, both of which discerning viewers would have recognized. The power of paintings to confer status and prestige on their patrons is not limited to this period. What is novel and particularly characteristic of seventeenth-century art, however, is the way that works like Fetti's were reflective, and indeed constitutive, of their patrons' sophisticated tastes.

PROVENANCE
Marquess Filippo Marignoli, Rome and Spoleto, until 1898; Marquess Francesco Marignoli, 1898–99; Don Marcello Massarenti, Rome, 1899; Henry Walters, 1902

SELECTED BIBLIOGRAPHY
Zeri 1976, 2:441–42 (with earlier literature); Zafran 1988a, 64–65; Safarik 1990, 145

NOTES
1 Significantly, Fetti painted his copy precisely during the decade of the seventeenth century when this particular painting by Titian was most celebrated. For seventeenth-century reactions to Titian's painting, including the relief that Cesare d'Este felt in 1612 when robbers who looted his private chapel in Modena left the canvas untouched, see J. Southorn, *Power and Display in the Seventeenth Century: The Arts and Their Patrons in Modena and Ferrara* (Cambridge, 1988), 17.
2 Safarik 1990, 145. See also *Domenico Fetti*, ed. E. A. Safarik, exh. cat., Mantua, Palazzo del Tè (Milan, 1996).
3 Zeri 1976, 2:441.
4 See Safarik 1990, 143, who suggests that Ferdinando sent the artist to Modena expressly for this purpose. Safarik also indicates that the dating of the picture is problematic. As the painting is executed with a confident, mature hand, he attributes it to the second half of Fetti's Mantuan period, which is to say 1617–20 (Safarik 1990, 145).

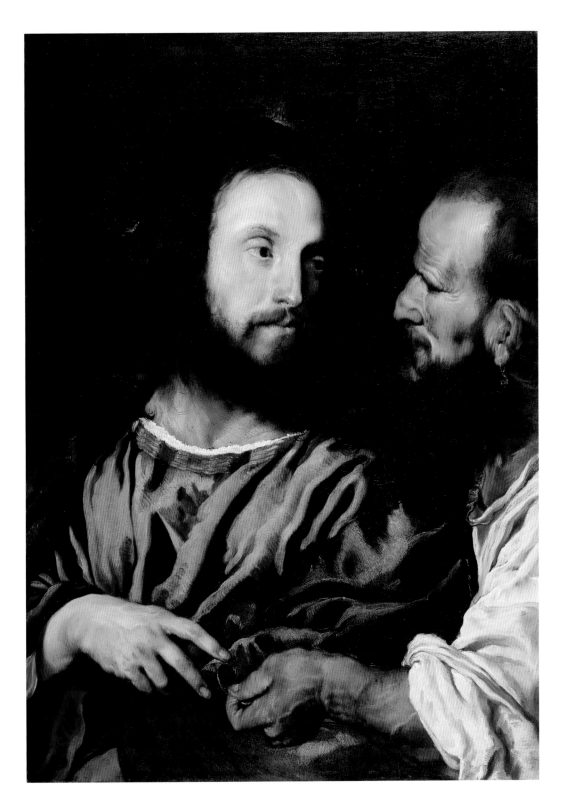

Christ and the Tribute Money, ca. 1618–20
Oil on panel, 31 ¼ x 22 ⅛ in. (79.3 x 56.2 cm)
37.582

Moreover, in the case of this specific commission, the painting performed a twofold function: it conferred courtly status on Fetti through his appropriation of the style of Rubens, one of the most learned and successful court painters in Europe, and it confirmed the impressive power and taste of its patron, whose possession of the painting linked him to both Alfonso d'Este of Ferrara (the patron of Titian's painting), and his own Mantuan predecessor, Vincenzo Gonzaga (to whom Rubens was court painter).

Fetti is indeed best known for the paintings that he executed at the court in Mantua, where he lived from 1614 to 1622. Following his stay there, the artist spent the final two years of his life in Venice, where, through painterly brush strokes and the use of *impasto* (thick, textured deposits of paint upon the surface of the canvas), he sought to emulate and surpass the style of Titian and other Venetian masters. However, the Walters' painting indicates that Fetti's interest in Titian preceded his Venetian sojourn. Indeed, Fetti seems to have copied Titian's canvas directly, even repeating the artist's signature (TICIANVS. F.) on the Pharisee's shirt. The signature and the compositional similarities between the works are responsible for the erroneous attribution of the Walters' paint-ing to Titian, which was sustained until 1943.[3] Titian's canvas, which was executed for Duke Alfonso d'Este of Ferrara, was trans-ferred to Modena in 1598, where it would have been available for Fetti to study.[4] Although Fetti's painting obviously depends upon Titian's style and composition, the later artist distinguishes his hand from Titian's in the heavy drapery folds, looser brushwork, and use of even thicker *impasto*, all hallmarks of Rubens' style.

SP

Opposite page
FIG. 1 Titian, *Christ and the Tribute Money*, ca. 1518, oil on canvas. Dresden, Gemäldegalerie.

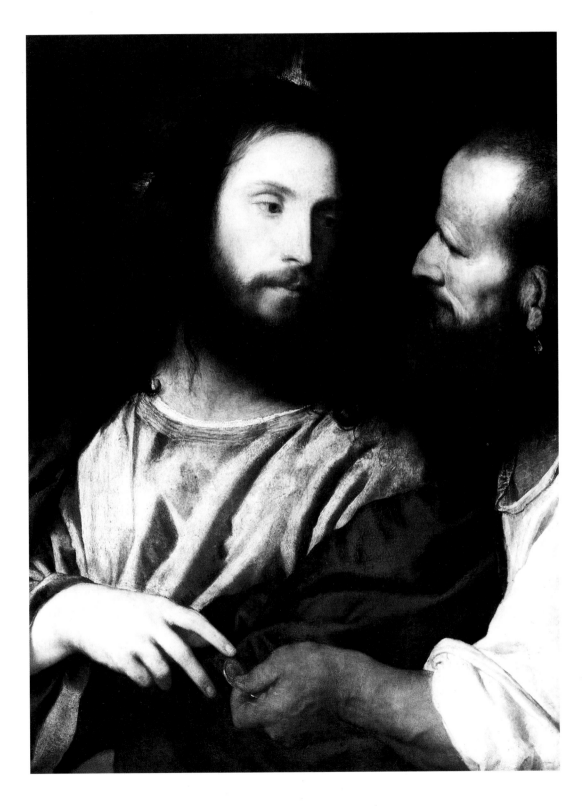

AGOSTINO TASSI, 1580–1644

Landscape with a Scene of Witchcraft, ca. 1620s–1644

AGOSTINO TASSI painted many enigmatic subjects that have proved difficult for the modern viewer to decipher. This mysterious scene centers around a figure, perhaps best labeled an "enchantress," surrounded by human bones, a torch, a mirror, a dog, and cabalistic writing. She loosely recalls witches from contemporary poetry without corresponding precisely to any of them and is thus a poetic invention by the painter. In contrast to this esoteric figure, the building recalls country villas owned by elite Roman families. The landscape, also meant to appeal to seventeenth-century viewers, evokes the pastoral retreats where such families would escape the urban summer heat. The figures shown in the loggia of the villa function in some sense as surrogates for the intended beholders of the painting. They watch the inhabitants of the countryside from a safe distance, and these urban elites are separated from their rustic counterparts by the pond; however, the group of four figures on the right also seems to be engaging in some sort of witchcraft.

Tassi's painting is typical of the new genre of landscape painting that was initiated by Annibale (1560–1609), Ludovico (1557–1602), and Agostino Carracci (1555–1619) and espoused by their followers, primarily Domenico Zampieri ("Domenichino," 1581–1641). The practice reached its apex in the works of French artists such as Nicolas Poussin (1594–1665) and Claude Lorrain (1600–82), who was, in fact, taught by Tassi. Though Tassi's role in the development of the emergent genre of landscape painting is significant, he is known primarily as a master of illusionistic architectural decorations in fresco, which he executed in Rome collaboratively with Orazio Gentileschi (1563–1639), Guercino (1591–1666), and Domenichino.

Although determining the precise date of the painting is problematic,[1] its attribution, which had been questioned in the past, is undeniable.[2] The sorceress clearly shows the influence of Domenichino, with whom Tassi worked at Palazzo Costaguti. The tree, which dominates the landscape, is almost identical to the one painted by Tassi in a fresco for the Salone del Ballo in the Palazzo Lancellotti.[3]

SP

PROVENANCE
Don Marcello Massarenti, Rome, by 1897;
Henry Walters, 1902

SELECTED BIBLIOGRAPHY
Zeri 1976, 2:447–48 (with earlier literature);
Pugliatti 1977, 127–28; Cavazzini 2002,
396–408

NOTES
1 Cavazzini 2002, 396. This is despite the wealth of archival material regarding the notorious painter's life; perhaps most well known are the documents relating to the trial of Tassi's rape of Artemesia Gentileschi, the most famous female painter of the seventeenth century.
2 See Zeri 1976, 2:447–48 and Pugliatti 1977, 127–28.
3 P. Cavazzini, *Palazzo Lancellotti ai Coronari: cantiere di Agostino Tassi* (Rome, 1998), 140.

Landscape with a Scene of Witchcraft, ca. 1620s–1644
Oil on canvas, 25 ⁹⁄₁₆ x 29 ¹⁵⁄₁₆ in. (65 x 76 cm)
37.541

GUIDO RENI, 1575–1642
The Penitent Magdalene, ca. 1635

THE PENITENT MAGDALENE demonstrates qualities that made Guido Reni one of the most influential painters in Rome and in his native city of Bologna for a quarter of a century and that made the subject such a favorite.

Mary from Magdala was Christ's devoted follower. She was beneath the cross on Calvary and was the first to whom the Risen Christ appeared. However, from earliest times, she was identified with the "woman who was a sinner" and who anointed Christ's feet in the house of Simon (Luke 7:37). According to a later legend, she was a prostitute before encountering Christ and spent her last years as a penitent hermit in a cave. Although this amplification is now rejected by the Catholic Church, it underlay the interpretation of the Magdalene in Reni's time.[4]

The decrees of the Council of Trent and other publications of the Catholic Reformation emphasized personal repentance, prompting particular reverence for hermit saints such as the Magdalene, Paul, and Jerome. Of these, the Magdalene was the most popular as a subject for art. She sinned in very human ways and, though honored for her spiritual purity, she could be portrayed as she was in the spiritual poetry of the day, as desirable, yet unavailable. Patrons, including the worldly cardinals who were the first owners of the Walters' *Magdalene*, could gaze at the creamy skin of her exposed neck and partially exposed breasts without apology. In writing of the passions generated by a *Magdalene* that Reni painted for a contemporary poet, the artist's friend and biographer Carlo Cesare Malvasia[5] notes that there was one cardinal who "was as jealous of that painting as he was enchanted" and that when he went to the poet's house "he always wanted to be seated opposite that beautiful Penitente, from which he never took his eyes, being almost carried away by such a divine concept."[6]

Reni's Magdalene is a beautiful, young blond woman who gazes toward heaven. She has been meditating on a human skull as a reminder of the brevity of human life and the vanity of caring about earthly pleasures. That she chose a life of deprivation and penance by living in a cave was sometimes shown explicitly (fig. 1) or more subtlety, as here, where a shaft of light filters through the cave's mouth and diffuses over the brown, uneven walls. With her left hand, she steadies a cross, the immediate subject of her thoughts. Reni clearly added the cross after the composition was completed as the Magdalene's mantle is visible

PROVENANCE
Possibly Cardinal Antonio Barberini, by 1671;[1] possibly Prince Maffeo Barberini, after 1672;[2] Cardinal Flavio Chigi, Rome, by 1692;[3] descended in the family until 1804; dealer Neville from sale, Christie's, London, 2 March 1804, lot no. 60; George, 7th Baron Kinnaird, Rossie Priory, Inchture, Perthshire, Scotland, d. 1805; by descent to Charles, 8th Baron Kinnaird, d. 1826; sale, Phillips, London, 21 May 1811, lot no. 5, unsold; sale, Sotheby's, London, 26 February 1812, lot no. 77, unsold; by descent to the 12th Baron Kinnaird; sale, Christie's, London, 21 June 1946, lot no. 31; private collection, Netherlands; sale, B. V. Notarishuis, Rotterdam, 26 February 1987, lot no. 75; Piero Corsini, Inc., New York, 1987; The Walters Art Museum, purchase through the W. Alton Jones Foundation Acquisition Fund and the Walters Acquisition Fund, 1987

SELECTED BIBLIOGRAPHY
Waagen 1857, 446; Zafran 1988a, 68–69; Zafran 1988b, 1–3; Pepper 1988, 339–40, no. 40; Guido Reni 1575–1642, 1988–89, Bologna no. 64, Los Angeles no. 52; Dempsey 1988, 106; Spear 1997, 163–64; Mormando, ed. 1999, 36–41

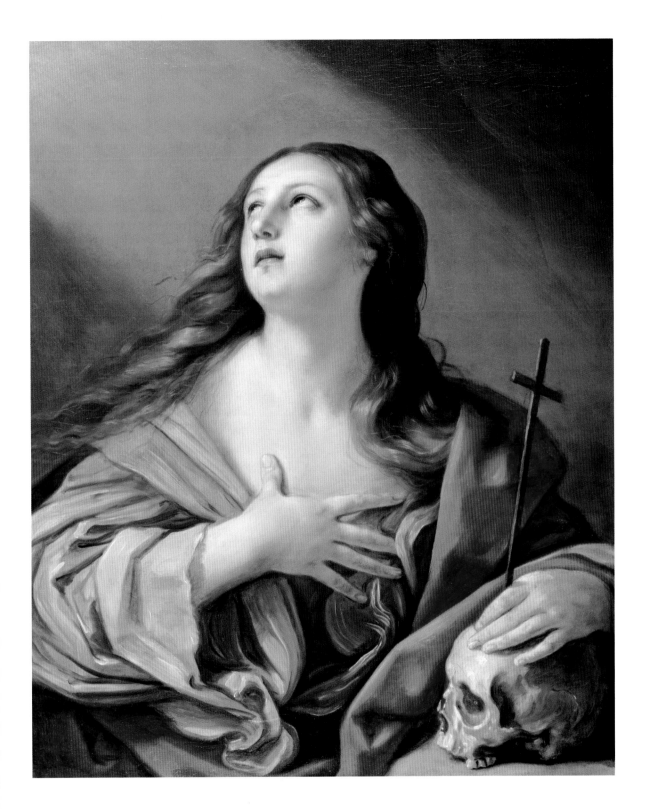

The Penitent Magdalene, ca. 1635
Oil on canvas, 35 ¾ x 29 ¼ in. (90.5 x 74 cm)
37.2631

PIETRO PAOLINI, ATTRIBUTED TO, 1603–81

Allegory of the Five Senses, ca. 1630

IN THE EARLY SEVENTEENTH CENTURY, a new kind of genre painting was developed in Rome, which soon spread throughout Italy and Europe. Painters filled their canvases with representations of men and women of the lower social layers. The new type of genre painting was collected for the galleries of noblemen and prelates and expressed the collectors' notions of social class. In this painting, the food placed on the plain, chipped wooden table, such as cheese and dark red wine, was then described as being fit only for the lowest ranks, as if even the digestive system of humans was determined by position in society.[1]

These genre paintings generally depicted half-length figures in frieze-like arrangements, primarily gathered around tables while drinking, playing music, or gambling. The represented spaces were illuminated by a single light source. The forceful chiaroscuro modeling applied in these works, which in the sixteenth century had been explored by Venetian painters like Leandro Bassano (cat. no. 32), was associated with the direct observation of nature.

This style of painting was derived from the works of Caravaggio (1571–1610), such as *The Calling of Saint Matthew* of 1600 (fig. 1). Caravaggio might never himself have executed secular subjects in this dark style, but a follower such as Bartolomeo Manfredi (1582–1622) soon popularized genre scenes painted in this way. *Allegory of the Five Senses* is a prime example of this style, attributed to the young Paolini, a painter from Lucca who in his youth studied in Rome before returning to settle in his hometown, where he founded the Accademia di pittura e disegno in 1640.[2] In this painting, Paolini pays homage to Caravaggio through quotations from his works. The old man holding his spectacles and the young soldier with the feathered hat are both based on characters at the table of the tax collector in Caravaggio's painting. The bared back of the drinking man and a centrally placed lute player imitate another famous work by Caravaggio, *The Musicians*, painted for Cardinal Vincenzo del Monte in Rome (fig. 2).

Despite its apparent realism, *Allegory of the Five Senses* is also a symbolic representation, with each of the figures acting out one of the senses: sound is the woman at center; taste is the drinker; smell, the young soldier; sight, the old man; and touch, the fighting couple. There is an element of irony in all of this. Emptying the

PROVENANCE
Philippe, duke of Orléans, d. 1723; Louis Philippe Joseph, duke of Orléans, Philippe Egalité, d. 1793, ; Orléans sale, Coxe, Burrell and Foster, London, 14 February 1800; Dr. Frank Lewarne, Cricklade, Wiltshire, by whom donated to Cricklade Town Hall, October 1945; private collection, London; sale, Sotheby's, London, 8 December 1993; Matthiesen Fine Art Ltd., London; The Walters Art Museum, with funds generously provided by the Ben and Zelda Cohen Foundation and the Alton Jones Acquisition Fund, 2003

SELECTED BIBLIOGRAPHY
Papi 1998, 26–35; Matthiesen Fine Art Ltd. 2001, 270–77; Ghia 2002, 192

NOTES
1 S. McTighe, "Foods and the Body in Italian Genre Paintings, about 1580: Campi, Passarotti, Carracci," *Art Bulletin* 86, no. 2 (June 2004): 301–23.
2 Matthiesen Fine Art Ltd. 2001, 270–77. As a young man Paolini studied in Rome. He is thought to have returned to his native city Lucca by 1629. P. Giusti, *Pietro Paolini pittore lucchese, 1603–1681* (Lucca, 1987); E. Struhal, "Pittura e poesia nel Seicento: il caso di Pietro Paolini," in *Lucca città d'arte e i suoi archivi: opere d'arte e testimonianze documentarie dal medioevo al Novecento*, eds. M. Seidel and R. Silva (Venice, 2001), 389–404. *Allegory of the Five Senses* cannot be identified with the painting that Joachim von Sandrart saw in Rome around 1630, as has previously been suggested. J. Costello, "The Twelve Pictures 'Ordered by Velasquez' and the Trial of Valguarnera," *Journal of the Warburg and Courtauld Institutes* 13, nos. 3–4 (July–December 1950): 251. When Paolini's painting was engraved for publication in the late eighteenth century, it was attributed erroneously to Valentin de Boulogne (1591–1632). L. F. Dubois de Saint Gelais, *Déscription des tableaux du Palais Royal* (Paris, 1727), 480–81. See also Papi 1998, 26–35.
3 The most elaborate criticism of Caravaggio is in Giovanni Pietro Bellori's 1672 *Le vite de' pittori, scultori e architetti moderni*. Seventeenth- and eighteenth-century sources on Caravaggio in English translation can be found in H. Hibbard, *Caravaggio* (London, 1983), 343–87.

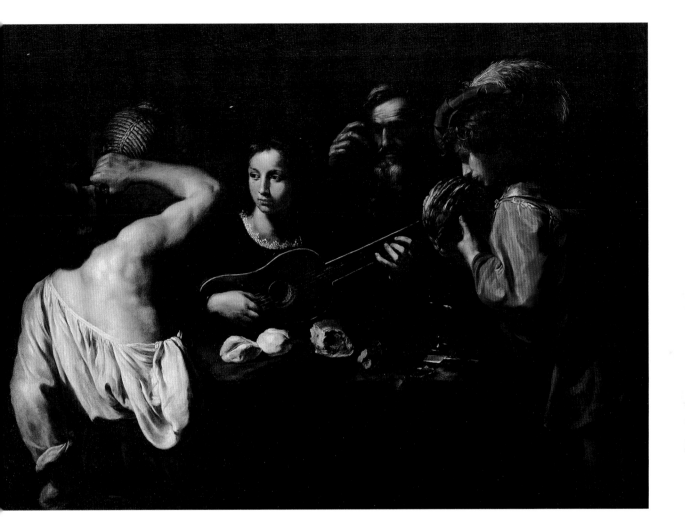

Allegory of the Five Senses, ca. 1630
Oil on canvas, 49 ¼ x 68 ⅛ in. (125 x 173 cm)
37.2768

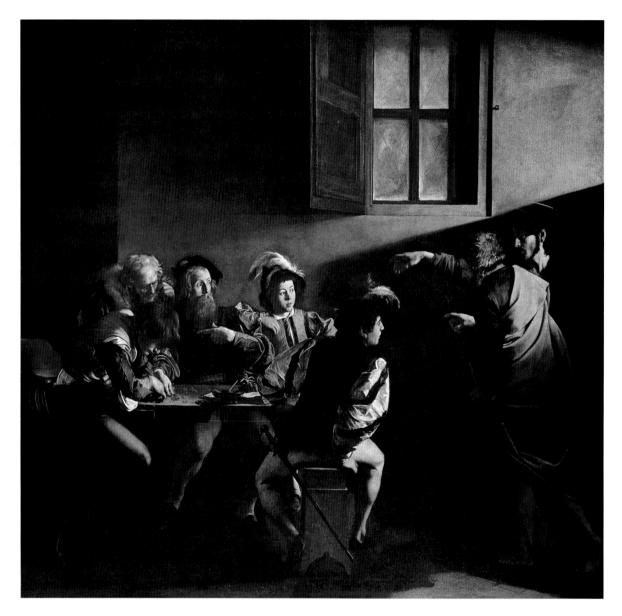

flask leads to drunkenness and the deadening of the senses. The drinking man is apparently oblivious to the fact that his shirt has come undone. The sight of the old man is distorted, and the scent of the melon is as ephemeral as the beauty of the young man himself. Touch, symbolized by a couple beating each other, speaks for itself. Considering the dubious company of the young woman, she is probably a courtesan, who uses the sense of sound to seduce her audience.

FIG. 1 Caravaggio, *The Calling of Saint Matthew*, 1599–1600, oil on canvas. Rome, Contarelli Chapel, San Luigi dei Francesi. Scala/Art Resource, NY.

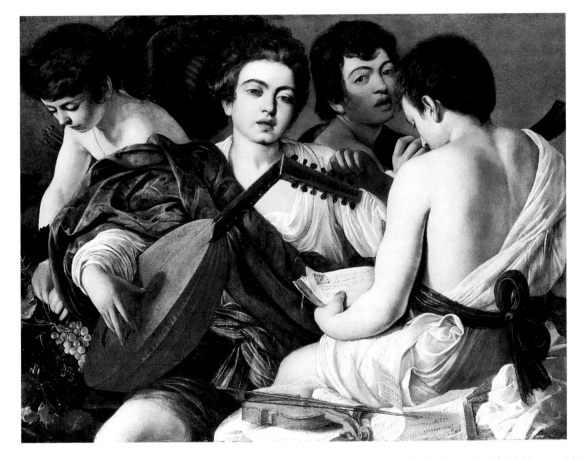

FIG. 2 Caravaggio, *The Musicians*, ca. 1595, oil on canvas. New York, The Metropolitan Museum of Art, 52.81.

Paolini's witty version of the senses takes on particular mean-ing when the Caravaggesque style of the painting is considered in relation to seventeenth-century writings on art. Caravaggio's dark style was immediately recognized for its radical novelty, but many found it objectionable because of its supposedly crude realism and lack of concern with beauty and decorum.[3] Critics thought his art only relied on the study of the model, in other words on the sense of sight in its most immediate and physical aspect. This was in contrast to the ideal of classical painting, based on the study of the most beautiful aspects of nature and art (ancient sculpture and Raphael, in particular), as practiced by Guido Reni (cat. no. 35). When seen in this light, this Caravaggesque depiction of the senses in their most bodily aspects takes on an ironic, polem-ical character.

MSH

129

BACICCIO (GIOVANNI BATTISTA GAULLI), 1639–1709
Portrait of a Man, ca. 1700

As is the case with so many portraits from the seventeenth century, we do not know the identity of the subject of this painting. On the basis of his embroidered uniform and long hair, however, it has been suggested that he is a Polish official, who was perhaps on a diplomatic visit to Rome when he was painted by the artist from Genoa.[1]

One of the artistic aims of the seventeenth century was to imbue portraits with a new sense of liveliness and spontaneity, in contrast to the more formal and mask-like portraits of the mannerists, as exemplified by the works of Sofonisba Anguissola and Lavinia Fontana (cat. nos. 28 and 30). Early sources describe how Baciccio used innovative methods to portray his models in order to achieve this goal. Rather than have his sitters quietly seated or standing, the artist allowed them to move their heads, speak, and laugh.[2] In that way, they would appear at their most pleasant and natural. This method was one that Baciccio learned from the great sculptor, architect, and painter Gian Lorenzo Bernini (1598–1680), with whom he had been affiliated in Rome since the early 1660s.

Here, Baciccio's sitter looks outward while addressing the painter/beholder with his hand, as if conversing. Speech was commonly depicted through such rhetorical gestures. If the identification of the sitter as a diplomat is correct, then the pose communicates this—indeed the Latin term for diplomat is *orator*.

The different textures in the painting are rendered with great skill, and the embroidery of the jacket almost sparkles when hit by the light. Among the most striking features to lend the portrait a sense of immediacy is the slight diagonal tilt of the body, balanced by the delicately posed hand. This is a kind of liberty that was not desirable for the portrayal of individuals of the highest social rank. In the fine workshop replica of the *Portrait of Pope Alexander VII* (fig. 1), for example, Baciccio has chosen the more traditional, static, and stately pyramidal compositional scheme for the half-length-figure portrait of the blessing Chigi pope, thereby imbuing the image of the pontiff with an entirely different expression.

MSH

PROVENANCE
Don Marcello Massarenti, Rome; Henry Walters, 1902

SELECTED BIBLIOGRAPHY
Zeri 1976, 2:451–52 (with earlier literature); Petrucci 1999, 100–101

NOTES
1 Zeri 1976, 2:451–52. A monograph on Baciccio in English is R. Enggass, *The Painting of Baciccio: Giovanni Battista Gaulli, 1639–1709* (University Park, Pennsylvania, 1964).
2 See Petrucci 1999, 89–102.

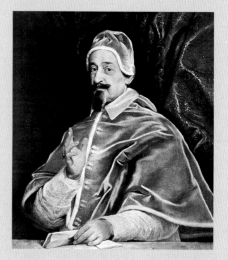

FIG. 1 Workshop of Giovanni Battista Gaulli, called Baciccio, *Portrait of Pope Alexander VII*, ca. 1667, oil on canvas. Baltimore, The Walters Art Museum, 37.598.

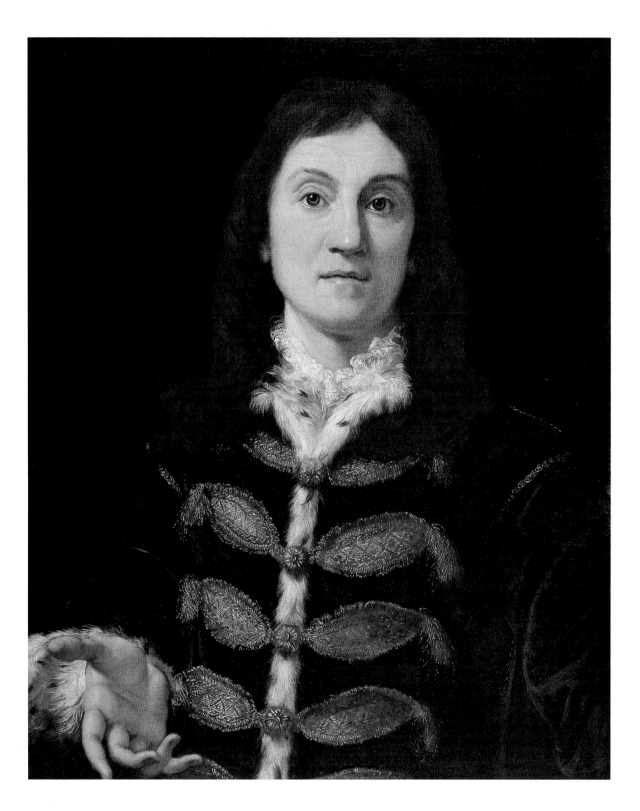

Portrait of a Man, ca. 1700
Oil on canvas, 35 ½ x 30 ³⁄₁₆ in. (90.1 x 76.7 cm)
37.1832

FRANCESCO FURINI, 1603–46

Saint Agatha, ca. 1635–45

THE LEGEND of the third-century Saint Agatha tells of a young Sicilian virgin who was pursued by a pagan consular official for her beauty and wealth. When she rejected him and the gods he worshiped, he submitted her to barbaric tortures that eventually killed her, including the cutting off of her breasts. The night after this torture, she was visited in prison by an angel and Saint Peter, who miraculously restored her breasts.

Saint Agatha is depicted as if in otherworldly meditation, a sense underlined by the fact that her face is turned slightly away from the viewer, a pose known as *profil perdu* (literally, "lost profile"). This makes her expression somewhat ambiguous and contributes to a sense of mystery.[1] A strong light illuminates her pale figure in the dark space, which recalls the divine intervention in the prison cell. This light echoes another version of the image of the saint in the Walters Art Museum by Alessandro Turchi (fig. 1). However, it is not a particular moment in the story of the saint that Furini has portrayed. The image, which most likely would have been displayed in a private home, is a timeless, devotional image intended to aid meditation and prayer.

Agatha holds a palm leaf, the triumphal attribute of martyr saints, and the pincers with which she was tortured. Her exposed breast also alludes to her sufferings. There is almost a tenderness in the way in which she holds the torture instrument to her chest, on which it throws a soft shadow. In the story of her martyrdom, as narrated in the much-read thirteenth-century *Golden Legend* by Jacobus da Voragine, Agatha knowingly welcomes her fate. When threatened with torture for refusing to worship the pagan gods, she responds: "These pains are my delight!... my soul cannot enter paradise unless you make the headsmen give my body harsh treatment."[2] Agatha believed that it was through her sufferings that she would meet the Lord.

Furini was one of the great masters of the Florentine baroque, and this painting is characteristic of his style: the pale, soft flesh that seems to radiate on a dark bluish background, a figural style that reveals his study of ancient marble statues, and a modeling with soft, transparent shadows.[3] Like other artists of his generation, Furini was rethinking the relationship between painting, perception, and the observation of nature. In so doing, he turned to the art and writings of Leonardo da Vinci (1452–1519), for whom painting had been a means of describing and understand-

PROVENANCE
Don Marcello Massarenti, Rome, by 1881;
Henry Walters, 1902

SELECTED BIBLIOGRAPHY
Zeri 1976 2:435 (with earlier literature)

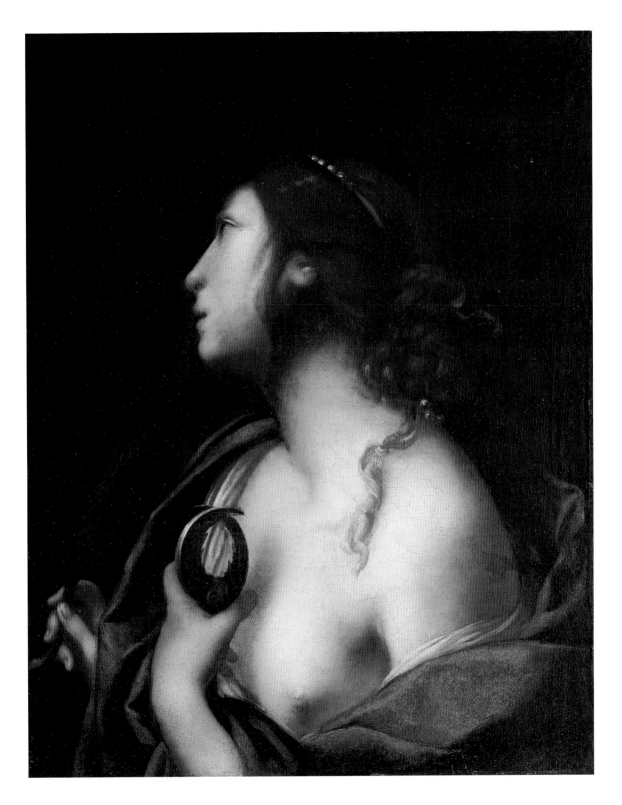

Saint Agatha, ca. 1635–45
Oil and tempera on canvas, 25 ¼ x 19 ¹³⁄₁₆ in. (64.2 x 50.3 cm)
37.1839

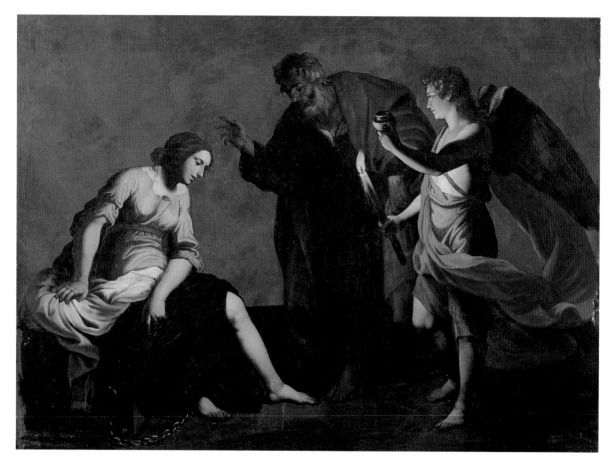

FIG. 1 Alessandro Turchi, called l'Orbetto, *Saint Agatha Attended by Saint Peter and an Angel in Prison*, ca. 1640–45, oil on slate. Baltimore, The Walters Art Museum. 37.552.

ing nature.[4] Based on his study of the human eye's perception of natural phenomena, Leonardo had invented the *sfumato* technique, in which light and shade are almost invisibly blended, and contours appear soft, as if seen through a slight atmospheric haze. The renowned artist was trained and had worked in Florence, but the city was only one among several places where he worked. Still, the citizens of Florence preferred to see him as a particularly Florentine painter.[5] Furini's artistic engagement with Leonardo was, therefore, also a way of demonstrating his pride in Tuscan artistic traditions.

To Furini, a seductive pictorial style was closely linked to the representation of feminine beauty. Consequently, the representation of women's bodies was a central aspect of his art, which troubled some of his contemporaries.[6] In Filippo Baldinucci's work on the history of Italian art, published in 1681, the Florentine author stated that the "more prudent and chaste were not pleased" by Furini's paintings for this reason. Indignation, however, is only one historically grounded response to Furini's work. To the artist (who by 1633 had become priest to the church of Sant'Ansano in the Mugello outside of Florence) and his patrons, Saint Agatha's desirability could also communicate spiritual love. With her parted lips and lifted gaze, Agatha's expression is almost ecstatic, as if she is consumed by her love of God, for which she gladly sacrificed her physical self. Such images of beautiful female saints in spiritual rapture constituted a type that had been perfected earlier by Guido Reni (cat. no. 35), whose works Furini greatly admired.

MSH

NOTES

1 A similar profile appears in the daughter on the right in *Lot and His Daughters* (Madrid, Museo del Prado). A red chalk drawing of a woman in profile has been identified as a study for the painting in Spain. Furini must also have used this study for *Saint Agatha. Lot and His Daughters* has been dated to around 1634. G. Cantelli, *Disegni di Francesco Furini e del suo ambiente*, Gabinetto Disegni e Stampe degli Uffizi, vol. 36 (Florence, 1972), 31, cat. 18 (9709 F). This type of profile also appears in *Lot and His Daughters* in the Museo Horne, Florence. For *Saint Agatha*, see Zeri 1976, 2:434–35.

2 J. de Voragine, *The Golden Legend: Readings on the Saints*, trans. W. G. Ryan (Princeton, 1993), 1:155.

3 Furini's study of ancient and modern sculpture is described in A. Barsanti, "Ancora sul Furini," *Paragone: Arte* 25, no. 293 (July 1974): 54–72.

4 Furini owned a copy of Leonardo's *Treatise on Painting*, which he illustrated; that copy is today in the Biblioteca Estense, Modena. For Leonardo's theories of the projection of light and shadow in the seventeenth century, see E. Cropper and C. Dempsey, *Nicolas Poussin: Friendship and the Love of Painting* (Princeton, 1996), 145–74. For Leonardo, see M. Kemp, *Leonardo da Vinci, the Marvelous Works of Nature and Man* (Cambridge, Massachusetts, 1981).

5 Leonardo's status as a Florentine artist and the instigator of the perfect modern style was set forth by Giorgio Vasari.

6 F. Baldinucci, *Notizie de' professori del disegno da Cimabue in qua*, Opere di Filippo Baldinucci, vol. 12 (Milan, 1812), 250.

Gothic cathedral. Many of De Nomé's Italian contemporaries imitated Raphael because of his graceful depiction of historical scenes (cat. no. 22). *Saint Paul Preaching*, Raphael's similar subject, designed for tapestries in the Sistine Chapel and engraved by Marcantonio Raimondi (ca. 1475–1534), has been evoked in the grouping of the figures and the architecture in the background (fig. 1).[2] However, all characteristics of Raphael's art have disappeared, and De Nomé's evocation of his famous predecessor seems like a parody of classicism and the reverent imitation of past art.

As alluded to in the inscription in the painting, when Paul was in Athens, he was "greatly distressed to see that the city was full of idols" (Acts 17:16). De Nomé has created a city consisting entirely of pagan and Jewish idols. Moses and David can be recognized below the angels of the Gothic façade of the synagogue, and a female goddess on the circular pagan temple perversely resembles the Virgin Mary (fig. 2). In De Nomé's art, the splendors of antiquity are closely linked to the demonic, and this ambiguity provided a source of fascination to his audience.

MSH

NOTES

1 Zeri 1976, 2:466–67. Marandel 2001, 13–14, 42–45. The artist was first mentioned in print in 1743 (De Dominici 1979). He was then referred to as Monsù Desiderio. On the basis of connoisseurship and documentary sources, scholars in the twentieth century discovered that two painters were covered by that name, De Nomé and Didier Barra, another painter from Metz active in Naples. R. Causa, "Francesco Nomé detto Monsù Desiderio," *Paragone* 7, no. 75 (March 1956): 30–46; *Enigma Monsù Desiderio: un fantastique architectural au XVIIe siècle*, exh. cat., Metz, Musées de la Cour d'Or, (Woippy, 2004). For Naples in the seventeenth century, see *Civiltà del Seicento a Napoli*, 2 vols., exh. cat., Naples, Museo di Capodimonte and Museo Pignatelli (Naples, 1984).
2 Nappi 1991, 76–77.

FIG. 2 Detail showing Moses and David on the façade of the synagogue and a female goddess resembling the Virgin Mary on the temple, from *Saint Paul Preaching to the Athenians*.

GIUSEPPE RECCO, 1634–95

Flowers by a Pond with Frogs, 1670s

A COMBINATION OF LANDSCAPE and still life, *Flowers by a Pond with Frogs* is an inventive departure from the decorative character of most seventeenth-century Italian still lifes.

Giuseppe Recco was the finest painter of still lifes in Naples during the second half of the century.[1] His subjects ranged from kitchen scenes to fish on a rocky shore, flowers, musical instruments, and plates of confections, sometimes in fanciful combinations.[2] Several of his paintings are signed, as is this one, and a few are dated (ranging from 1659 to 1691).[3] The artist was trained by his father Giacomo Recco (1603–53), a flower painter,[4] but he was more influenced by the paintings of Paolo Porpora[5] (1617–73) who had spent some time in Giacomo's shop. By 1654, Porpora had moved to Rome, where he perfected the *sottobosco*, underbrush or underwood painting, exemplified by his nocturnal *Still Life with Owl and Ibis*[6] (Paris, Musée du Louvre), after seeing similar paintings by the Netherlanders Otto Marseaus van Schriek (1619–78) and Matthias Withoos (1627–1703), who worked for Ferdinand II de' Medici.[7]

Recco offers the intense, intimate, ground-level view of a naturalist out in a field at first light, probing for specimens of plants, insects, and reptiles. However, this is not the record of a field trip—as a contemporary viewer would delight to recognize. The flowers clustered in the lee of this hill in an upland meadow are not sturdy wildflowers, but cultivated garden flowers with heavy blossoms. At the center are striped tulips. The frenzy of the Dutch tulip mania in the late 1630s, when a single bulb of this flower, recently imported from Turkey, might be exchanged for a farm had passed, but tulips were not for casual planting. Recco has applied the paint defining the blossoms, especially the white ones, in thick strokes, aiming at a voluptuous quality that points to familiarity with the still-life tradition in Lombardy that encompassed the young Caravaggio.[8] Although the dark pigments have deepened further over time, the original impact depended on the play of creamy pale petals against dark rock, set off by glistening beads of water on the slippery frogs at the pond's edge. Drawing on Porpora's dark, moist sensuality, Recco has created his own engaging invention.

JS

INSCRIPTION AND ANNOTATION
On lower right: "GIOS RECCO"; on the reverse: "GIOS RSCCO [sic] FIAMMEGO/G.M.R. No...."

PROVENANCE
Don Marcello Massarenti, Rome, by 1881; Henry Walters, 1902

SELECTED BIBLIOGRAPHY
Zeri 1976, 2:468 (with earlier literature); Spinosa 1984, fig. 610; Pirovano, ed. 1989, 2:906, 1092; *Tres siglos de oro de la pintura napolitana*, 2003–4, 68, under no. 22

NOTES
1 Middione in Pirovano, ed. 1989, 903–4; also, M. Gregori and J. G. von Hohenzollern, eds., *Natura morta italiana tra Cinquecento e Settecento*, exh. cat., Munich, Kunsthalle der Hypo-Kulturstiftung (Munich, 2002).
2 For a representative selection of his paintings, see those featured in Gregori and von Hohenzollern, eds. 2002, along with those in J. T. Spike, *Italian Still Life Paintings from Three Centuries*, exh. cat., New York, National Academy of Design, Tulsa, Philbrook Art Center, Dayton, Dayton Art Institute (New York, 1983).
3 Middione in Gregori and von Hohenzollern, eds. 2002, 474.
4 See *Vase of Flowers*, The Walters Art Museum (Zeri 1976, 2:467–68).
5 For Porpora, see Gregori and von Hohenzollern, eds. 2002, 192–94, 474.
6 R.F. 1969–1, oil on canvas, 74 x 100 cm.
7 M. Chiarini, *La natura morta a palazzo e in villa, Le collezioni dei Medici e dei Lorena*, exh. cat., Florence, Palazzo Pitti (Florence, 1998). "Fiammego" (Fleming) written by a later hand on the back of the Walters' painting referred to anyone from the Netherlands and may have been a nickname suggesting a debt to these Netherlanders.
8 Recco's biographer, De Dominici 1971, 292, wrote that his uncle took him to Milan before he was twenty. If Giovanni Battista Recco, who painted *Kitchen Interior* (Naples, Museo Nazionale di Capodimonte), ca. 1650, was his uncle, this is credible; his still lifes are very similar to those of the Milanese Evaristo Baschenis (see A. Bayer, ed., *Painters of Reality, the Legacy of Leonardo and Caravaggio in Lombardy*, exh. cat., New York Metropolitan Museum of Art (New York, 2004). Baschenis focused on musical instruments and also confections, which Giuseppe later incorporated into fanciful still lifes (in notes 2 and 3).

Flowers by a Pond with Frogs, 1670s
Oil on panel, 16 $^{7}/_{16}$ x 31 $^{7}/_{8}$ in. (41.7 x 81 cm)
37.1856

LUCA GIORDANO, 1632–1705
Ecce Homo, 1650s

AS TOLD IN THE GOSPEL of John, after the mocking of Christ, Pilate brought him before the people and said to them "'Behold I bring him forth to you, that ye may know that I find no fault in him.' Then came forth Christ, wearing the crown of thorns and the purple robe. And Pilate said unto them, 'Behold the Man' [*Ecce Homo*]" (John 19:4–6).

The Neapolitan painter Luca Giordano executed this New Testament subject together with a pendant showing Christ before Pilate (fig. 1).[1] In *Ecce Homo*, the figure of the humiliated Christ on the balcony, confronted with the hostile crowd, seems small and obscure. The three men shown as half-length figures and depicted with bright colors in the foreground are the main focus of the painting. One holds a pole that ends in a hammer, and a cross can be seen rising through the crowd as well. These attendants are not just calling for Christ's death on the cross but are ready to participate actively in his tortures.

The attending Jews are represented as strange and even grotesque. The costume of the man dressed in white and wearing a turban might be seen as representing ancient Eastern dress. The man with the feathered hat, however, does not conform to any known clothing of the time of Christ, and the man on the right with the goiter is wearing what seems to be a sixteenth-century costume. These features reveal the artist's study of northern prints, especially Albrecht Dürer's *Ecce Homo* (fig. 2), ca. 1498–99, from the famous *Large Passion* woodcut series.

PROVENANCE
Earl of Dudley, London, by 1871; sale, Christie's, London, 16 June 1900; Ichenhauser, Munich, by 1900; Henry Walters, before 1909

SELECTED BIBLIOGRAPHY
Zeri 1976, 2:473–74 (with earlier literature); Zafran 1988a, 70–71

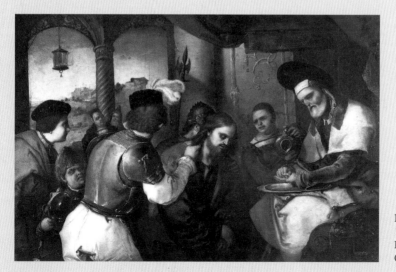

FIG. 1 Luca Giordano, *Christ before Pilate*, 1550s, oil on canvas. Philadelphia, The Philadelphia Museum of Art, The Johnson G. Johnson Collection, 249.

Ecce Homo, 1650s
Oil on panel, 17 ¾ x 27 ⁷⁄₁₆ in. (45.1 x 69.7 cm)
37.243

JUSEPE DE RIBERA, 1591–1652
Saint Paul the Hermit, ca. 1638

THIS AUSTERE REPRESENTATION of the hermit saint isolated against a dark background epitomizes the intense spirituality of the Catholic Church during the period of renewal (1560–1648) known today as the Counter-Reformation. Ribera has depicted the saint as an emaciated old man and has captured his emotions by representing him with watery eyes, parted lips, and hands clasped in prayer. Paul the Hermit was a third-century saint who escaped religious persecution by retreating to a cave in the Egyptian desert, where he lived until he was over a hundred years old.[1] Each day, God miraculously sustained him by sending a raven to provide him with a half loaf of bread.

Ribera emphasized the saint's astonishment at this daily occurrence by depicting him gazing in wonder at the bread borne by the raven in the upper left-hand corner. The saint turns from the stone platform, as if suddenly interrupted in his contemplation of the skull and book: instruments of his continual preparation for death. His loincloth of palm leaves testifies to his adherence to an ascetic life.

Although Ribera was born in Spain, he moved to Italy as a young man and was fully integrated into Italian artistic traditions. After working in northern Italy and Rome, he settled in Naples (then ruled by the Spanish crown) and soon became the preferred artist of the city's Spanish viceroys and Italian ecclesiastical patrons. Seventeenth-century writers particularly stressed Ribera's study of works by the controversial Italian painter Caravaggio (fig. 1).

Saint Paul the Hermit exemplifies Ribera's commitment to giving visual form to religious doctrine through Caravaggio's new, realist pictorial language. According to his eighteenth-century Spanish biographer, Antonio Palomino, Ribera adopted Caravaggio's novel method of painting (rather than drawing) after live models. Palomino explains that Ribera enjoyed "expressing horrifying and harsh things, such as the bodies of old men: dry, wrinkled, and lean, with gaunt and withered faces, everything done accurately after the model with extraordinary skill, vigor, and elegant technique."[2] Ribera specialized in elderly penitential saints and painted several images of Paul the Hermit (fig 2). In the Walters' version, Ribera's skill is evident through the varied brush strokes, which suggest the saint's enraptured state and impart a tactile quality to his naked body.

TT

PROVENANCE
Don Marcello Massarenti, Rome, by 1900;
Henry Walters, 1902

SELECTED BIBLIOGRAPHY
Danilova 1995, 233; Spinosa 2003, 233

NOTES
1 Jerome, "The Life of Saint Paul the Hermit," in *The Desert Fathers*, trans. with introduction by H. Waddell (Ann Arbor, 1957).
2 A. Palomino, *Lives of the Eminent Spanish Painters and Sculptors*, trans. N. Ayala Mallory (Cambridge, 1987), 123.

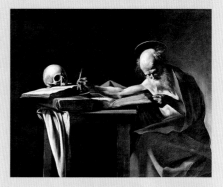

FIG. 1 Caravaggio, *Saint Jerome*, ca. 1605, oil on canvas. Rome, Galleria Borghese. Alinari/Art Resource, NY.

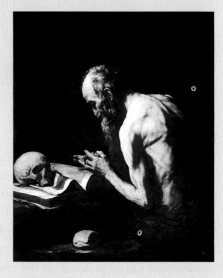

FIG. 2 Jusepe de Ribera, *Saint Paul the Hermit*, 1640, oil on canvas. Madrid, Museo del Prado, 1115.

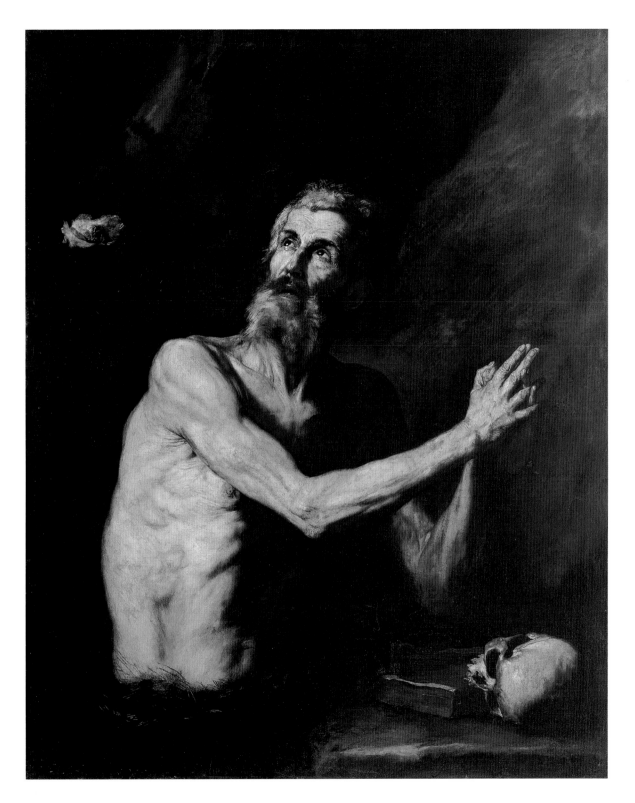

Saint Paul the Hermit, ca. 1638
Oil on canvas, 52 ¼ x 42 in. (132.7 x 106.7 cm)
37.278

BERNARDO STROZZI, 1581/82–1644
Adoration of the Shepherds, ca. 1615

THE *ADORATION OF THE SHEPHERDS* highlights the beliefs and heritage of Bernardo Strozzi, the most important Genoese painter of his time. In 1598, the young artist entered the Capuchin order, a reform branch of the Franciscans, dedicated to the vows of simplicity and poverty established by Francis of Assisi. After a decade of painting devotional images, Strozzi left the monastery to support his widowed mother and resumed his career, but he kept his commitment to Franciscan values.

The subject of the Adoration of the Shepherds derives from Franciscan teachings. Luke records the announcement of the birth of Christ to shepherds in the fields who then go to Bethlehem to find the baby, but he does not say that the shepherds actually worshiped Jesus. This interpretation was introduced by Saint Francis, who stressed that the glad news was first revealed to poor shepherds, signifying the importance of the poor in God's plan.[1]

Attention is on Christ, swaddled in Mary's veil, which foreshadows the shroud used to wrap the dead Christ. The ostentatiously crude basket underlines the humility of God being born as a human being. Joseph is hardly distinguished from the shepherds; however, Mary's central position, set off by the light shimmering behind her head and her hands crossed in homage, emphasizes her role as Mother of God and the embodiment of the Church. The prayers of the angel and the offering of the shepherd create models of response for the viewer.

The naturalistic elements, such as the shepherd's goiter,[2] combined with dazzling mannerist brushwork with blended colors are typical of Strozzi's style around 1615,[3] as is the repetition of motifs, such as the praying angel and the Madonna's face here and in the *Madonna of the Rosary* of ca. 1615 (fig. 1).[4] In the *Adoration*, the simplicity of the subject is complemented by compositional clarity. After the reforms of the Council of Trent (1545–63), numerous churchmen were critical of the artifice and ambiguity favored by many painters of religious subjects; in 1582, Gabriel Paleotti, archbishop of Milan, condemned religious paintings that were "so obscure and ambiguous that instead of illuminating,... they confound and distract the mind...to the detriment of devotion" and praised those that were "intelligible and plain to all."[5]

JS

PROVENANCE
Don Marcello Massarenti, Rome, by 1897 (noted in 1897 catalogue as Murillo); Henry Walters, 1902

SELECTED BIBLIOGRAPHY
Zeri 1976, 2:492–93 (with earlier literature); Zafran 1988a, 66–67; Gavazza et al., eds., 1995, no. 20; Mortari 1995, no. 156; Spicer, ed. 1995, no. 9; Lukehart in Spicer, ed. 1995, 6; Pallucchini 1993, 157; Krawietz 1996, 784

NOTES
1 See G. Schiller, *Iconography of Christian Art* (Greenwich, Connecticut, 1971), 1:58–88.
2 Such details suggest a familiarity with Italian genre paintings by Annibale Carracci or Vincenzo Campi.
3 The Walters' painting has been dated to: 1615–20 (Mortari 1995, 90); ca. 1616–19 (Dugoni in Gavazza et al., eds. 1995), under no. 20; ca. 1618 (Spicer, ed. 1995), under no. 9.
4 Gavazza et al., eds. 1995, no. 8.
5 G. Paleotti, *Discorso intorno alle imagini sacre e profane* (Bologna, 1582) in P. Barocchi, *Trattati d'arte del Cinquecento* (Bari, 1961), 2:408. For a short introduction, see J. Spicer, "Bernardo Strozzi and the Counter Reformation," in Spicer, ed. 1995.

FIG. 1 Bernardo Strozzi, *Madonna of the Rosary*, ca. 1615, oil on canvas. Framura, San Martino.

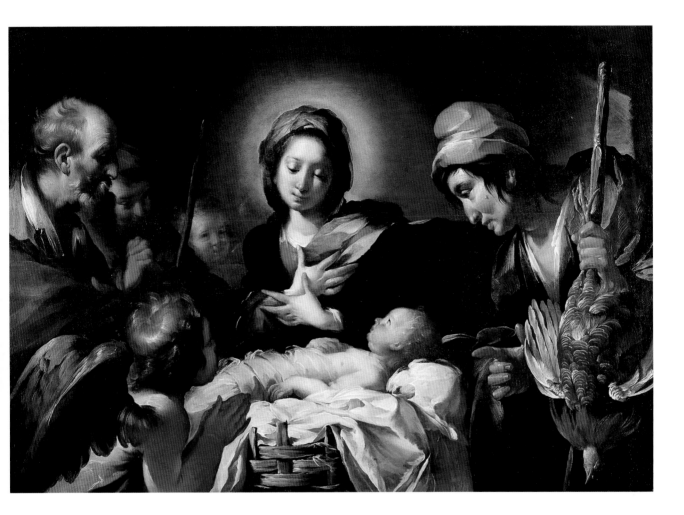

Adoration of the Shepherds, ca. 1615
Oil on canvas, 38 ½ x 54 ⅞ in. (97.8 x 139.4 cm)
37.277

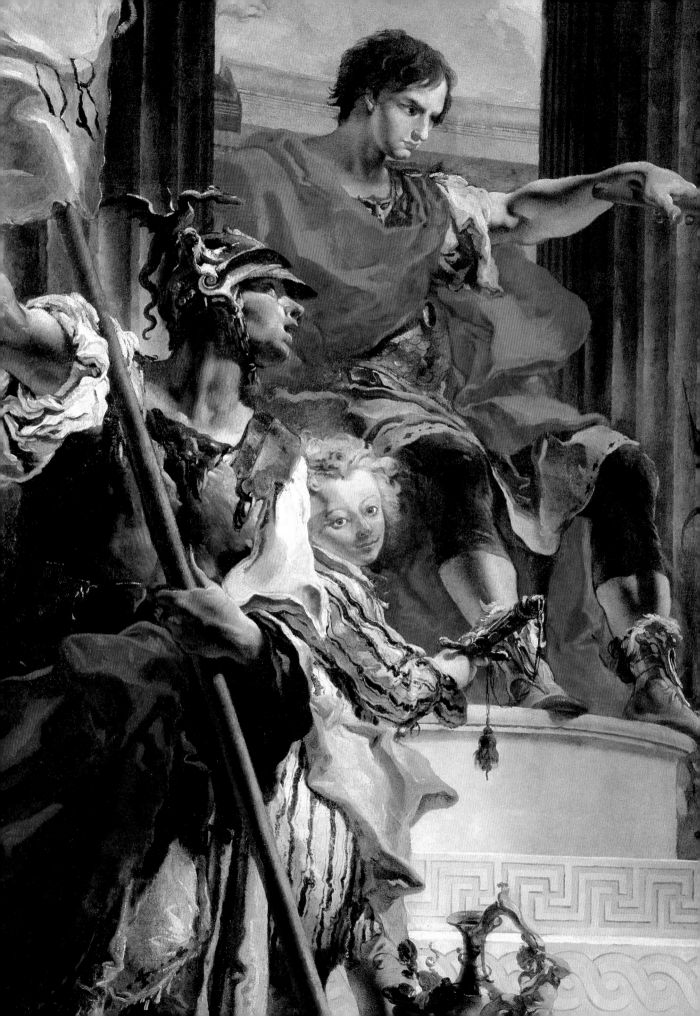

The Eighteenth Century

The baroque style in seventeenth-century Italy, with its dynamic and dramatic compositions and intense realism, was in the early eighteenth century gradually imbued with a different spirit of lightness and grace. In France, a new style had emerged, the rococo, which favored light color schemes, erotic subjects, and organic, assymetrical ornament with shapes that recalled both plants and shells. The influence of the French style was soon felt on the Italian peninsula, particularly in Venice.

Characteristic of the rococo was a fascination with the people and customs of the East, which was expressed by European artists in their use of exotic ornament. The paintings of the Venetian Giambattista Tiepolo, the greatest painter in eighteenth-century Italy, abound with people dressed in turbans and colorful silk robes (cat. no. 44). The objectification of foreign cultures served as a vehicle for the artist's ingenuity and inventiveness. The fame of Tiepolo's genius brought him princely commissions in Germany and Spain, where he decorated vast palace walls with compositions marked by an unprecedented lightness and occasional wit.

By mid-century, some painters reacted against the late baroque and rococo styles by abandoning the fluid, energetic brush strokes, dramatic chiaroscuro modeling, and flickering play of light. Under the influence of the German Johann Joachim Winckelmann (1717–68) in Rome, who was later labeled the "father of modern archaeology," painters turned to classical statues for the development of elegant styles that represented nature in its most noble and idealized form. The pictorial vocabulary of the neoclassical painters was characterized by clear outlines and compositions that placed emphasis on planes parallel to the painted surface as opposed to the dramatic diagonal movements so characteristic of baroque painting (cat. no. 47). Subjects from ancient history were perceived to convey moral examples and emblems of heroic virtue.

To educated Europeans in eighteenth-century Europe, Greek and Roman antiquity represented the origins of Western civilization. A journey to Italy became a standard part of the education of a gentleman, particularly one from the British Isles. This was the so-called Grand Tour, and it created a new audience for Italian painting. In the age before photography, these visitors often acquired topographical (though also idealized) views as souvenirs of their travels. Splendid, light-filled views or charming scenes with ruins from Venice and its surroundings were produced especially for a tourist audience (cat. no. 46), while painters in Rome (cat. no. 48) depicted the ancient ruins of the city in accordance with the burgeoning archaeological interests of the age. The neoclassical painter Pompeo Batoni received large sums for his portraits of visiting gentlemen pictured with props that alluded to their stay in the Eternal City (cat. no. 50). At a time when the political systems of many of the Italian states were in decline, Italy still thrived in the consciousness of the rest of Europe through its cultural riches and splendid artistic productions.

MSH

GIAMBATTISTA TIEPOLO, 1696–1770

Scipio Africanus Freeing Massiva, 1719–21

AMONG THE GLORIES of eighteenth-century Venice are the monumental wall and ceiling paintings that Giambattista Tiepolo executed for the palaces of the city's patrician class. This imposing canvas with its inventively orchestrated narrative is recognized as pivotal[1] in understanding Tiepolo's mastery of this genre when in his twenties and just beginning to receive commissions from the city's powerful families.[2] The heritage of Veronese (cat. no. 31), whose rethinking of the possibilities of wall painting for the private residence, especially his use of architecture suggestive of Roman power and magnificence to stage his stately dramas, influenced Tiepolo throughout his career.[3]

Here, the young Roman general P. Cornelius Scipio (called Africanus after his victories in Africa) frees Massiva, nephew of Massinissa, a chieftain of eastern Numidia (in present-day Algeria).[4] The moment is described by the Roman historian Livy in his chronicle of Rome's struggles with its ancient rival Carthage,[5] settled by Phoenicians on the coast of present-day Tunisia. In 209 B.C., Scipio, only twenty-six but already renowned for his tactical skills and his humanity, campaigned against the Carthaginian general Hasdrubal (brother of the famed Hannibal) in Spain, where Rome hoped to end Carthaginian control. At the battle of Baecula, Scipio's soldiers defeated the Carthaginian forces, capturing troops from Spanish tribes allied with Carthage as well as "Africans" (i.e., Carthaginians and their North African allies). He ordered the Spaniards to be freed, in order to keep them as potential friends of Rome, but gave orders to sell the Africans. Word came that among the latter was a boy of unusual stature and beauty who was of royal blood. When brought before Scipio, the youth identified himself as Massiva, nephew of Massinissa, a Numidian chieftain allied to Carthage. Wanting to show his mettle, he disobeyed his uncle's orders to stay in camp. A stern-faced Scipio here chastises the youth (who turns away in humiliation) before ordering that he be freed and sent back to his uncle with presents.[6] The impression that this magnanimity made on Massinissa contributed to his decision, after Scipio landed in Africa in 204 B.C., to put his forces under Scipio's command, making possible Rome's eventual victory.

That the judgment conveyed by the extended military baton of the stern young man in gilded armor on the elevated seat of authority represents the Roman state is suggested by the architec-

PROVENANCE

Don Marcello Massarenti, Rome, before 1897; Henry Walters, 1902

SELECTED BIBLIOGRAPHY

Zeri 1976, 2:559–60 (with earlier literature); Knox 1979, 419; Gemin and Pedrocco 1993, 19, 127, no, 28; Gordon 1993, 4–5; Knox 1996; Lucy 1996, 4–5; Christiansen, ed. 1996, no. 4; Pedrocco 2002, 29–30, no. 25

NOTES

1 Christiansen, ed. 1996, under no. 4. This entry provided a touchstone for many issues.
2 Pedrocco 2002, 23–39. He also worked on church commissions and small devotional works, as the Walters' *Madonna and Child* (Zeri 1976, 2:558–59; Pedrocco 2002, no. 34).
3 Christiansen posited (ed. 1996, under no. 4; also Pedrocco 2002, 30) that, although Veronese's *Christ Among the Doctors* (Madrid, Museo del Prado [T. Pignatti and F. Pedrocco, *Veronese* (Milan, 1995), no. 87]) was taken to Spain before 1700, similarities in the use of architecture indicate that it was Tiepolo's source, if only through a copy. Given both artists' ingenuity with architecture, insistence on a specific source seems unnecessary. As Christiansen suggests, the "balletic attitudes" of figures in the Walters' painting reflect an appreciation of Tintoretto.
4 Previous proposals: the Numidian king Jugurtha before Sulla, 104 B.C. (Valerius Maximus, *Factorum et dictorum memorabilium*, 6.9) or the Numidian king Syphax before Scipio, 203 B.C. (Livy [30.13]). Knox (1996) proposed the current title, accepted with qualifications by Christiansen and Pedrocco.
5 Titus Livius, *Ab urbe condita libri*... (*The History of Rome*, ca. A.D.10; see F. G. Moore, ed., *Livy* [Cambridge, Massachusetts, 1963]), book 27.19. Livy has Scipio explain his magnanimity in a speech the previous year: Romans prefer "to bind men by favor rather than by fear, and to keep foreign nations linked by loyalty and alliance, rather than reduced to a harsh slavery" (26.49.8–9). Scipio manifests the best of Roman character; it is this "character" that Livy wants readers to take as a model.
6 Livy writes that Massiva wept "tears of joy." Such a failure of manly decorum would be unthinkable in Tiepolo's heroic universe, even for a youth or a non-Roman. We see the moment *before* the youth is freed.
7 In the x-ray, it looks as if he was first conceived as shorter.
8 Christiansen, ed. 1996, under no. 4.
9 One of the subjects appears to be the same

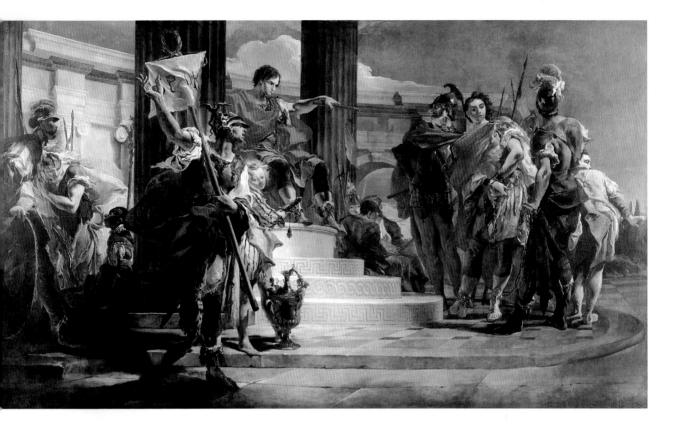

Scipio Africanus Freeing Massiva, 1719–21
Oil on canvas, 110 x 192 in. (279 x 488 cm)
37.657

ture, but made explicit by the standard bearing the abbreviation S.P.Q.R. (Senate and People of Rome). The strapping youth in gilded armor and manacles,[7] attended by an officer and a jailor, is Massiva (fig. 1). Tiepolo had ample opportunity to see North Africans in Venice, a crossroads for European trade with all the Mediterranean, but he represents Massiva as a European—the convention for depictions of North Africans as well as biblical figures from the Near East. That the black African boy seated behind the column is in casual conversation with the lounging soldiers indicates that he is not a captive but Scipio's servant.[8]

The subject is rare and possibly unprecedented. While the subject matter of private commissions does not need to be as easily understood as those for public spaces, they would need to be comprehensible to the owner's guests. It is likely that *Scipio Africanus Freeing Massiva* was part of an ensemble of paintings with better-known subjects that addressed the same theme, possibly the Magnanimity of Scipio. Tiepolo treated the subject of the Walters' painting again around 1731 in a series for the Palazzo Dugnani[9] in Milan on this overarching theme that also included the "the continence of Scipio," in which the general declines to accept the war booty awarded to him—a young, recently betrothed noblewoman—and "the death of Sophonisba," in which Scipio arranges for the Carthaginian wife of the defeated Numidian king Syphax to be offered the opportunity to take poison rather than be sent to Rome as a slave.

The original placement of the Walters' painting is unknown. It and its companion(s) may have been among the unidentified paintings executed by Tiepolo around 1720 for Giovanni Corner, whose family claimed descent from that of Scipio.[10] A series on the character and statecraft of such a forebear would be appropriate.

The paint surface has suffered extensive damage, but a thorough treatment in 1996 restored the impression of bravura brushwork that initially characterized the execution.[11] In contrast, in passages such as Scipio's arm (fig. 2), x-rays reveal the firmly modeled armature in white lead upon which Tiepolo built his composition.[12] A major change introduced after Tiepolo produced an oil study (Marinotti collection, Milan)[13] for the unknown patron was the elimination of reclining figures in the lower right, opening up the composition to accommodate viewers approaching from that direction.

JS

as that of the Walters' painting, and Knox has identified that image among the Dugnani frescoes as "Scipio Freeing Massiva" (Knox 1996), for which see also Christiansen, ed. 1996, no. 4; Pedrocco 2002, no. 72/3, keeps the old identification "Scipio Freeing Syphax."

10 Knox 1996. The existence of an earlier series by various painters including "Syphax before Scipio" at Ca' Corner eliminates that subject for a second series. The Walters' painting may also be that called "Syphax before Scipio" by Tiepolo in a 1760 description of the Palazzo Gaifami, Brescia (Christiansen, ed. 1996, no. 4, n. 7).

11 This immense work was carried out under the direction of Eric Gordon, Head of Paintings Conservation at the Walters. Its completion occasioned an exhibition co-curated by Joaneath Spicer and Eric Gordon.

12 X-rays reflect the paintings' damaged state; however, other small changes are legible, such as the elevation of the steps and Massiva's head (initially lower).

13 Pedrocco 2002, no. 25a.

FIG. 2 X-ray showing Scipio's arm.

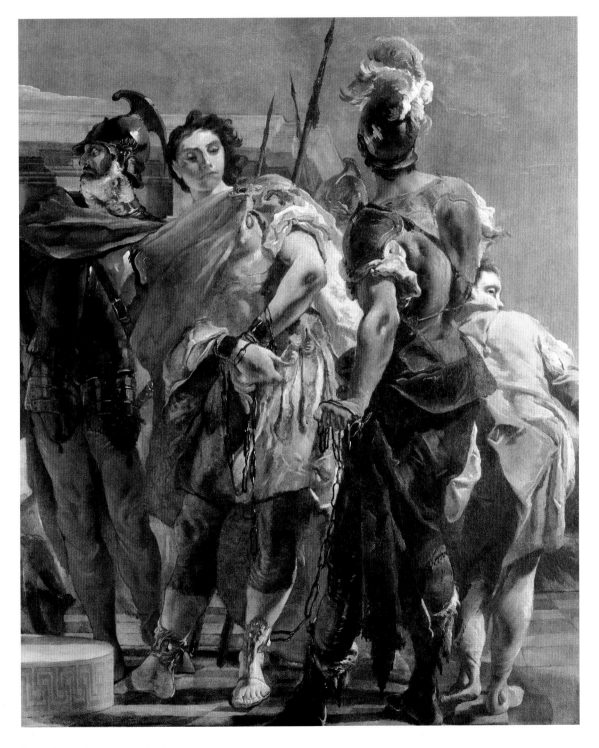

FIG. 1 Detail showing Massiva in chains.

PIETRO LONGHI, 1702–85
The Music Lesson, ca. 1760

THE CHARM of Pietro Longhi's genre scenes is abundantly registered in this painting,[1] which is one of only two known works by the master done on copper. The subject pokes sly fun at the romantic indiscretions of an upper-middle-class Venetian woman, who is obviously receiving a bit more than just music lessons from her attentive teacher. He leans towards her, pressing her hand meaningfully, stealing a moment of intimacy while the servants are momentarily distracted. With characteristic wit, Longhi includes a caged parrot and a lap dog, two not so subtle allusions to feminine virtue and fidelity, both of which are evidently being tested. The richly described interior is quintessentially Venetian, and would have delighted Longhi's audience with its realistic detail.

That this smallish painting could have once been identified as eighteenth-century French is in fact reconcilable with Longhi's probable artistic evolution. Although his manner of painting is unmistakably Venetian in palette and technique, Longhi's subject matter and gracious figural style are without question in part the result of his familiarity with the art of French rococo artists Antoine Watteau (1684–1721) and Nicolas Lancret (1690–1743), if only through prints. It is also quite likely that Longhi would have known William Hogarth's (1697–1764) crueler satires of middle-class and aristocratic society, which would have been equally accessible through the portable medium of the print. However, Longhi's distinct paint application and gentle humor set him apart from his rococo counterparts in France and England. His figures are more overtly caricatures; rather closer to Francisco Goya's (1746–1828), at times, puppet-like players than to Watteau's elegant figures. Longhi's broad brushwork and atmospheric use of light and shadow are characteristic of his native Venetian tradition. The artist's genius lies in his novel and highly original adaptation of rococo scenes of refined leisure activities, made his own through an unerring eye for specifically Venetian décor, fashion, and social behavior.

EK

PROVENANCE
Henry Walters, before 1909 (described in Walters catalogues as "*Voltaire chez la Princesse de Condé*, French school, eighteenth century"; published as Longhi by Zeri in 1966)

SELECTED BIBLIOGRAPHY
Pignatti 1974, no. 150; Zeri 1976, 2:564 (with earlier literature); Spike 1986, cat. no. 45; Zafran 1988a, 78–79; Mariuz, Pavanello, and Romanelli, eds. 1993

NOTES
1 Date of work assigned according to Terisio Pignatti, see Pignatti 1974, no. 150.

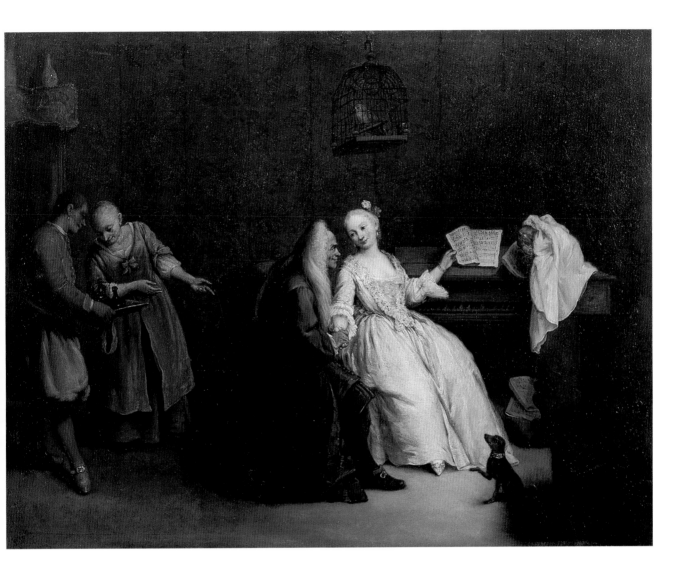

The Music Lesson, ca. 1760
Oil on copper, 17 9/16 x 22 11/16 in. (44.6 x 57.6 cm)
37.397

FRANCESCO GUARDI, 1712–93
A Venetian Courtyard, ca. 1770s

DURING THE EIGHTEENTH CENTURY, a new type of pictorial subject was cultivated: the view. The extent to which this genre was explored by painters in Italy can be understood in connection with the Grand Tour. This phenomenon, which generally comprised an extended sojourn to the Italian cities of Rome, Florence, and Venice, flourished during this period. Travel to Italy became a normative part of the cultural education of a European gentleman. These visitors, including many from the British Isles, often acquired works of art, and view paintings were popular as souvenirs. Guardi and Antonio Canaletto (1697–1768), who perhaps was his mentor, depicted scenes of their native Venice.[1]

Guardi explored unexpected angles that gave the Adriatic city a fantastic character. He also painted *capricci*, imaginary poetic scenes, and even when representing actual architecture, the suggestive and allusive aspects of the subjects are emphasized.[2] Guardi favored depictions of ruins. In this image of the interior of a courtyard, the focus is on the beauty of the tonal variations of the shaded, decaying walls, portrayed with thin, translucent layers of oil paint. Black lines define architectural structure, such as the grid pattern of the pavement. This technique has a graphic quality that resembles pen drawings and calls attention to the virtuosity of the artist's handling of the brush.

A variety of mundane activities are played out in the courtyard, such as the men walking up the stairs dressed in capes and the woman washing linens at the well in the foreground, approached by a curious but not too energetic dog. When the painting is viewed from a distance, the figures capture perfectly gestures and attitudes, but, upon closer scrutiny, they almost dissolve into blotches of paint. The way of painting with stains (*macchie* in Italian) had been an integral part of Venetian painting since the sixteenth century, and Guardi's technique placed him in a distinctly Venetian tradition that favored the visible painterly mark of the brush.[3]

The majority of the figures are shown with their backs to the viewer (a persistent feature in Guardi's work). Placed within the scenic space of the courtyard, which is itself the "backside" of the building, they lend the image an unexpected stage-like and almost mysterious element.

MSH

PROVENANCE
Don Marcello Massarenti, Rome, by 1897; Henry Walters, 1902

SELECTED BIBLIOGRAPHY
Zeri 1976, 2:567–68 (with earlier literature)

NOTES
1 This painting did not figure in the literature before it was published in Zeri 1976, 2:567–68. Recent works on the Grand Tour include *Grand Tour: The Lure of Italy in the Eighteenth Century*, eds. A. Wilton and I. Bignamini, exh. cat., London, Tate Gallery (London, 1996); J. Black, *Italy and the Grand Tour* (New Haven and London, 2003).
2 M. Levey, *Painting in XVIII Century Venice* (Garden City, New Jersey, and New York, 1959), 96. See also M. Merling, "The Guardi Brothers," in *The Glory of Venice*, eds. J. Martineau and A. Robison, exh. cat., London, Royal Academy of Arts; Washington, D.C., National Gallery of Art (New Haven and London, 1994), 293–327.
3 For the history of the painterly mark in Venetian art, see Ph. Sohm, *Pittoresco: Marco Boschini, His Critics, and Their Critiques of Painterly Brushwork in Seventeenth- and Eighteenth-Century Italy* (Cambridge, 1991).

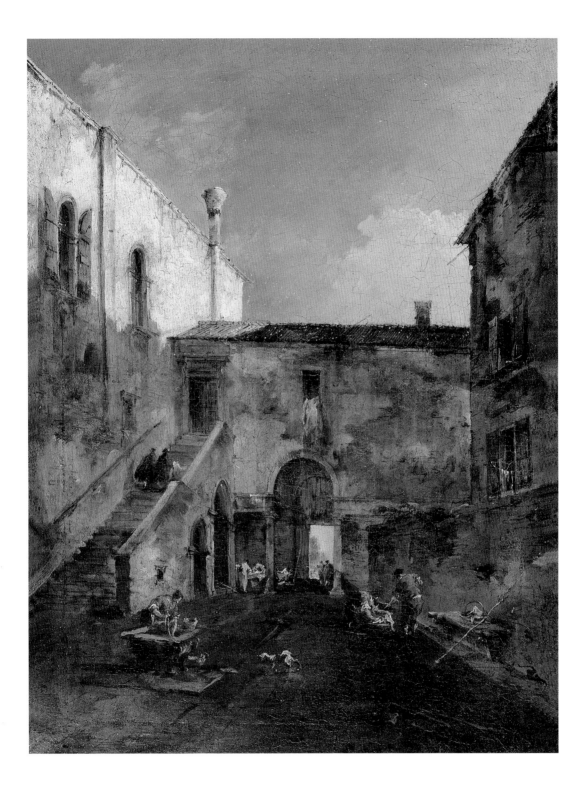

A Venetian Courtyard, ca. 1770s
Oil on canvas, 21 ³⁄₈ x 16 in. (54.4 x 40.7 cm)
37.607

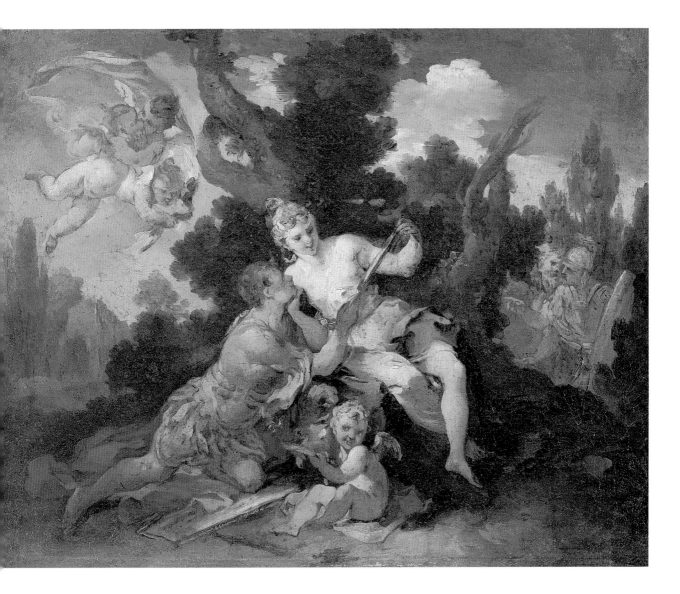

Rinaldo and Armida, ca. 1720–50
Oil on canvas, 14 ⅝ x 19 ⁹⁄₁₆ in. (37.2 x 49.7 cm)
37.879

GIOVANNI PAOLO PANINI, 1691–1765

View of the Roman Forum and View of the Colosseum, 1747

IN THE EIGHTEENTH CENTURY, Panini was one of the most avidly collected artists in Europe. A specialist of *vedute* (literally, "view" paintings), he brought lively brushwork and anecdotal detail to his depictions of the famous historical sites of Rome. This pendant pair is typical of his work in this genre. The subjects were the focus of multiple variations, most likely repeated by the artist and/or his studio to satisfy market demand.[1] In one view, we are shown a view of the Roman forum that is very close to the actual topography of the site during the mid-eighteenth century (an example of what were termed *vedute prese del luogo*, literally, "views taken on the spot"). At this time, the area around the forum was referred to as the Campo Vaccino (literally, "cow field"). Excavation had not yet begun, and it was still used for the grazing of cattle, some of which Panini shows ambling about in the middle distance (fig. 1). For added piquancy, an array of people dots the landscape, including local peasants and well-heeled tourists. As Richard Wunder points out in his extended analysis of the Walters' pictures,[2] the perspectival accuracy of this landscape may be in part the result of the artist's use of the camera obscura (a portable device that generated an upside-down image of a view that could then be traced as a drawing aid), a common practice in the eighteenth century.

In its pendant, we are treated to the artist's virtuoso improvisation on the Roman landscape (an example of the *vedute ideate*, literally, "ideal views"), with the familiar silhouette of the great Colosseum and nearby Arch of Constantine as the predominant motifs. Although individual monuments are recognizable,[3] the artist has deftly rearranged and combined known elements to create a happy compositional invention. For example, he includes the great Borghese Vase at the lower left (fig. 2), now preserved in the Louvre, and one of the most admired works of ancient art in eighteenth-century Rome. The great structure of the Colosseum is actually presented as it would appear if spun around 180 degrees, so that its more complete aspect may be enjoyed in conjunction with the Arch of Constantine. The compositional pairing thus demonstrates both the artist's ability to transcribe nature with convincing verve, as well as his ability to invent the world anew through the sheer power of his imagination.

Panini was extremely popular among the international clientele of the Grand Tour, particularly the British. In fact, the Walters' paintings were commissioned by William Drake (1723–96), an

INSCRIPTION

On *View of the Roman Forum*: on the block of stone at lower left corner: "I.P. PANINI ROMAE/1747"

On the *View of the Colosseum*: on the block of marble at lower left corner: "I.P. PANINI ROMAE/1747"

PROVENANCE

Tyrwhitt-Drake, Shardeloes, Amersham, Buckinghamshire; Agnew, London; The Walters Art Museum, acquired from David Koetser, London and New York, 1954

SELECTED BIBLIOGRAPHY

Wunder 1958, 161–64; Zeri 1976, 2:520–23 (with earlier literature)

NOTES

1 Related versions include the pair of paintings at the Detroit Institute of Arts, signed and dated 1735; another, smaller pair, signed and dated 1740 at the National Gallery of Ireland; and an unsigned and undated pair now preserved at the Palais des Papes in Avignon.

2 R. P. Wunder, "Two Roman Vedute by Panini in the Walters Art Gallery," *Journal of the Walters Art Gallery* 17 (1954): 12.

3 These include from left to right if only in fragmentary form, the Arch of Septimius Severus, the Temple of Antoninus and Faustina, the Basilica of Maxentius and Constantine, the Colosseum, the Arch of Titus, the Temple of Castor and Pollux, and the Temple of Saturn. For a more complete accounting of the featured monuments, see Wunder 1954, 12.

4 Another painting by Panini, *Interior of the Pantheon, Rome*, also dated 1747, now in the Cleveland Museum of Art, may have been a third commission by Drake.

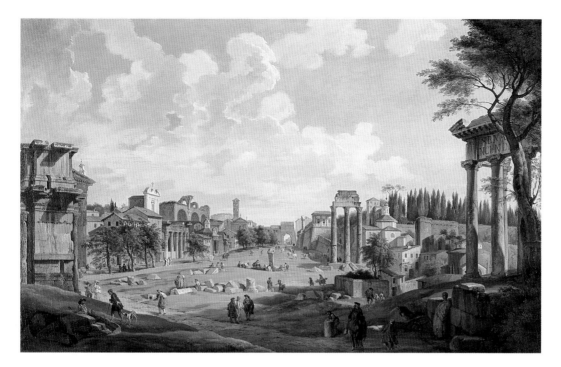

View of the Roman Forum, 1747
Oil on canvas, 32 ¼ x 52 ⁹⁄₁₆ in. (81.9 x 133.5 cm)
37.2366

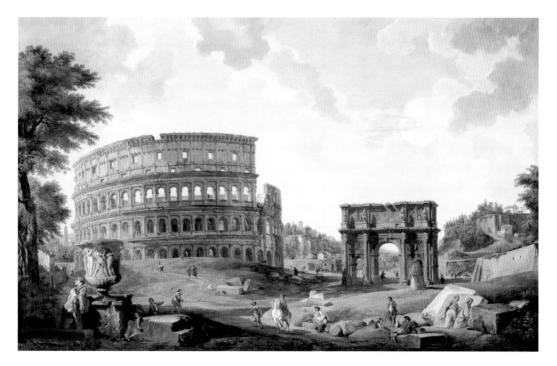

View of the Colosseum, 1747
Oil on canvas, 32 ¼ x 52 ⁷⁄₁₆ in. (81.9 x 133.2 cm)
37.2367

Englishman who visited the Eternal City in 1743. He most likely intended them for the renovation of his family estate, Shardeloes, which he began in 1747.[4] Like Panini's wildly popular gallery interiors stacked from floor to ceiling with paintings of the most famous sites of Rome, such pendant pairs of landscapes functioned as the perfect souvenir. Their composite nature allowed the Drakes to have an idealized visual record of the familiar monuments they experienced in Rome, seen in the drenching Mediterranean sunlight so alien to their native land. As in the landscapes of the Frenchman Hubert Robert (1733–1808), on whom Panini exerted an obvious influence, we find here the flowing brushwork and tonal warmth that so delighted connoisseurs throughout Europe. The added layer of interest provided by Panini's figures is a feature also adapted by another Frenchman, Claude-Joseph Vernet (1714–89), whose Italian landscapes were frequently collected by Panini's British patrons.

EK

FIG. 1 Detail of cattle grazing from *View of the Roman Forum.*

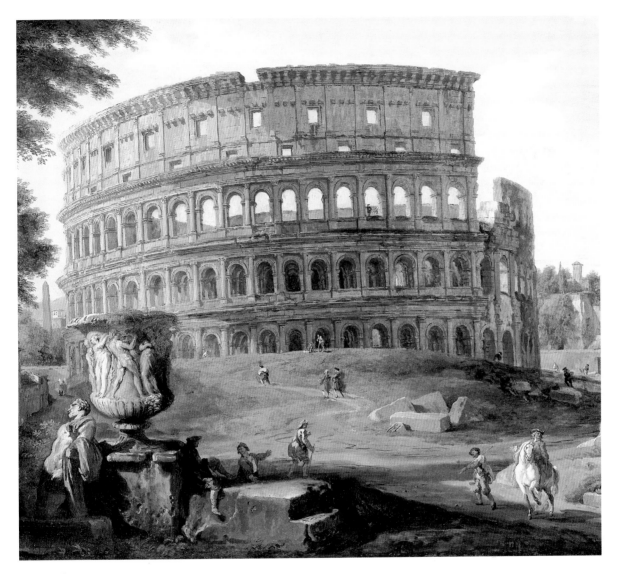

FIG. 2 Detail of the Borghese Vase from *View of the Colosseum*.

DOMENICO CORVI, 1721–1803

Allegory of Painting, 1764

DIPPING HER BRUSH on to the palette, the allegorical figure of painting (*pittura*, a feminine noun in Italian) is seated in an ornate chair. A cupid holds up an octagonal mirror for her contemplation: she must be in the act of painting a self-portrait. Dressed in robes in the ancient style, she is not a historical person but a timeless allegory. On top of her head, the lower part of a mask is visible, tied to her with a golden chain. The chained mask was described as a symbol of imitation in Cesare Ripa's 1593 book of emblems, which appeared in many later editions and was consulted by artists and art lovers alike.[1] By having the figure look into the mirror and paint her own likeness, Corvi suggests that painting is essentially an art of imitation that depicts nature in its most beautiful aspect. Her raised brow and the serene light that illuminates her pale face and chest indicate that painting is no mere craft but an inspired, noble art.[2]

Corvi, who executed this painting for the royal household of Turin, belonged to the first generation of neoclassical painters in Italy. Like his friend Anton Raphael Mengs (1728–79), an acquaintance of Johann Joachim Winckelmann (see p. 151), Corvi desired to return painting to the ideals of beauty espoused in classical antiquity. As very little ancient painting survived, these artists studied Greco-Roman sculpture in order to learn the perfect proportions of the human body. As a guide for painting, it was Raphael (cat. no. 22) in particular who almost became a substitute for the ancient artists. Corvi reacted against the preceding baroque and rococo styles as he, like Winckelmann, likely would have thought them to be vulgar and decadent. The new style cultivated clarity and simplicity of form that lent a new dignity to the subject. In the *Allegory of Painting*, the emphasis is on clear, unbroken outlines in harmonious counterbalancing movements, which give the soft figures a sculptural quality.

In Corvi's allegory, love and imitation are closely linked as it is Cupid that holds the mirror. The amorous reference is reinforced by the painter's poetic evocation of a particular pictorial subject known as the Toilet of Venus, in which a cupid holds up a mirror for the goddess of love.[3] The painting poetically expresses that it is love that leads the artist to contemplate ideal beauty.

MSH

PROVENANCE
Royal collections, Turin; Don Marcello Massarenti, Rome, by 1897; Henry Walters, 1902

SELECTED BIBLIOGRAPHY
Zeri 1976, 2:536–37 (with earlier literature); Tscherny 1977–78, 23–27; Curzi 1998, 37–38

NOTES
1 Tscherny 1977–78, 24.
2 For Corvi's art, see Zeri 1976, 2:536–37; *Domenico Corvi*, eds. V. Curzi and A. L. Bianco, exh. cat., Viterbo, Museo della Rocca Albornoz (Rome, 1998).
3 A famous example is Titian's *Venus at Her Toilet* in the National Gallery of Art, Washington, D.C. Tscherny 1977–78, 23.

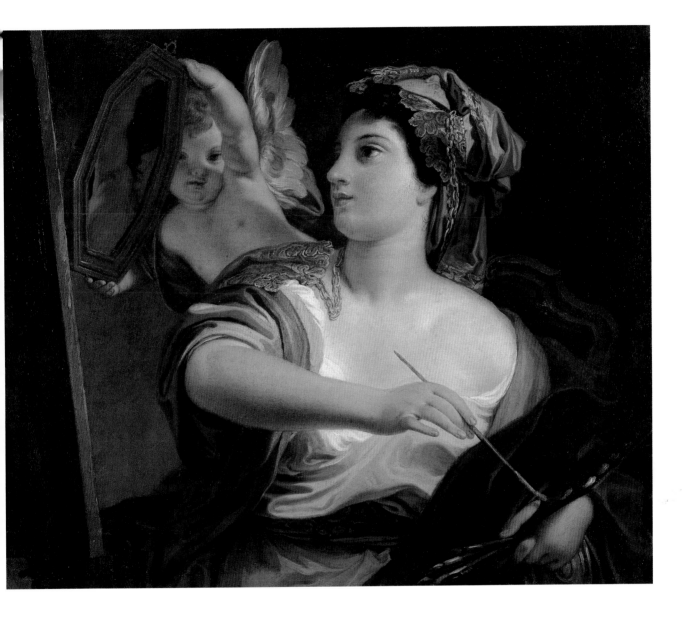

Allegory of Painting, 1764
Oil on canvas, 23 $^{13}/_{16}$ x 28 $^7/_8$ in. (60.5 x 73.3 cm)
37.1011

POMPEO BATONI, 1708–87

Portrait of Cardinal Prospero Colonna di Sciarra, ca. 1750

IN EIGHTEENTH-CENTURY ROME, commissions for clerical portraits offered artists the opportunity to create paintings that rivaled some of the most revered works of the Western tradition. During the Renaissance, Raphael's celebrated portraits of Pope Julius II (fig. 1, p. 104) established the basic conventions for the portrayal of religious officials: the sitter is often shown seated or standing at three-quarters length, as in this fine portrait of Cardinal Colonna di Sciarra by Batoni. The richly described red velvet and lace of the cardinal's official vestments allow the artist to showcase his technique. Unlike more formal presentations in which the sitter is shown with right hand raised in a gesture of blessing, the cardinal is given a more naturalistic air, as if momentarily interrupted by our arrival. Batoni's isolation of the figure against a neutral, undefined background concentrates all of the viewer's attention on the sitter's refined features. The cardinal's liquid eyes rest comfortably on the viewer, while the splendor of his dress and patrician demeanor immediately convey the prestige of his office. Batoni manages to idealize the cardinal's facial features without entirely sacrificing an immediately recognizable likeness, an ability for which he was universally admired.

Typically, such clerical portraits would have been replicated many times, either by the artist himself or by studio assistants, for distribution to the sitter's colleagues and patrons. However, the high finish and sheer quality of this portrait can only be the result of Batoni's hand, suggesting that the Walters' portrait is very likely either the prime version or an autograph replica of a now lost original.[1] There exists, as well, a print after the portrait by the well-known artist Johann Georg Wille (1715–1808), dated 1754 (fig. 1). Presumably Wille, who was active in Paris, based his engraving on a version of the original that must have been sent to France by the cardinal for the usual diplomatic reasons.

The demand for portraiture in eighteenth-century Rome was in part the result of the flourishing tourist trade. Batoni was popular with travelers on the Grand Tour. Every important visitor to Italy seemed to require a visual record of his or her experiences in Rome, a function that Batoni's portraits performed to perfection. However, like his supposed rival Anton Raphael Mengs (1728–79), Batoni placed great importance on official commissions, whether for large-scale religious altarpieces[2] or clerical portraits such as this depiction of Cardinal Colonna di Sciarra.

INSCRIPTION
On the front of the letter held by the sitter:
"ALL'EMIN^MO E REV^MO PRIN^E / IL CARD COLONNA DE SCIAR^RA"

PROVENANCE
Colonna di Sciarra family (?), Rome; Don Marcello Massarenti, Rome, by 1897; Henry Walters, 1902

SELECTED BIBLIOGRAPHY
Zeri 1976, 2:526–27 (with earlier literature); Clark and Bowron 1985, no. 140, pl. 131; Zafran 1988a, 76–77; Bowron and Rishel, eds. 2000, cat. no. 166

NOTES
1 Bowron and Rishel, eds. 2000, 311.
2 For example, *The Blessed Bernardo Tolomei Attending a Victim of the Black Death*, commissioned for a chapel of San Vittore al Corpo in Milan, which is of about the same date as the Walters' portrait. Reproduced and catalogued in Clark and Bowron 1985, cat. 141, pl. 132.

FIG. 1 Johann Georg Wille, after Pompeo Batoni, *Cardinal Prospero Colonna di Sciarra*, 1754, engraving. The Baltimore Museum of Art, Garrett Collection, BMA 1984.81.3704.

EK

Portrait of Cardinal Prospero Colonna di Sciarra, ca. 1750
Oil on canvas, 39 ¾ x 29 ⅝ in. (100.7 x 75.4 cm)
37.1205

Bibliography

Acidini Luchinat, C. 1999. *Pintoricchio.* Florence.

Aikema, B. 1996. *Jacopo Bassano and His Public: Moralizing Pictures in an Age of Reform, ca. 1535–1600.* Translated by A. P. McCormick. Princeton.

Algeri, G., and A. de Floriani. 1991. *La pittura in Liguria: il Quattrocento.* Genoa.

Allegri, E., and A. Cecchi. 1981. *Palazzo Vecchio e i Medici, Guida storica.* Florence.

Angelini, A. 1982. "Pietro Orioli e il momento 'urbinate' della pittura senese del Quattrocento." *Prospettiva* 30: 30–43.

Barriault, A. 1994. *"Spalliera" Paintings of Renaissance Tuscany: Fables of Poets for Patrician Homes.* University Park, Pennsylvania.

Battisti, E. 1992. *Piero della Francesca.* Milan.

Bellosi, L., ed. 1993. *Francesco di Giorgio e il Rinascimento a Siena, 1450–1500.* Exh. cat., Sant'Agostino, Siena. Milan.

Bernini, D., and G. Bernini, eds. 1978. *Il restauro della città ideale di Urbino. Mostra documentaria.* Exh. cat., Galleria Nazionale delle Marche, Urbino. Urbino.

Berti, L. 1990. "L'Alabardiere del Pontormo." *Critica d'Arte* 55: 45–48.

Biancana, S. 1998. In *Lavinia Fontana of Bologna 1552–1614*, edited by V. Fortunati. Exh. cat., National Museum of Women in the Arts, Washington, D.C. Milan.

Bober, P. P., and R. Rubenstein. 1986. *Renaissance Artists and Antique Sculpture: A Handbook of Sources.* London.

Bologna, F. 1977. *Napoli e le rotte mediterranee della pittura da Alfonso il Magnanimo a Ferdinando il Cattolico.* Naples.

Borchert, T. H., ed. 2002. *The Age of Van Eyck: the Mediterranean World and Early Netherlandish Painting 1430–1530.* Exh. cat., Groeningemuseum, Bruges. London.

Boskovits, M. 1990. *Early Italian Painting 1290–1470.* London.

Boskovits, M., and D. A. Brown. 2003. *Italian Paintings of the Fifteenth Century.* The collections of the National Gallery of Art systematic catalogue. Washington, D.C. and New York.

Bowron, E. P., and J. J. Rishel, eds. 2000. *Art in Rome in the Eighteenth Century.* Exh. cat., Philadelphia Museum of Art. London.

Brown, B. L., and P. Marini, eds. 1992. *Jacopo Bassano c. 1510–1592.* Exh. cat., Museo civico, Bassano del Grappa; Kimbell Art Museum, Fort Worth. Bologna.

Brown, D. A. 1983. *Raphael and America.* Exh. cat., National Gallery of Art, Washington, D.C. Washington, D.C.

Brown, D. A. et al. 2001. *Virtue and Beauty: Leonardo's 'Ginerva de' Benci' and Renaissance Portraits of Women.* National Gallery of Art, Washington, D.C. Washington, D.C. and Princeton.

Buffa, P., ed. 1994. *Sofonisba Anguissola e le sue sorelle.* Exh. cat., Santa Maria della Pietà, Cremona; Kunsthistorisches Museum, Vienna; National Museum of Women in the Arts, Washington, D.C. Milan.

Butterfield, A. 1997. *The Sculptures of Andrea del Verrocchio.* New Haven.

Calvesi, M. "La 'Città ideale' in Baltimora." In Dal Poggetto, ed. 2001.

Cantaro, M. T. 1989. *Lavinia Fontana Bolognese "pittora singolare," 1552–1614.* Milan and Rome.

Caroli, F. 1987. *Sofonisba Anguissola e le sue sorelle.* Milan.

Cavazzini, P. 2002. "Towards a Chronology of Agostino Tassi." *Burlington Magazine* 144, no. 1192 (July): 396–408.

Christiansen, K. 1982. *Gentile da Fabriano.* Ithaca, New York.

———, ed. 1996. *Giambattista Tiepolo 1696–1770.* Exh. cat., The Metropolitan Museum of Art, New York. New York.

Christiansen, K. et al. 2004. *From Filippo Lippi to Piero della Francesca: Fra Carnevale and the Making of a Renaissance Master.* Exh. cat., Pinacoteca di Brera, Milan; The Metropolitan Museum of Art, New York. New York.

Christiansen, K., L. B. Kanter, and C. B. Strehlke. 1988. *Painting in Renaissance Siena 1420–1500.* Exh. cat., The Metropolitan Museum of Art, New York. New York.

Ciammitti, L. 1985. "La cappella Garganelli di Ercole Roberti: storia di una distruzione." In *Tre artisti nella Bologna dei Bentivoglio: Francesco del Cossa, Ercole Roberti, Niccolò dell'Arca*, edited by F. Varignana. Exh. cat., Pinacoteca Nazionale, Bologna. Bologna.

Ciardi, R. P., and A. Mugnaini. 1991. *Rosso Fiorentino: catalogo completo dei dipinti.* Florence.

Ciardi Dupré Dal Poggetto, M. G. 1983. "*La Città Ideale di Urbino*, saggio e scheda." In Ciardi Dupré Dal Poggetto and Dal Poggetto, eds. 1983.

———. 2001. "Luciano Laurana (attribuito a) 'Città ideale.'" In Dal Poggetto, ed. 2001.

Ciardi Dupré Dal Poggetto, M. G., and P. Dal Poggetto, eds. 1983. *Urbino e le Marche prima e dopo Rafaello.* Exh. cat., Galleria Nazionale delle Marche and San Domenico, Urbino. Florence.

Ciccuto, M. 2000. "Alberti verso le città ideali: la sua reflessione sul concetto di figura." In *Leon Battista Alberti: actes du congrès international de Paris*, edited by F. Furlan et al. Paris.

Cieri Via, C. 1999. "Ornamento e varietà: riflessi delle teorie Albertiane nella produzione artistico-figurativa fra '400 e '500." In *Leon Battista Alberti: architettura e cultura, Atti del convegno internazionale, Mantova, 16–19 novembre 1994.* Florence.

Clark, A. M., and E. P. Bowron. 1985. *Pompeo Batoni: A Complete Catalogue of His Works with an Introductory Text.* New York.

Cleri, B. 1997. *Antonio da Fabriano.* Cinisello Balsamo.

Cole, B. 1985. *Sienese Painting in the Age of the Renaissance.* Bloomington, Indiana.

Conti, A. 1976. "Le prospettive urbinati: tentative di un bilancio ed abbozzo di una bibliografia." *Annali della scuola normale superiore di Pisa* 6, no. 4, ser. 3: 1193–234.

Corti, L. 1989. *Vasari: catalogo completo dei dipinti.* Florence.

Costamagna, P. 1994. *Pontormo.* Milan.

———. 2002a. "Maria Salviati and a Child (Cosimo I?)." In C. Acidini Luchinat et al., *The Medici, Michelangelo and the Art of Late Renaissance Florence.* Exh. cat., Palazzo Strozzi, Florence; Detroit Institute of Arts, Detroit; The Art Institute of Chicago, Chicago. New Haven, London, and Detroit.

———. 2002b. "De l'idéal de beauté aux problèmes d'attribution: vingt ans de recherche sur le portrait florentin au XVIe siècle." *Studiolo* 1: 193–220.

Costamagna, P., and A. Fabre. 1986. *Les portraits florentins du début du XVI siècle à l'avènement de Cosimo I: catalogue raisonné d'Albertinelli à Pontormo, Mémoire de recherche de l'Ecole du Louvre.* 5 vols. Paris.

Cox-Rearick, J. 1981. *The Drawings of Pontormo.* Cambridge, Massachusetts.

———. 1982. "Bronzino's Young Woman with Her Little Boy."
Studies in the History of Art 12: 67–79.

———. 1984. Dynasty and Destiny in Medici Art. Princeton.

———. 1989. An Important Painting by Pontormo from the Collection of
Chauncey D. Stillman. Christie's, New York, 13 May 1989.

———. 1993. Bronzino's Chapel of Eleonora in the Palazzo Vecchio. Berkeley,
California.

Cropper, E. 1997. Pontormo: Portrait of a Halberdier. Los Angeles.

———. 2001. "Maria Salviati with Giulia de' Medici." In Brown et
al. 2001.

Curzi, V. 1998. "Committenti, intermediari e collezionisti: fortuna
di Domenico Corvi e sistemi di diffusione delle sue opera fuori
di Roma." In Domenico Corvi, edited by V. Curzi and A. Lo Bianco.
Exh. cat., Museo della Rocca Albornoz, Viterbo. Rome.

Dal Poggetto, P., ed. 1992. Piero e Urbino. Piero e le corti rinascimentali. Exh.
cat., Palazzo Ducale and Oratorio di San Giovanni Battista,
Urbino. Venice.

———. 2001. "Un'ipotesi per la 'Città ideale'." In Dal Poggetto, ed.
2001.

———, ed. 2001. Ricerche e studi sui 'Signori del Montefeltro' di Piero della
Francesca e sulla 'Città ideale'. Urbino.

Damisch, H. 1994a. The Origin of Perspective. Translated by J. Goodman.
Cambridge, Massachusetts.

———. 1994b "The Ideal City." In Millon and Magnago
Lampugnani, eds. 1994.

Danilova, I. E. 1995. State Pushkin Museum of Fine Arts: Catalogue of Painting.
Moscow.

De Benedictis, C. 1974. "Naddo Ceccarelli." Commentari 25, no. 29:
139–54.

De Dominici, B. 1971. Vite de pittori, scultori ed architetti napoletani. Reprint
of 1742–43 edition. Bologna.

De Marchi, A., 1992. Gentile da Fabriano: un viaggio nella pittura italiana alla
fine del gotico. Milan.

———. 1994. "Diversità di Antonio da Fabriano." In Un Testamento
pittorico di fine '400, Gli affreschi restaurati di Antonio da Fabriano in San
Domenico. Fabriano.

———. 1996. "Centralità di Padova." In Dempsey, ed. 1996.

———. 2002. "Olivuccio di Ciccarello." In De Marchi, ed. 2002.

———, ed. 2002. Pittori a Camerino nel Quattrocento. Milan.

———. 2004. "Antonio di Agostino da Fabriano, St. Jerome in his
Study." In Christiansen et al. 2004.

De Nicolò Salmazo, A. 1987. "La pittura rinascimentale a Padova."
In La pittura in Italia. Il Quattrocento, edited by F. Zeri. Vol. 1. Milan.

———. 1990. "Padova." In La pittura nel Veneto: Il Quattrocento, edited by
M. Lucco. Vol. 2. Milan.

Dempsey, C. 1988. "Guido Reni in the Eyes of his Contemporaries."
In Guido Reni 1575–1642.

———, ed. 1996. Quattrocento adriatico: Fifteenth-century Art of the Adriatic
Rim. Bologna.

Droghini, M. 2001. Raffaellino del Colle. n.p.

Eaton, R. 2001. Utopianism and the (Un)built Environment. Antwerp.

Faietti, M., and D. Scaglietti Kelescian. 1995. Amico Aspertini. Modena.

Falciani, C. "Maria Salviati ritratta dal Pontormo." In Natali, ed.
1995.

Ferino Pagden, S. 1989. "Giulio Romano pittore e disegnatore a
Roma." In Giulio Romano, edited by S. Polano. Exh. cat., Palazzo del
Te and Palazzo Ducale, Mantua. Milan.

———. 1995. Sofonisba Anguissola, Die Malerin der Renaissance (um
1535–1625), Cremona-Madrid-Genua-Palermo. Exh. cat.,
Kunsthistorisches Museum, Vienna. Vienna.

Ferino Pagden, S., and M. Kusche. 1995. Sofonisba Anguissola, a
Renaissance Woman. Exh. cat., National Museum of women in the
Arts, Washington, D.C. Washington, D.C.

Ferriani, D. 1994. In Lavinia Fontana 1552–1614, edited by V. Fortunati.
Exh. cat., Museo Civico Archeologico, Bologna. Milan.

Forssman, E. 1973. Il Palazzo da Porto Festa di Vicenza. Vicenza.

Franklin, D. 1994. Rosso in Italy. New Haven.

Freuler, G. 1994. Bartolo di Fredi Cini: ein Beitrag zur sienesischen Malerei des
14. Jahrhunderts. Disentis.

Gandolfo, F. 2003. "La pittura nell'Umbria meridionale e gli affres-
chi di San Pietro in Valle a Ferentillo." In Gli affreschi di San Pietro
in(?) Valle a Ferentillo, edited by G. Tamanti. Naples.

Garrard, M. 1994. "Here's Looking at Me: Sofonisba Anguissola and
the Problem of the Woman Artist." Renaissance Quarterly 47, no. 3:
556-622.

Gavazza, E., et al., eds. 1995. Bernardo Strozzi, Genova 1581/82—Venezia
1644. Exh. cat., Palazzo Ducale, Genoa. Milan.

Gemin, M., and F. Pedrocco. 1993. Giambattista Tiepolo: i dipinti, opera
completa. Venice.

Ghia, G. S. 2002. In Colori della musica: dipinti, strumenti e concerti tra
Cinquecento e Seicento, edited by A. Bini, C. Strinati, and R. Vodret.
Exh. cat., Galleria Nazionale d'Arte Antica di Palazzo Barberini,
Rome; Santa Maria della Scala, Siena. Milan.

Ghirardi, A. 1990. Bartolomeo Passerotti pittore (1529–1592). Translated
by I. Vichi. Rimini.

Gibbs, R. 1989. Tomaso da Modena. Painting in Emilia and the March of Treviso,
1340–80. Cambridge, Massachusetts.

Gilbert, C. 1986. "On Castagno's Nine Famous Men and Women:
Sword and Book as the Basis for Public Service." In Life and Death
in Fifteenth-Century Florence, edited by M. Tetel, R. G. Witt, and R.
Goffen. Durham and London.

Gnann, A. 1999. In Raphael und der klassische Stil in Rom 1515–1527,
edited by K. Oberhuber. Exh. cat., Albertina, Vienna. Milan.

Goffen, R. 1989. Giovanni Bellini. New Haven and London.

Gordon, D. 1994. "The Mass Production of Franciscan Piety:
Another Look at some Umbrian Verres églomisés." Apollo 140, no.
394, n.s. (December): 33–42.

Gordon, E. 1993. "Restoring a Masterpiece: Giovanni Battista
Tiepolo's King Jugurtha Brought Before Sulla." The Walters Art
Gallery Bulletin (December): 4–95.

———. 1999. "Pictures at an Exhibition." The Walters (July–August):
2–3.

Grafton, A. 2002. Leon Battista Alberti: Master Builder of the Italian Renaissance.
New York.

Guido Reni 1575–1642. Exh. cat., Pinacoteca Nazionale, Bologna; Los
Angeles County Museum of Art, Los Angeles; Kimbell Art
Museum, Fort Worth. Bologna.

Harping, P. 1993. The Sienese Painter Bartolo di Fredi. London and Toronto.

Heinemann, F. 1991. Giovanni Bellini e i Belliani, III Supplemento e
Ampliamenti. Hildesheim.

Helke, G. 2002-3. "Lorenzo Lottos Spiegel im Dienst von Paragone
und Religion." Jahrbuch des Kunsthistorischen Museums Wien 4–5:
77–119.

Holmes, M. 1999. *Fra Filippo Lippi: the Carmelite Painter*. New Haven and London.

Höper, C. 1987. *Bartolomeo Passarotti (1529–1592)*. 2 vols. Worms.

Hueck, I. 1991. "Ein umbrisches Reliquiar im Kunstgewerbe-museum Schloß Köpenick." *Forschungen und Berichte. Staatliche Museen zu Berlin* 31: 183–88.

Jacks, P. 2002. "The Renaissance Prospettiva: Perspectives of the Ideal City." In *The Cambridge Companion to Piero della Francesca*, edited by J. M. Wood. Cambridge.

Johnston, W. R. 1999. *William and Henry Walters, the Reticent Collectors*. Baltimore and London.

Kanter, L. B. 1983. "A Massacre of the Innocents in the Walters Art Gallery." *Journal of the Walters Art Gallery* 41: 17–28.

———. 1988. "Pietro Orioli." In Christiansen, Kanter, and Strehlke 1988.

———. 2000. "Rethinking the Griselda Master." *Gazette des Beaux-Arts* 135 (February): 147–56.

Kemp, M. 1985. *Geometrical Perspective from Brunelleschi to Desargues: a Pictorial Means or an Intellectual End?* London.

———. 1991. "Central Italian Artist, Ideal City with a Fountain and Statues of the Virtues." In *Circa 1492, Art in the Age of Exploration*, edited by J. A. Levenson. Exh. cat., National Gallery of Art, Washington, D.C. New Haven and Washington, D.C.

Knox, G. 1979. "Giambattista Tiepolo, Queen Zenobia and Ca' Zenobio: 'una delle prime sue fatture.'" *Burlington Magazine* 121, no. 916 (July): 409–18.

———. 1996. "Giambattista Tiepolo in Baltimore: a Painting in Search of a Subject." *Apollo* 143, no. 411 (June): 15–17.

Kokole, S. 1990 "Notes on the Sculptural Sources for Giorgio Schiavone's Madonna in London." *Venezia Arti* 4: 50–56.

Krautheimer, R. "The Panels in Urbino, Baltimore, and Berlin Reconsidered." In Millon, ed. 1994.

Krawietz, C. 1996. "Strozzi, Bernardo." In *The Dictionary of Art*, edited by J. Shoaf Turner. London.

Langdon, G. 1992. "Pontormo and Medici Lineage: Alessandro, Giulia and Giulio de' Medici." *Revue d'art canadienne/Canadian Art Review* 19, no. 1–2: 20–40.

Langedijk, K. 1981. *Portraits of the Medici*. 2 vols. Florence.

Lauts, J., and I. L. Herzner. 2001. *Federico da Montefeltro, Herzog von Urbino: Kriegsher, Friedensfürst und Förderer der Künste*. Berlin.

Levy, A. 2003. "Framing Widows: Mourning, Gender and Portraiture in Early Modern Florence." In *Widowhood and Visual Culture in Early Modern Europe*, edited by A. Levy. Burlington, Vermont.

Lightbown, R. 2004. *Carlo Crivelli*. New Haven and London.

Lucy, M. 1996. "Tiepolo's Powers of Invention," *The Walters Monthly Bulletin* (Summer): 4–5.

Lukehart, P. 1995. "Bernard Strozzi: a Biographical Overview." In *Bernardo Strozzi, Master Painter of the Italian Baroque*, edited by J. Spicer. Exh. cat., The Walters Art Gallery, Baltimore.

Manca, J. 1992. *The Art of Ercole de' Roberti*. 2 vols. Cambridge and New York.

Marandel, J. P. 2001. In *François de Nomé: Mysteries of a Seventeenth-Century Neapolitan Painter*. Exh. cat., The Menil Collection, Houston. Houston.

Mariuz, A., G. Pavanello, and G. Romanelli, eds. 1993. *Pietro Longhi*. Exh. cat., Museo Correr, Venice. Milan.

Marques, L. 1987. *La Peinture du Duecento en Italie centrale*. Paris.

Matthiesen Fine Art Ltd. 2001. *2001: An Art Odyssey 1500–1720*, edited by B. L. Brown and Matthiesen. Exh. cat., Matthiesen Fine Art Ltd., London. London.

Millon, H. A. and Magnago Lampugnani, eds. 1994. *The Renaissance from Brunelleschi to Michelangelo: The Representation of Architecture*. Exh. cat. Palazzo Grassi, Venice; National Gallery of Art, Washington, D.C. Milan.

Mode, R. L. 1974. "Ancient Paragons in a Piccolomini Scheme." In *Hortus Imaginum*, edited by R. Enggass and M. Stokstad. Lawrence, Kansas.

Mormando, F., ed. 1999. *Saints & Sinners: Caravaggio & the Baroque Image*. Exh. cat., McMullen Museum of Art, Boston College. Boston.

Morolli, G. "Nel cuore del palazzo, la città ideale. Alberti e la prospettiva architettonica di Urbino." In Dal Poggetto, ed. 2001, 215–29.

Mortari, L. 1995. *Bernardo Strozzi*. Rome.

Murphy, C. P. 1997. "Lavinia Fontana and the Female Life Cycle Experience in Late Sixteenth-Century Bologna." In *Picturing Women in Renaissance and Baroque Italy*, edited by G. A. Johnson and S. F. Matthews Grieco. Cambridge.

———. 2003. *Lavinia Fontana: A Painter and Her Patrons in Sixteenth-century Bologna*. New Haven and London.

Musacchio, J. M. 2001. "Weasels and Pregnancy in Renaissance Italy." *Renaissance Studies* 15, no. 2: 172–87.

———. 2004. "Review of *The Medici, Michelangelo and the Art of Late Renaissance Florence*." *Art History* 27, no. 2: 311–12.

Nappi, M. R. 1991. *François de Nomé e Didier Barra: l'enigma Monsù Desiderio*. Milan and Rome.

Natale, M. 2001. "El Mediterráneo que nos une." In *El Renacimiento Mediterráneo. Viajes de artistas e itineraries de obras entre Italia, Francia y España en el siglo XV*. Exh. cat., Museo Thyssen-Bornemisza, Madrid; Museu de Belles Arts de València. Madrid.

Natali, A., ed. 1995. *Rosso e Pontormo: fierezza e solitudine*. Soresina.

Oberhuber, K. 1999. *Raphael: The Paintings*. Milan.

Padoa Rizzo, A., and C. Frosinini. 1984. "Stefano d'Antonio di Vanni (1405–1483): opere e documenti." *Antichitàviva* 23, nos. 4–5: 5–26.

Pallucchini, R. 1993. *La pittura veneziana del Seicento*. Milan.

Papi, G. 1998. "Il maestro dei cinque sensi." *Bollettino dei Musei Comunali di Roma* 12, n.s.: 26–35.

Parrocchi, A. 1992. "Urbino, Baltimora, Berlino, fonti di cassoni quattrocenteschi o modelli di scena del 1518?" In *Kunst des Cinquecento in der Toskana*, edited by M. Cämmer. Munich.

Pedrocco, F. 2002. *Tiepolo, the Complete Paintings*. New York.

Pepper, D. S. 1988. *Guido Reni, L'opera completa*. Novara.

Pérez Sanchez, A. E., and N. Spinosa, eds. 1992. *Jusepe de Ribera: 1591–1652*. Exh. cat., The Metropolitan Museum of Art, New York. New York.

Perlingieri, I. S. 1992. *Sofonisba Anguissola, the First Great Woman Artist of the Renaissance*. New York.

Petrucci, F. 1999. "La ritrattistica." In *Giovanni Battista Gaulli: Il Baciccio 1639–1709*, edited by M. Fagiolo dell'Arco, D. Graf, and F. Petrucci. Exh. cat., Palazzo Chigi, Ariccia. Milan.

Pignatti, T. 1974. *L'opera completa di Pietro Longhi*. Milan.

Pilliod, E. 2001. *Pontormo, Bronzino, Allori: A Genealogy of Florentine Art*. New Haven and London.

Pinelli, A. 2004. *La bellezza impura: arte e politica nell'Italia del Rinascimento.* Bari.

Pirovano, C., ed. 1989. *La natura morta in Italia.* Milan.

Polverari, M. 1989. *Carlo da Camerino.* Ancona.

Prajatelj, K. "La pittura in Dalmazia nel Quattrocento e i suoi legami con l'altra sponda." In Dempsey, ed. 1996.

Preising, D. 1995–97. "Bild und Reliquie: Gestalt und Funktion gotischer Reliquientafeln und Altärchen." *Aachener Kunstblätter* 61:13–84.

Priever, A. 2000. *Paolo Caliari, genannt Veronese 1528–1588.* Cologne.

Pugliatti, T. 1977. *Agostino Tassi tra conformismo e libertà.* Rome.

Pujmanová, O. 1992. "Trecento and Quattrocento Paintings in Czechoslovakia." *National Gallery of Art: Record of Activities and Research Reports* 12: 83–84.

Rearick, W. R. 1988. *The Art of Paolo Veronese 1528–1588.* Exh. cat., National Gallery of Art, Washington, D.C. Washington, D.C.

———. 1990. "The Early Portraits of Paolo Veronese." In *Nuovi Studi su Paolo Veronese,* edited by M. Gemin. Venice.

———. 1992. "Vita ed opere di Jacopo dal Ponte, detto Bassano, c. 1510–1592." In Brown and Marini, eds. 1992.

Reynaud, N. 1989. "Barthélemy d'Eyck avant 1450." *Revue de l'art* 84: 22–43.

Il Rosso e Volterra. 1994. Exh. cat., Pinacoteca comunale, Volterra. Florence and Venice.

Rowlands, E. W. 1979. "Sienese Painted Reliquaries of the Trecento: Their Format and Meaning." *Konsthistorisk Tidskrift* 48: 122–38.

Ruda, J. 1993. *Fra Filippo Lippi.* New York and London.

Safarik, E. 1990. *Fetti.* Milan.

Salvi, F. "Luciano Laurana (attri.), *Città ideale.*" In Dal Poggetto, ed. 1992.

Sangiorgi, F. 1976. *Documenti urbinati: inventari del Palazzo Ducale (1583–1631).* Urbino.

Scalini, M., ed. 2001. *Giovanni delle Bande Nere.* Florence.

Scarpellini, P., and M. R. Silvestri. 2004. *Pintoricchio.* Milan.

Sestieri, G. 2004. *Michele Rocca e la pittura rococò a Roma.* Rome

Simon, R. B. 1982. "Bronzino's Portraits of Cosimo de' Medici". Ph.D. Dissertation, Columbia University, New York.

———. 1986. "The Identity of Sofonisba Anguissola's Young Man." *Journal of the Walters Art Gallery* 44: 117–22.

Spear, R. 1997. *The "Divine" Guido: Religion, Sex, Money, and Art in the World of Guido Reni.* New Haven and London.

Spicer, J. 1994. "The Ideal City, Its Structures and Structure." *The Walters Art Gallery Bulletin* (January): 2–3.

———. ed. 1995. *Bernardo Strozzi: Master Painter of the Italian Baroque.* Exh. cat., The Walters Art Gallery. Baltimore.

———. 2001. "Pontormo's *Maria Salviati with Giulia de' Medici* of ca. 1539: The Earliest Portrait of a Child of African Descent in European Art?" *The Walters* (Summer): 4–6.

Spike, J. T. 1986. *Giuseppe Maria Crespi and the Emergence of Genre Panting in Italy.* Exh. cat., Kimbell Art Museum, Fort Worth. Florence.

Spinosa, N. 1984. *La pittura napoletana del '600.* Milan.

———. 2003. *Ribera: L'opera completa.* Naples.

Steinberg, L. 1970. "The Metaphors of Love and Birth in Michelangelo's Pietàs." In *Studies in Erotic Art,* edited by T. Bowie and C. V. Christenson. New York and London.

———. 1996. *The Sexuality of Christ in Renaissance Art and in Modern Oblivion,* 2nd edition. Chicago and London.

Strehlke, C. 2004. *Pontormo, Bronzino, and the Medici: The Transformation of the Renaissance Portrait in Florence.* Exh. cat., Philadelphia Museum of Art. Philadelphia.

Tatrai, V. 1979. "Maestro della storia di Griselda e una famiglia senese di mecenati dimenticata." *Acta Historiae Artium* 25: 27–65.

Tempestini, A. 1992. *Giovanni Bellini.* Milan.

———. 1999. *Giovanni Bellini.* Milan.

Thomas, A. 1997. "A New Date for Neri di Bicci's S. Giovannino dei Cavalieri 'Coronation of the Virgin'." *Burlington Magazine* 139, no. 1127 (February): 103–6.

Thornton, D. 1997. *The Scholar in His Study: Ownership and Experience in Renaissance Italy.* New Haven and London.

Todini, F. 1989. *La pittura umbra dal Duecento al primo Cinquecento.* 2 vols. Milan.

Tolnay, C. 1943. "The Music of the Universe: Notes on a Painting by Bicci di Lorenzo." *Journal of the Walters Art Gallery* 6: 83–104.

Tres siglos de oro de la pintura napolitana. 2003. Exh. cat., Museo de Bellas Artes de Valencia. Valencia.

Trionfi, H. M. 1983. "Prospettive architettoniche a tarsie: le porte del Palazzo Ducale di Urbino." *Notizie di Palazzo Albani* 12: 38–50.

Tscherny, N. 1977–78. "Domenico Corvi's *Allegory of Painting:* An Image of Love." *Marsyas: Studies in the History of Art* 19: 23–27.

Vasari, G. 1906. *Le Vite de' più eccellenti pittori, scultori ed architettori,* edited by G. Milanesi. 8 vols. Reprint of 1568 edition. Florence.

Verdier, P. 1983. "Bramante's *Belvedere* and a Painting by Raffaello dal Colle in the Walters Art Gallery." *Journal of the Walters Art Gallery* 41: 45–58.

Volpe, C. 1989. *Pietro Lorenzetti,* edited by M. Lucco. Milan.

Von Gaertringen, R. H. 2004. *Italienische Gemälde im Städel 1300–1550.* Mainz.

Waagen, G. 1857. *Galleries and Cabinets of Art in Great Britain,* vol. 4. London.

The Walters Art Gallery: Guide to the Collections. 1997. Baltimore and London.

Weil-Garris Brandt, K. "The Relation of Sculpture and Architecture in the Renaissance." In Millon and Magnago Lampugnani, eds., 1994.

Wixom, W. 1978. "Eleven Additions to the Medieval Collection." *Bulletin of the Cleveland Museum of Art* 66 (March/April): 128–32.

Wunder, R. P. 1958. "The Colloseum Series: A Glimpse into Panini's Stylistic Development." *The Art Quarterly* 12, no. 2 (Summer 1958): 161–64.

Zafran, E. M. 1988a. *Fifty Old Master Paintings from the Walters Art Gallery.* Baltimore.

———. 1988b. "A Newly Acquired Masterpiece by Guido Reni." *The Walters Art Gallery Bulletin* (January): 1–3.

Zampetti, P. 1986. *Carlo Crivelli.* Florence.

Zeri, F. 1976. *Italian Paintings in the Walters Art Gallery,* edited by U. E. McCracken. 2 vols. Baltimore.

———. 1977. "The Final Addition to a Predella by Andrea di Bartolo." *Journal of the Walters Art Gallery* 35: 87–88.

———. 2000. *Federico Zeri: diario marchigiano, 1948–1988.* Turin.

Index